THE METROPOLITAN MUSEUM OF ART NEW YORK · THE METROPOLITAN MUSEUM OF ART NEW YORK · THE METROPOLITAN MUSEUM OF ART NEW YORK · THE METROPOLITAN MUSEUM OF ART NEW YORK · THE METROPOLITAN MUSEUM OF ART NEW YORK · THE METROPOLITAN MUSEUM OF ART NEW YORK · THE METROPOLITAN MUSEUM OF ART NEW YORK · THE METROPOLITAN MUSEUM OF ART NEW YORK · THE METROPOLITAN MUSEUM OF ART NEW YORK · THE METROPOLITAN MUSEUM OF ART NEW YORK · THE METROPOLITAN MUSEUM OF ART NEW YORK · THE METROPOLITAN MUSEUM OF ART NEW YORK · THE METROPOLITAN MUSEUM OF ART NEW YORK · THE METROPOLITAN MUSEUM OF ART NEW YORK · THE METROPOLITAN MUSEUM OF ART NEW YORK · THE METROPOLITAN MUSEUM OF ART NEW YORK · THE METROPOLITAN MUSEUM OF ART NEW YORK · THE METROPOLITAN MUSEUM OF ART NEW YORK · THE METROPOLITAN MUSEUM OF ART NEW YORK

THE METROPOLITAN
MUSEUM OF ART

The Islamic World

THE METROPOLITAN

The Islamic World

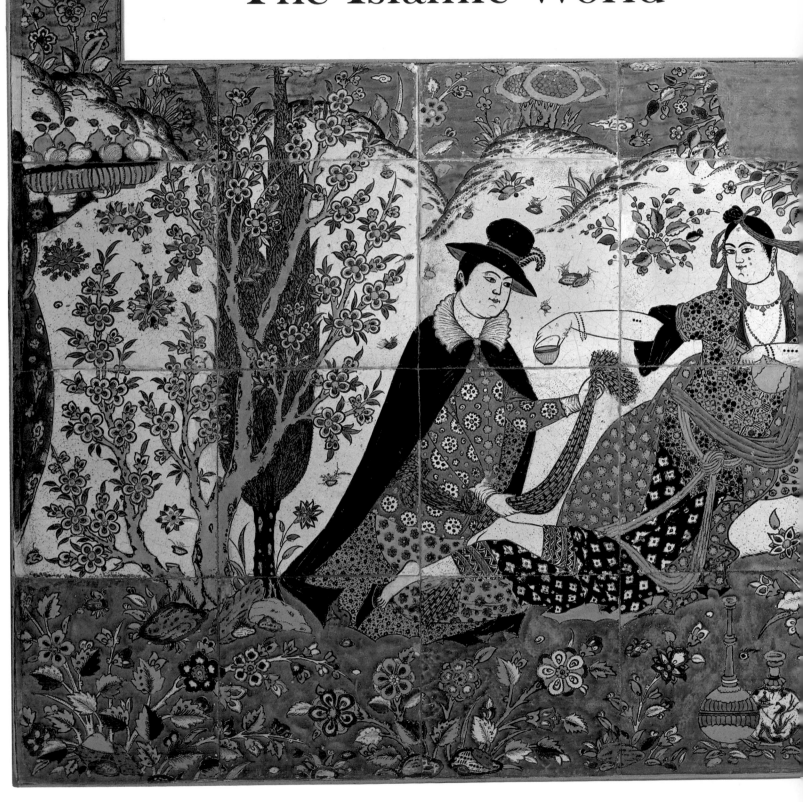

MUSEUM OF ART

INTRODUCTION BY

Stuart Cary Welch

SPECIAL CONSULTANT IN CHARGE
DEPARTMENT OF ISLAMIC ART

THE METROPOLITAN MUSEUM OF ART, NEW YORK

PUBLISHED BY

THE METROPOLITAN MUSEUM OF ART
New York

PUBLISHER
Bradford D. Kelleher

EDITOR IN CHIEF
John P. O'Neill

EXECUTIVE EDITOR
Mark D. Greenberg

EDITORIAL STAFF
Sarah C. McPhee

Josephine Novak

Lucy A. O'Brien

Robert McD. Parker

Michael A. Wolohojian

DESIGNER
Mary Ann Joulwan

———

Commentaries written by the curatorial staff of the Department of Islamic Art: Plates 27, 62, 63, 70, 71, 73, 76, 81, 82, 101–104, 106, 107, 109, 111, 113, 114, 117, 120, and 121, by Stuart Cary Welch, special consultant in charge. Plates 1, 19, 20, 30, 37, 41, 50, 56, 57, 59, 85, 93, 98, and 118, by Annemarie Schimmel, consultant. Plates 2, 3, 22, 34, 35, 51–53, 58, 60, 69, 72, 79, 87, 89–91, 99, 100, and 105, by Marie L. Swietochowski, associate curator. Plates 4–6, 8–14, 16–18, 21, 23–26, 31–33, 36, 40, 42, 46, 54, 61, 66, 83, and 86, by Marilyn Jenkins, associate curator. Plates 7, 29, 45, 47, 55, 68, 74, 75, 77, 78, 80, 84, 88, 92, 97, 108, 112, 119, and 122, by Carolyn Kane, assistant curator. Plates 15, 28, 38, and 39, written jointly by Annemarie Schimmel and Carolyn Kane. Commentaries on Plates 43, 44, 48, 49, 64, 65, 67, 94–96, 110, 115, and 116, written by D. G. Alexander, senior research associate, Department of Arms and Armor.

Photography commissioned from Schecter Lee, assisted by Lesley Heathcote: Page 6 and Plates 3, 6–11, 15, 19, 20, 22, 27, 28, 34, 39, 45–47, 50, 51, 53, 55, 57–62, 64–66, 69–75, 77, 78, 80, 84, 87, 90, 91, 92, 94, 95, 97, 98, 100, 106–108, 112. All other photographs including the details on page 97 were taken by The Photograph Studio, The Metropolitan Museum of Art.

Maps and time chart designed by Irmgard Lochner.

TITLE PAGE

Tile Panel Iran (Isfahan); 1st quart. 17th c.
Composite body, underglaze-painted; 78 x 40 in.
(198.1 x 101.6 cm.) Rogers Fund, 1903, (03.9c)

Library of Congress Cataloging-in-Publication Data

Metropolitan Museum of Art (New York, N.Y.)
 The Islamic world.

 1. Art, Islamic—Catalogs. 2. Art—New York (N.Y.)—
Catalogs. 3. Middle East—Antiquities—Catalogs.
4. Metropolitan Museum of Art (New York, N.Y.)—Catalogs.
I. Welch, Stuart Cary. II. Title.
N6263.N4M46 1987 709′.17′67107401471 87-11063
ISBN 0-87099-461-1 ISBN 0-87099-456-5 (pbk.)

Printed and bound by Dai Nippon Printing Co., Ltd., Tokyo.
Composition by U.S. Lithograph, typographers, New York.

This series was conceived and originated jointly by The Metropolitan Museum of Art and Fukutake Publishing Co., Ltd. DNP (America) assisted in coordinating this project.

This volume, devoted to the arts of the Islamic world, is the eleventh publication in a series of twelve volumes that, collectively represent the scope of the Metropolitan Museum's holdings while selectively presenting the very finest objects from each of its curatorial departments.

This ambitious publication program was conceived as a way of presenting the collections of The Metropolitan Museum of Art to the widest possible audience. More detailed than a museum guide, broader in scope than the Museum's scholarly publications, this series presents paintings, drawings, prints, and photographs; sculpture, furniture, and the decorative arts; costumes, arms, and armor —all integrated in such a way as to offer a unified and coherent view of the periods and cultures represented by the Museum's collections. The objects that have been selected for inclusion in the series constitute a small portion of the Metropolitan's holdings, but they admirably represent the range and excellence of the various curatorial departments. The texts relate each of the objects to the cultural milieu and period from which it derives and incorporates the fruits of recent scholarship. The accompanying photographs, in many instances specially commissioned for this series, offer a splendid and detailed tour of the Museum.

We are particularly grateful to the late Mr. Tetsuhiko Fukutake, who, while president of Fukutake Publishing Company, Ltd., Japan, encouraged and supported this project. His dedication to the publication of this series has contributed greatly to its success.

The collections of the Metropolitan Museum are particularly rich in Islamic art, and the collections have grown through gifts of many generous donors, and by bequests and judicious purchases made possible by the Museum's acquisitions funds.

Among the many donors of objects, we must mention especially Edwin Binney, 3rd, George C. Pratt, Richard Ettinghausen, Charles K. Wilkinson, J. Pierpont Morgan, Mr. and Mrs. Horace Havemeyer, Beatrice Kelekian, Alice Heeramaneck, Alexander Smith Cochran, Arthur A. Houghton, Jr., The Hagop Kevorkian Fund, and John D. Rockefeller, Jr. Many objects were given by bequest of Cora Timken Burnett, Edward C. Moore, George C. Stone, Isaac D. Fletcher, Benjamin Altman, James F. Ballard, Joseph V. McMullan, and William Milne Grinnel. Purchases were made possible by funds available from the Fletcher Fund, the Rogers Fund, the Joseph Pulitzer Bequest, the Harris Brisbane Dick Fund as well as by gift of Richard Perkins, the Vincent Astor Foundation, the Louis E. and Theresa S. Seley Purchase Fund for Islamic Art, and Mr. and Mrs. Nathaniel Spear, Jr.

In preparing this volume, the editors drew on the expertise of the curatorial staff of the Museum's Department of Islamic Art. We are especially grateful to Stuart Cary Welch, special consultant in charge, for having prepared the introduction to this volume as well as many of the commentaries, and to Marie Lukens Swietochowski and Marilyn Jenkins, associate curators, Carolyn Kane, assistant curator, and Annemarie Schimmel, consultant, all of whom wrote commentaries on objects and paintings within their special fields of interest. In addition, the entire staff helped immeasurably by selecting the objects to be reproduced, organizing the book, and reviewing its design.

Philippe de Montebello
Director

Carpet (detail) Northwest or central Iran; Safavid period,
1st half 16th c.
Silk warp and weft, wool pile, ca. 550 Senneh knots per sq. in.;
16 ft. 4 in. x 11 ft. 2 in. (4.97 x 3.4 m.)
Frederick C. Hewitt Fund, 1910 (10.61.3) *Page 104:* text

Basin　Iran; early 14th c.; Brass, inlaid with silver and gold; H. 5⅛ in. (13 cm.) D. 20⅛ in. (51.1 cm.)
Edward C. Moore Collection, Bequest of Edward C. Moore, 1891 (91.1.521)

THE ISLAMIC WORLD

Verily God is beautiful and loves beauty.
—Saying of the Prophet Muhammad

The pictures and objects shown in this book range in style from the purely abstract to the naturalistic, and their materials from humble clay to jeweled gold. Some are stunningly "primitive," others almost unapproachably refined and subtle. Among them are delightfully vital yet serious characterizations of extraordinary people and of bounding and roaring animals. However luxuriously ornamental and worldly, many of these pictures and objects take spiritual flight. Their provenances—from Spain to India and far beyond—are as disparate as their styles and moods; yet they come together harmoniously, unified by a touch of divine fire—Islam.

Islam ("submission to God") began in Arabia, a starkly beautiful land of scrub and desert, of endless horizons and starry skies, a land where survival was hard and required discipline and order but that inspired poetry and thought. With little water, few trees grow. Food was scarce and luxuries rare. But camels trudged far between water holes; and there were hardy men to guide them along desert trade routes and protect them from sandstorms. Mecca—a center of pilgrimage and fairs that also prospered as a crossroad of trade—grew up around the holy Ka'ba with its sacred stone and Well of Zamzam, where worshipers performed the rite of *tawaf* (circumambulation). Nearby in this mercantile republic (ruled by a council of merchants and notables) was the quarter of the aristocracy, beyond whom lived lesser folk—the craftsmen, humbler merchants, tavern keepers, visiting Bedouin tribesmen, singing girls, and shamanlike soothsayers. Prior to Islam, there existed, beyond the numerous idols, the notion of an all-powerful but very distant deity, called Allah. Stone idols of his "daughters" were revered at the Ka'ba by country folk, who also paid homage to tree or rock spirits. From this background came Islam, the world's last monotheistic religion, whose people and culture now circle the world.

The seeds of Islamic art are found in the life and teachings of Muhammad the Prophet, a historical personage very much of his time and place. Little is known of the early years of this extraordinary mystic and visionary who was born in about A.D. 570 to a respected but poor family of Hashimites, members of the Quraysh clan. Since his father died before his birth and his mother, Amina, died when he was about six, he was raised by an uncle, Abu Talib, a father figure who, however, never adopted Islam. Like most Meccans, this orphan boy grew up speaking the pure and direct language current at Mecca and believing in the city's sanctity as a spiritual center. He tended toward the monotheistic beliefs of many urban Arabs. As a young boy, he helped his uncle in trade (bringing honor to the occupation in Islam) and he was admired for his honesty and intelligence. At twenty-five he married Khadija, the widow of his employer; she was an older woman who bore him four daughters and one or two sons who died in infancy.

During "the night of power" in the hillside cave of Hira near Mecca, Muhammad, at the age of forty, experienced a profound revelation. Although the awesome vision was followed by a period of suffering ("the dark night of the soul"), it was totally confirming and expanding. Muhammad realized that the one and unique God had revealed Himself to him as both the creator of the world and as its judge. As His messenger, Muhammad knew Allah in a multitude of aspects —as the Omnipotent, the Generous, the Provider, the Pardoner, the Admonisher and the Merciful, the Fearful, the Wrathful Punisher, and the Subtle—in all of which aspects he was "closer than one's own neck vein." (Koran, Sura 50, verse 16.) At first, this profoundly humble but successful man of affairs was extremely reluctant to follow Allah's mission; he accepted it only when the initial illumination was followed by powerful messages from God through spiritual voices and the angel Gabriel. Even then, he saw himself not as the founder of a new religion but as a "warner" bent upon reforming an old one by convincing mankind that it faced the terrors of Judgment Day unless it obeyed His commands.

The word of Allah was brought piecemeal from the same primordial treasure of God's wisdom and orders as had been

divulged to such earlier prophets, or "people of the Book," as Abraham, Moses, and Jesus. For the sake of clarity and "so that he could communicate it to men," the words came in forceful Meccan Arabic, translated from God's own volume of Heavenly Scripture. In the press of inspiration, little was written down; but after the Prophet's death in 632 his secretary Zayd b. Thabit was commissioned by Caliph (successor of the Prophet) 'Uthman ibn 'Affan (r. 644–656) to compile the definitive redaction of the Koran. He assembled all the *suras* (chapters) he could find from sources that included inscribed stones, shoulder blades of sheep, or palm leaves. The gist of Allah's message in the 114 suras of the Koran is profound and elemental. To be spared the horrors of the Last Judgment, one should assist one's fellow men, avoid love of wealth and cheating, live chastely, preserve the lives of newly born daughters (contrary to current practice), and follow a few simple religious duties: believe in God, appeal to Him for forgiveness of sins, and offer Him prayers.

Although he was wholly convinced by this call from God—as was his devoted wife, the first believer, who died in 619—most Meccans at first rejected his message. But Muhammad was more than an inspired and charismatic man of God. He was also a realistic, flexible, and practical leader, a soldier, statesman, and diplomat. When Meccans not only denied his apostleship but tried to prevent him and his followers from praying, Muhammad, on the one hand, experienced the visionary nocturnal journey—"to the remotest place of prayer," probably to heaven accompanied by angels —while, on the other, he arranged to move to Yathrib, an oasis city north of Mecca (soon known as *Madinat an-nabi*, the City of the Prophet, or Medina) where he and his followers were protected and respected as citizens. The Hijra (Separation) of 622 not only marks the birth of Islam as an independent religion with a national character but also establishes the starting point of Muslim chronology.

Belief in Allah was soon accompanied by belief in the Prophet, one of whose goals was to settle his account with the Meccans. A new command—"war on the path of Allah" —came from above. Military successes wore down resistance. Prominent Meccans became Muslims ("those who practice Islam"), and the city soon welcomed Islam. Muhammad and his ever-increasing followers pressed harder. Before the Prophet's death in 632, most of the tribes of Arabia had been subdued. Islam was established not only as a world religion but as a rapidly expanding community with its own system of government, laws, and institutions.

Islam burst forth. Six years after Muhammad's death, Syria and Iraq were tributary to Medina; and ten years later, Egypt was part of the Muslim empire. By 732, the Muslim world included all of Arabia as well as Persia, Mesopotamia, Sind, Egypt, and the rest of North Africa and Spain. Islam could now draw upon cultures as disparate as those of Samarkand, North Africa, and Spain, ancient Greece, Persia, and India—all of which were transformed under the new faith, and which, in turn, contributed to its character.

Those who accepted Islam received several unifying fundamentals that permeated their lives and culture. Paramount are the word of God, the Koran—much of which was composed in compellingly forceful rhymed prose—and its language, Arabic, still the theological idiom of the Muslims. Also important is their adherence to the Five Pillars of Islam, the first being the profession of faith: *La ilaha illa Allah, Muhammadun rasul Allah* ("There is no deity save God, [and] Muhammad is the messenger of God"). They vowed to observe five daily ritual prayers preceded by ablutions (at daybreak, noon, mid-afternoon, after sunset, and early in the night) to be carried out with strictly regulated prostrations either in the mosque or wherever the worshiper might be, since the Prophet explains that the entire world is the same to God, in effect a mosque. On Fridays, Muslims are expected to offer the noon prayer in the main congregational mosque (*jami'*), and if possible to devote the day to Allah. They must also pay the tithe (*zakat*), as distinguished from voluntary alms to the poor (*sadaqa*) and those customary on ending a fast. Moreover, Muslims must fast from the first sign of dawn to the completion of sunset for twenty-nine or thirty days during the month of Ramadan, abstaining from all eating, drinking, and sexual excitement; and at least once in their lives, if possible, they should make the pilgrimage (*hajj*) to Mecca. A visit to the Prophet's tomb at Medina is often connected with the hajj, although it is not a prescribed duty.

Although Muslims from Morocco to China are reminded of their shared religion at least five times daily, another factor in Islam also profoundly unifies the community of faithful: the mosque (*masjid*—"place of prostration"), a center for believers, hence basic to government, law, and the arts as well as to worship. When Muhammad and his followers established the first mosque in Medina, it was there that he addressed the community on secular regulations as well as spiritual subjects.

The importance of the mosque in extending vital patronage and guidance to Muslim architects, calligraphers, and artist-craftsmen cannot be overestimated. Although mosques—like all other artistic forms—vary in style according to time and place, all include certain essentials, such as the *mihrab*, the niche showing the direction of Mecca faced by all Muslims during the five daily prayers; the *minbar*, on which the preacher stands for a brief sermon each Friday noon; and a stand for the Koran (see Plate 50), usually carved from wood and one of the few pieces of furniture.

Mosques also contain smaller, movable objects of the sort we isolate as "works of art," objects that often influenced (and were influenced by) the techniques, patterns, and styles of comparable articles for secular use. Among these are the hanging lamps of glass often decorated with colorful enamels and donated by rulers or wealthy patrons. Equally appealing to the eye, and therefore desirable for palaces and homes, are the rugs stretched over the floor, since prayers must be performed in a clean place.

Most mosques also include lofty minarets from which the muezzin summons the faithful to ritual prayer. They remind us of Bilal, an Ethiopian slave in Mecca who had been tortured by his master for adopting Islam and who later became Muhammad's muezzin. In popular tradition, Bilal symbolizes black people who embrace Islam and are taken into the community without hesitation, since Islam knows

no differentiation of races. But Bilal also brings to mind the Prophet's request that he "refresh us with the call to prayer," which seems to imply Muhammad's appreciation of the beauty inherent in the muezzin's vocalization of the divine word.

Such beauty is also markedly evident in calligraphy and arabesque, the preeminently original expressions of Islamic art, both of which are associated with the mosque. Their qualities attest to the accuracy of the Hadith (tradition) that reads, "Verily God is beautiful and loves beauty." Writing the letters of the Koran beautifully is meritorious, and thus the simple, unvocalized Arabic characters were soon refined and embellished. Early Korans, written in the angular, so-called Kufic style, possess an almost iconic expressive power supremely suited to the word of God (see Plate 1). Stunningly impressive, these forms were perfected at the hands of professional scribes—always admired and encouraged in Islamic countries—and of many amateurs: caliphs, sultans, and emperors as well as lesser beings have reverently copied out Korans, documents, and poetry in hands of great quality.

Although canons of proportion for letters and spacing are dutifully followed, innovation and variation are admired. Over the centuries throughout the Islamic world, many scripts—Maghribi, Thuluth, Nasta'liq, etc., as well as many forms of Kufi—have been developed, most of which are found not only on mosque walls and on such mosque furnishings as glass lamps (often inscribed with the Light Verse from the Koran, Sura 24, verse 35) and rugs, but also on domestic objects, such as ceramics, salvers, basins, and on arms and armor. Could an object be more noble than the deep, creamy white bowl (Plate 11), whose thin walls are inscribed in Kufic letters long as writing reeds?

Also associated with the embellishment of mosques and secular places is the arabesque, the second and equally characteristic contribution of Islamic art. Many marvelous examples of many periods and styles enliven these pages with their fascinating, never-ending progressions of stems, leaves, and blossoms that sometimes substitute angelic faces, or animal or dragon masks for flowers. Although based upon the floral swags and scrolling tendrils of late classical and Byzantine ornament, under fresh patronage these once-decorative vines took on the surging fervor of a pioneering culture. In their energy they invite comparison to so-called animal-style art, which, like Islamic art, crossed borders with lightning speed.

Closely linked to the organic, meandering forms of vegetal arabesques are the geometric patterns upon which Islamic designers and artist-craftsmen composed infinite variations. Thought provoking as the sight of night skies or rippling sand, these rigorously logical, masculine patterns often provide the skeletons to be fleshed over by the lyrically feminine vegetal and floral arabesques. Compelling in perfection of proportion, intricacy of rhythms, and in the flickering changes seen in their interlocking shapes, these crystalline configurations have affinities to scientific and mathematical speculation, considered to be Islam's greatest contribution to human knowledge. Men capable of navigating deserts by the stars—or of locating the precise direction

of Mecca for prayer—also learned how to determine square roots of numbers and devised decimal fractions, geometry, and trigonometry. Indeed, the term "algebra" is derived from the Arabic term *al-jabr wa'l-muqabala*, which means "breaking and reconstitution," and the scholar al-Khwarizmi has lent his name to the term "algorithm."

When Muhammad reconquered Mecca in 630, the idols inside the Ka'ba were destroyed as gravely sinful. For many Muslims, this act of iconoclasm is seen as an implicit warning against the representation of living beings, although an outright prohibition of figural art is found only in the Hadith, sayings attributed to the Prophet. Islam's position is attuned to the starkly monotheistic doctrine according to which, since there is no creator but God, the creation of likenesses of living beings is an illicit arrogation. But the many pictures of people in Islamic art—in which there are virtually no figural sculptures in the round—support the argument that this prohibition applies primarily to sculpture, such as the pre-Islamic idols in the Ka'ba, and not to painting or to bas reliefs.

Among the early Muslims were some who wanted to see the succession of the Prophet descend through his daughter Fatima and cousin, 'Ali, and their sons, Hasan and Husayn. Hasan had been forced to yield the caliphate to the Umayyads, who then killed Husayn in the Battle of Kerbela in 680. The Shia faction, who supported the succession through 'Ali, developed a piety around the passion of Husayn along with the expectation that the last of his descendants, the twelfth imam, would reappear at the end of time "to fill the world with justice as it is filled now with injustice." Various Shia groups grew in North Africa and Egypt (the Fatimids, for example), in Iran, Iraq, and later in India. With the beginning of the Safavid dynasty in 1501, Shia Islam became the official religion in Iran. Although the Shiites follow the sunna, or custom, of the imams, they, like the Sunnites, also follow the sunna of the Prophet. Therefore, the development of miniature painting predominantly in Iran cannot be ascribed to a Shiite rejection of the Prophetic sunna prohibiting the representation of living beings.

Just as there are informative and lively biographical writings in Islamic literature, so are there vital characterizations of people in Islamic art, as is sparklingly evident from many of the illustrations here, not only on paper but incised or painted on pottery, carved into ivory, and in other mediums. Like Muslim storytellers, Muslim artists evoke vivid personalities through a few bold, deft strokes. Even the simplified silhouettes of men and animals woven into carpets or of silver inlaid into bronze vessels (in Islam, solid gold or silver vessels were usually discouraged if not forbidden as vainglorious) express moods ranging from the heroic to the sublime and the comical. Occasionally, too, varying moods meet in exciting profusion, as in a fifteenth-century tinted drawing on silk of glowering fire-born jinns (evil spirits) who are at once terrible, funny, poignant, ugly, threatening, and wholly charming (see Plate 63).

When Islam spread from Arabia to places as distant as Spain, western China, and India, a great many artists and craftsmen came to accept Islam. Patronage usually contin-

ued uninterrupted, even if traditional styles required adaptation or change. In Iran, for instance, the brilliantly vital tradition of figural art still blossomed, with minor modifications, after the Muslim conquest in the years between 642 and 651. This is apparent in the generously illustrated Iranian epic, *The Book of Kings*, which was codified by the poet Firdausi in about 1010 for Sultan Mahmud of Ghazna. Although the traditional exploits of Rustam the paladin—some of whose attributes can be traced to ancient Near Eastern mythology—lose nothing in their Muslim retelling, and even the pre-Islamic religion of Zoroastrianism is treated with respect, there is never any doubt as to the religious beliefs of either the poet or patron. The illustrations, however—whether painted in the fourteenth century or later (see Plates 52, 53, 73, 100)—are hearty survivals of a masterful, exceedingly long-lived artistic tradition. Whatever the date of these small pictures with their jewellike color, minute workmanship and spritely action, many of their qualities hark back to ancient Iranian prototypes, demonstrating that artists and craftsmen were so esteemed by the conquerors, whom they usually outlived, that not only were their lives spared but they were able to pass on techniques and motifs down the centuries.

Thus, the zany yet serious animals painted by the extraordinary Safavid artist Sultan-Muhammad in ca. 1520 (see Plate 73), are descended from more stately ones known from reliefs of the Achaemenid period. Although the arts of Islam are zoomorphically rich, it could be argued that in depicting goats, cows, deer, and bears the great *animalier* was as true to his Near Eastern upbringing as to his religious tradition. Like most Muslim artists, he filled his work—whatever the primary subject—with vignettes of everyday life. One of those rare artists in world history who can be described as a visionary and mystic, Sultan-Muhammad was also a ubiquitous reporter, whose pictures transport us back to sixteenth-century Iran through captivating anecdotes of life in court, camp, and village.

Insights into Muslim life await us in unexpected places, often in objects Europeans and Americans forbiddingly lump together as the "minor" or "decorative" arts (as compared to the "major" arts of painting and sculpture). Bonbon dishes, vinaigrettes, and snuffboxes—hardly the domain of "serious" artists—are, therefore, left to connoisseurly specialists. A quite different attitude prevails in traditional Islam, where gardens are seen as tastes of paradise, offering respite from the heat and dust, and where small, portable objects are valued by people often on the move to hunt, fight, or trade. Since there is no need for oil paintings on walls or of sculptures on pedestals, the compacted beauty of ewers, manuscripts, and foldable carpets makes them "major," and it is to them that those who wish to understand Islamic art must refer. Once this is understood, the rewards are infinite.

Another difference must also be accepted. Unlike Western art, in which artists and viewers usually concentrate upon the subject at hand—a crucifixion, portrait, still life, landscape, or even abstraction—Islamic art more often places (one is tempted to write *hides*) its subjects within a network of appealingly dense ornament, although in objects such as the bowl in Plate 11 there are austerely spare exceptions. This network contains many focal points: arabesques and inscriptions as well as trees, animals, flowers, or figures. Like a bird-watcher eyeing a thicket, one must view the rhythmically patterned field or three-dimensional shape as a whole, and only then enjoy its parts. A superb Spanish ivory plaque (Plate 17), belying its small scale, abounds in stately birds, lively animals, and dancing figures. All are set within a powerful system of arabesques, a wondrous microcosm suited to any level of comprehension. If the niceties of its volutes beguile some as delicious ornament, it inspires others to speculate upon life's cosmic fandango.

Sultan-Muhammad also brings to mind the mystical—or Sufi—element within Islam. Sufism developed out of early ascetic movements, when devout Muslims wanted to counterbalance the growing worldliness of their prospering society. Its heart was meditation on the Koran and an intense life of prayer, as well as other forms of devotions and austerities. The experience of unconditional love of God transformed this movement, which slowly integrated foreign elements from neighboring religious systems and which developed a refined language of allusions and symbols that reached its highest form in the poetry of the Islamic peoples, especially those under Persian influence: Everything was seen as a witness to the divine unity and beauty, and calligraphy, music—religious music and whirling dance—and painting are permeated with this attitude. During Sultan-Muhammad's lifetime, Sufi thought and orders were particularly admired in Iran and India. Visionary artists such as he were encouraged to inspirit their pictures with idiosyncratic fancies, and they concealed comical, mysterious, and awesomely profound grotesques in tree trunks and rocks.

Some of these amiable horrors, and elements of their settings, are recognizably foreign. Just as Islam welcomes proselytes, so does it welcome ideas and motifs from exotic cultures. After the Mongols espoused Islam, for instance, the arts of China—including dragons and other mythical beasts and cloud bands—were imported and emulated in Iran and in other parts of the Islamic world. Once accepted, foreign motifs lingered enrichingly, as can be seen not only in the orientalizing flowers and costumes of late fifteenth-century Turkman miniature from Tabriz (Plate 62) but also in the whiplash clouds, trees, flowers, and other configurations excitingly recycled by Sultan-Muhammad.

As late as the second half of the seventeenth century, Muslim ceramists and artists breathed new life into Chinese motifs that had come west centuries earlier. Although they never succeeded in emulating the hard purity of fabric that had been achieved in Ming China through the use of uniquely fine clays and remarkable techniques, their spirited interpretations of Chinese floral and ornamental motifs are captivatingly original and, if less harmonious, usually more vital than their prototypes. Occasionally, as in a celebrated Ottoman dish (Plate 91), Chinese palmettes were so imaginatively caught up in a scurrying arabesque as to be scarcely identifiable.

Islam's cluster of styles, like most artistic traditions, wel-

comed only those ideas and motifs suited to the current ethos and taste. In Hindustan, the naturalism of European engravings coincided with Mughal delight in the world of appearances. Emperors Akbar (r. 1556–1605) and Jahangir (r. 1605–1627), collected engravings by such artists as Albrecht Dürer, George Pencz, or Marten de Vos and showed them to their artists as sources of ideas and motifs. Muslim artists, however, did not accept every aspect of exotic modes. An early seventeenth-century Mughal artist might emulate Dürer's folds of drapery or trace a Flemish Mannerist's study of a hare and yet reject European perspective, sensing that it violated his essentially two-dimensional picture plane. But art, like life, is always in flux, and by 1635, a few Mughal painters not only understood and employed perspective but added trompe-l'oeil portrayals of still life, complete with reflections and cast shadows, to their borrowed accomplishments.

A wonder of Islamic art is its infinity of themes and variations. Flowers, for instance, burgeon during all periods, in every school, and in all mediums. Like the edges of breaking waves, their forms never exactly repeat. Moreover, each little stylized blossom symptomizes not only the current state of its culture but the evolving nature of its artist-craftsman. Boldly stylized Ottoman flowers woven into a sumptuous brocade (Plate 88) reveal their descent from Chinese prototypes, usually via Turkman Tabriz, while also proclaiming Turkey's dynamic earthiness and exemplifying the innate aesthetic rightness of their designer and weaver.

Patronage in Islamic countries was as varied as in the West. Although Islam possesses no clergy in our sense of the word, the officials in charge of mosques and *madrasas* (theological colleges) commissioned buildings as well as manuscripts and objects. Most of the works of art here, however, were made for rulers—members of Islam's many reigning dynasties, some of which still continue to rule—and for other secular figures. Benefactors such as Emperor Akbar —comparable to François I or the Medici—gathered talented men not only within India but from abroad, and guided them with such perspicacious delight that many of their works should be seen as collaborative. Princes, courtiers, well-to-do merchants, and other townspeople also commissioned or paid for works of art, as did humbler folk of the villages and countryside.

Much of the direct appeal of Islamic art, even when created for courtly circles, can be ascribed to its roots in tent compounds and urban bazaars, from which ambiance Islam emerged in Mecca. Sometimes as sensitively effective as princely patrons were the creative and discriminating dealers who commissioned and sold everything from manuscripts to textiles and metalwork and who influenced their artists and craftsmen by selecting patterns and modes. Of the bazaars, too, were the guilds of artists and craftsmen who provided stability, a degree of patronage, and outlets for work. As links in the mercantile information network, they circulated invaluable news about employment, trade, techniques, and many other matters of interest. Thus, when patronage failed due to the death or fickleness of a prince at Bukhara, his artists were more likely to learn of opportunities for employment in Bijapur or Agra through the "caravan express" than by royal summons.

The family was at least as important to craftsmen and artists as the courts, merchants, and guilds. Ordinarily, artistic skills were learned in early childhood through apprenticeship to a father or uncle. Each household treasured its trade secrets, whether in the form of accumulated sketches of designs or in ways of maintaining heat levels while annealing silver. Artistic judgment was constantly sharpened by frequent discussions of art at home as well as at court or in the bazaar, and in families of artists dowries included sketchbooks, tools, and examples of the creative prowess of other family members or forebears.

Artists came from many social strata in Islam, where there were no regulations to block movement up or down the social scale. Although most professional artists and craftsmen came from families long established in such work, aristocrats and even princes practiced art and crafts. In Ottoman Turkey, most of the sultans took pride in their accomplishments as calligraphers, bookbinders, or as makers of archers' rings. Shah Tahmasp I (r. 1524–1576), the great Safavid patron, was a talented painter and draftsman; and as a prince, the Mughal emperor Akbar was instructed in painting by 'Abd as-Samad, one of Shah Tahmasp's artists who had been invited to India by Emperor Humayun (r. 1530–1556). Some artists, such as Aqa-Mirak, Shah Tahmasp's great painter and boon companion, cut wide swathes at court. Master artists like Bihzad during the later Timurid period ranked high for their intellectual stature and creativity as well as for their extraordinary skill. Important patrons throughout the Islamic world vied for the services of such geniuses, examples of whose work were welcome gifts from one court to another.

Despite the disciplines of working within a traditional artistic mode in which designs and motifs usually conformed to prescribed patterns, individuals—whether famous masters or anonymous craftsmen—possessed a considerable degree of freedom. Painters studied and drew from nature as well as from art and were usually encouraged to improvise as extravagantly and playfully as they pleased, as can be seen in the joyous swirl of calligraphy and surrounding arabesques (see Plate 37) and in the enameled arabesques of a glass mosque lamp (see Plate 36). These and many more works of art here are imbued with the elusive quality often known as "inspiration," one unrelated to value in the marketplace, to prestige, or to "importance." A few swiftly but knowingly sketched lines by the great Safavid draftsman Reza-ye 'Abbasi (see Plates 81, 82) soar above most highly finished miniatures. Like many other artists and craftsmen represented here, he experienced the ecstasies that are the highest reward of a creator and lover of art. Indeed, every work of art, as well as the artist himself, bears witness to the extra-Koranic divine word: "I was a hidden treasure and I loved to be known, therefore, I created the world," and thus everything created, by its very existence, is a witness to God's creativity and fulfills the Koranic saying, "Everything that is in the heavens and on earth praises God."

Stuart Cary Welch

PAGE FROM A KORAN

This Koranic fragment (containing Sura 2, verse 200 and the beginning of verse 201) belongs to the finest early manuscript of the holy book of Islam.

As with most of the Koranic manuscripts from the eighth to the tenth century, this one is written on vellum, and the pages are in broad format. The letters, in Kufic script, are written with brownish ink; the diacritical marks and vowel signs, which were added somewhat later, are in colored ink.

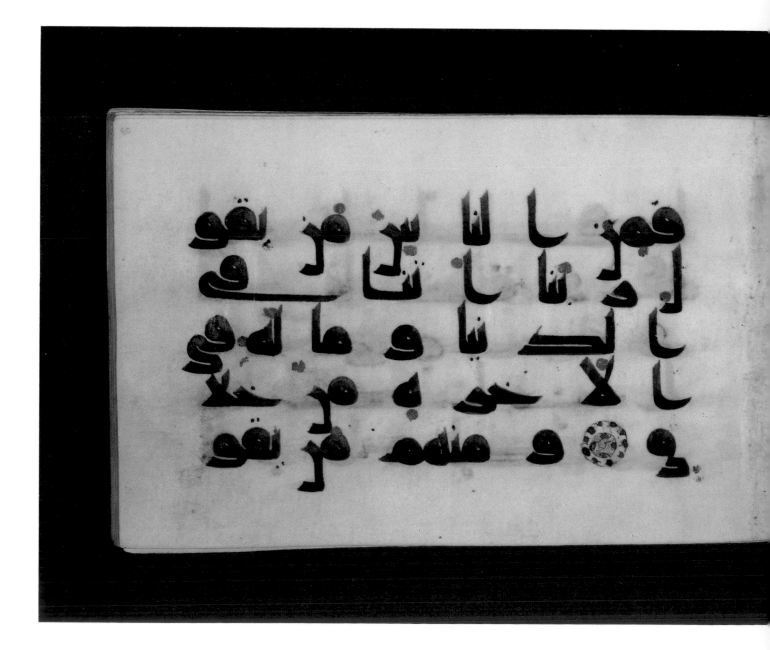

Typical of the best Kufic style, the letters are very extended, and words are separated according not to grammar but to space. Although we assume, because of the regularity of the letters and the fine quality of execution, that the manuscript may belong to the ninth century, it is difficult indeed to ascertain where it was written, as apparently several centers of Kufic calligraphy existed in the major cities of the central Islamic areas.

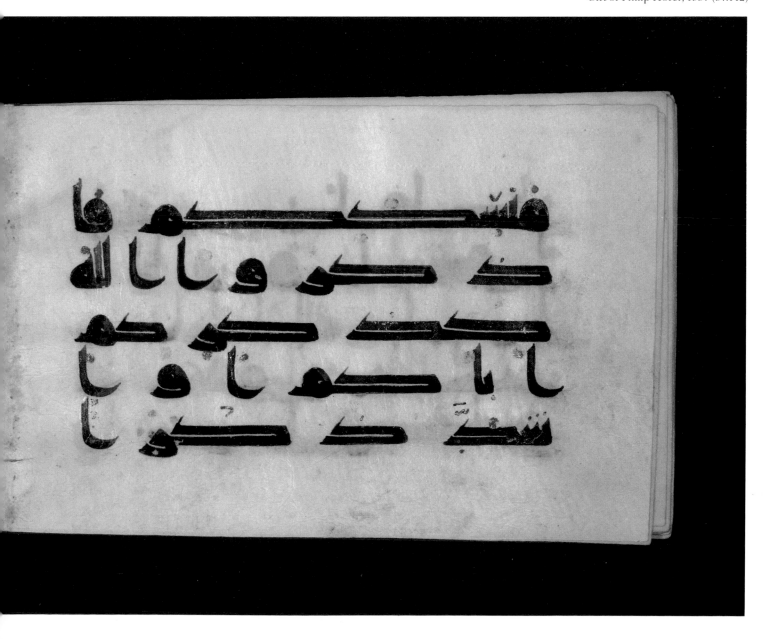

2 Ewer
Iran; 7th c.
Bronze, chased and originally inlaid;
H. 19 1/16 in. (48.5 cm.)
Fletcher Fund, 1947 (47.100.90)

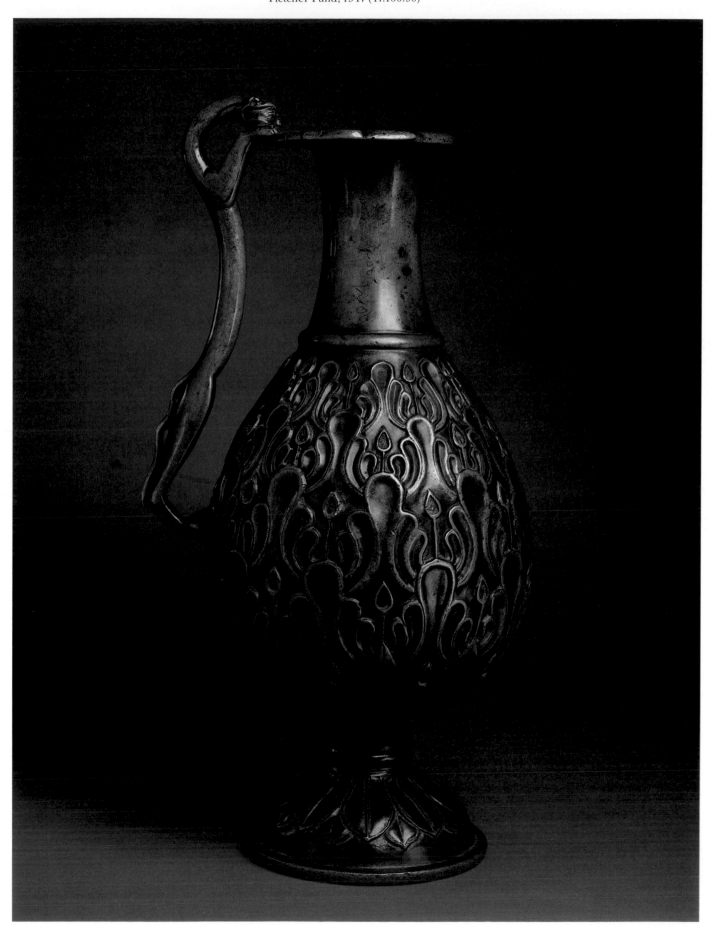

Bronze Ewer

The Parthian and Sasanian dynasties in Greater Iran lasted from 249 B.C. to A.D. 651, at which time the Sasanians were overthrown by the Arab invaders carrying the banner of Islam. Bringing with them the Arabic language and calligraphic script, the conquerors absorbed much from the artistic traditions of their new subjects and neighbors.

This noble bronze ewer, with its grand size, elegant proportions, and controlled exuberance of design, bears clear witness to its cultural antecedents. From the Parthians comes the evidence of Greek influence, as seen, for example, in the pattern of overlapping petals on the foot. The head of a duck on the rim is reminiscent of a motif popular in Sasanian art. Ewers of this shape are found in both Parthian and Sasanian metalwork, and the abstract plant design that covers the body is also of Sasanian derivation.

Ultimately, however, the ewer is neither Parthian nor Sasanian; it is Islamic. The proliferation of surface decoration is a universal characteristic of Islamic art. In Sasanian art this plant motif is used with great restraint, but here it has become a complex abstract pattern, particularly effective in the diminishing scale as it rises toward the neck of the vessel. The feline form of the handle has also become abstracted and elongated, artistically distanced from its more naturalistic Parthian prototypes. Finally, the duck's head on the lip, so easily overlooked, exhibits a tendency to artistic playfulness found elsewhere in Islamic art.

Bronze Throne Leg

The mighty Sasanian empire was organized as a centralized state, with the monarch serving as the symbol of supreme authority. Zoroastrianism, as the official state religion, had a considerable impact on all aspects of society. The lion and eagle, with their long history of solar symbolism, were found in representational art, in such capacities as throne supports, lending a semidivine aura to the royal presence. The throne leg shown here is in the form of the forepart of a griffin, a mythological beast that combined both lion and eagle. Placed here, it served to reinforce the ruler's association with the power of the sun, the divine light of Ahuramazda, and suggested the throne's function as a vehicle of apotheosis.

In order to appear to their subjects as convincing successors to their royal predecessors, Muslim rulers not infrequently arrogated to themselves the familiar symbols of power, and even when this was not deliberate, it often came about simply because they had no tradition of royal insignia. However, even here the beginning of a Muslim point of view makes its tentative appearance where a curling hair turns into a leaf form, exhibiting the playful use of natural forms and an instinct for surface patterning that was later to become a hallmark of Islamic art.

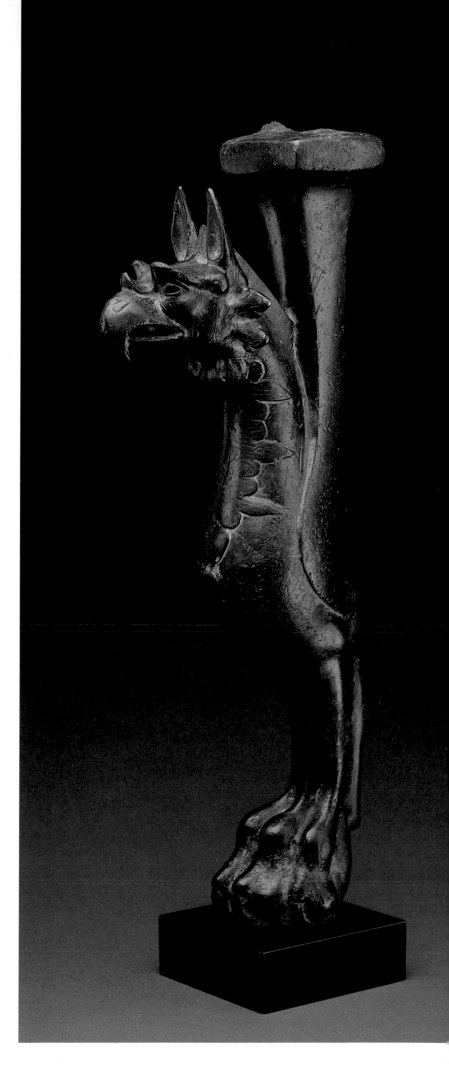

3 Throne Leg
Iran; late 7th–early 8th c.
Bronze, cast, chased; H. 22⁷⁄₁₆ in. (57 cm.)
Purchase, Joseph Pulitzer Bequest, 1971
(1971.143)

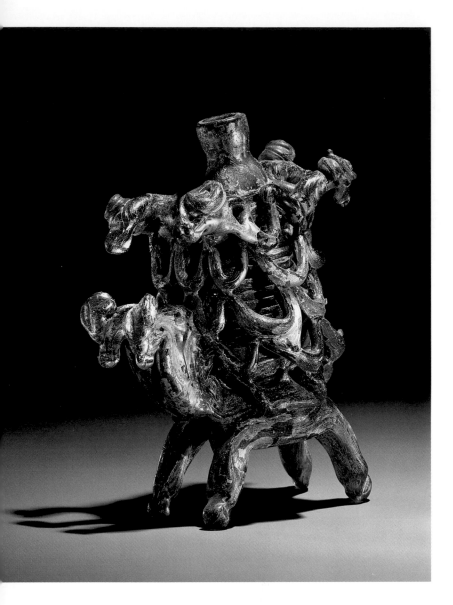

4 Cosmetic Bottle
Eastern Mediterranean; 8th–9th c.
Tooled and free blown, with trailed thread
decoration, pontil on base; H. 4¾ in. (12.1 cm.)
Gift of Mrs. Charles S. Payson, 1969 (69.153)

COSMETIC BOTTLE

Judging from the number that have survived, it is safe to postulate that single, double, or quadruple glass cosmetic tubes, usually elaborately decorated with trailed threads and multiple handles, were extremely popular in the eastern Mediterranean before the Arab conquest. Islamic adaptations of these late Roman Imperial *balsamaria* have been found in Egypt, Syria, Iraq, and Iran, attesting not only to their continued popularity, but to an international vogue for them in the Early Islamic period. Unlike their Imperial Roman prototypes, the Islamic objects are almost invariably in the form of pack animals that carry the tubes—or more often, bottles—on their backs.

BOWL

The technique of wheel cutting was brought to a consummate level in the relief-cut glass of the Early Islamic period. Perhaps the only other artisans to apply this exacting technique to glass with such perfect skill were the fashioners of the late antique so-called diatreta cups. Indeed, the Early Islamic creators of relief-cut glass, together with the originators of luster painting on glass, can be credited with two of the most important Islamic contributions to the technology of this medium.

Before the decorating process of wheel cutting could begin, the artisan would form either solid glass blocks or blanks with especially thick walls to withstand the great pressure of the wheel. The surface was then selectively cut away, leaving the design in relief, with the highest point of the decoration on each piece representing the original surface.

This six-lobed vessel, with horizontal flutes cut into the interiors of alternate lobes, has parallels in stone, glazed pottery, and metal, variously dated between the eighth and the thirteenth century.

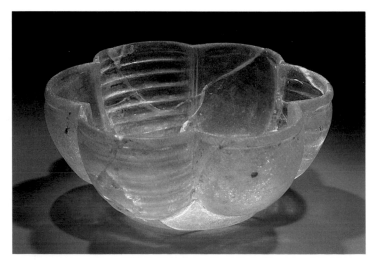

5 Bowl
9th c.
Mold blown and wheel cut;
H. 2⁷/₁₆ in. (6.4 cm.)
Rogers Fund, 1970 (1970.20)

Beaker

One of the most beautiful monochrome relief-cut objects extant is this beaker belonging to a group of exquisite relief-cut glass vessels with vegetal and figural decoration that are related to magnificent pieces in rock crystal. Whether the glass objects led up to or were made in imitation of the rock-crystal ones is yet to be determined.

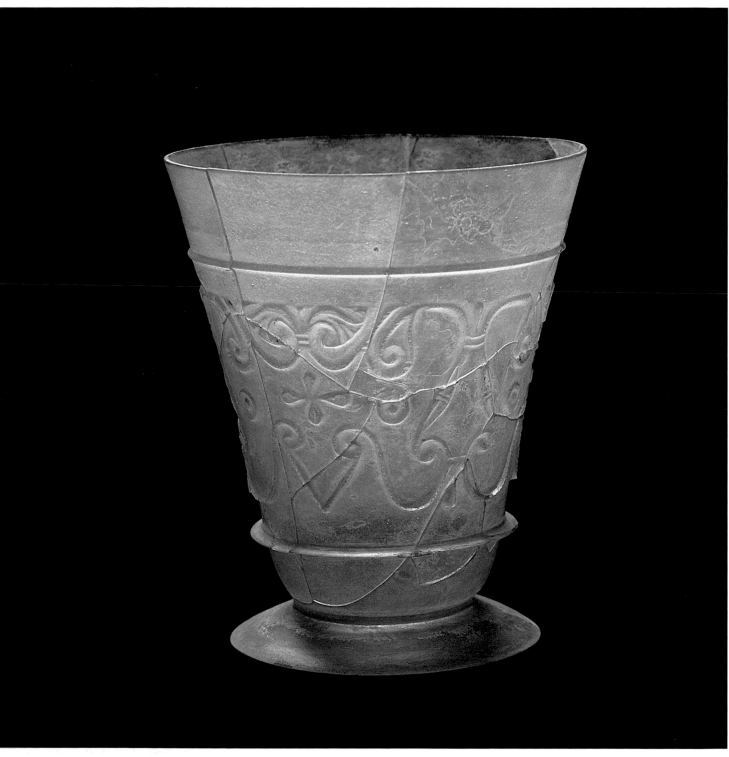

6 Beaker
10th c. or later
Free blown and relief cut; H. 5⅜ in. (13.7 cm.)
Purchase, Rogers Fund and Jack A. Josephson,
Dr. and Mrs. Lewis Balamuth and Mr. and Mrs.
Alvin W. Pearson Gifts, 1974 (1974.45)

Door

The city of Samarra in Iraq, upriver from Baghdad, was founded in A.D. 836 by the caliph al-Mu'tasim to accommodate his unruly Turkish soldiers, who had made life impossible in the capital city of Baghdad. Samarra was the second and temporary capital of the Abbasid caliphs until near the end of the ninth century.

Extensive ruins of the palaces and houses have revealed a variety of decorative styles. One motif, called the "beveled style," is particularly well known. It has a symmetrical abstract floral motif, highlighted, in this case, with volutes and skillfully and deeply carved with a curving and slanted angular cut emphasizing the contrast between light and shadow. This door illustrates one variety of the design and was probably originally painted and highlighted with gilding. The door is said to have been found at Takrit, but it probably came from Samarra.

The beveled style is found on many of the lavish, molded stucco dadoes of the royal and domestic residences from the once prosperous city and was the source for the design, which is also found on woodwork, metalwork, pottery, and glass. It developed in the late eighth century and, together with later adaptations and modifications, was found in an area ranging from the Maghrib—which corresponds roughly to the area from present-day Libya to Morocco—to present-day Afghanistan. It remained popular until the beginning of the fourteenth century.

7 *Door*
Iraq (prob. Samarra); Abbasid period, 9th c.
Carved wood; 87¾ in. x 42 in. (222.9 x 106.7 cm.)
Fletcher Fund, 1931 (31.119.1,2)

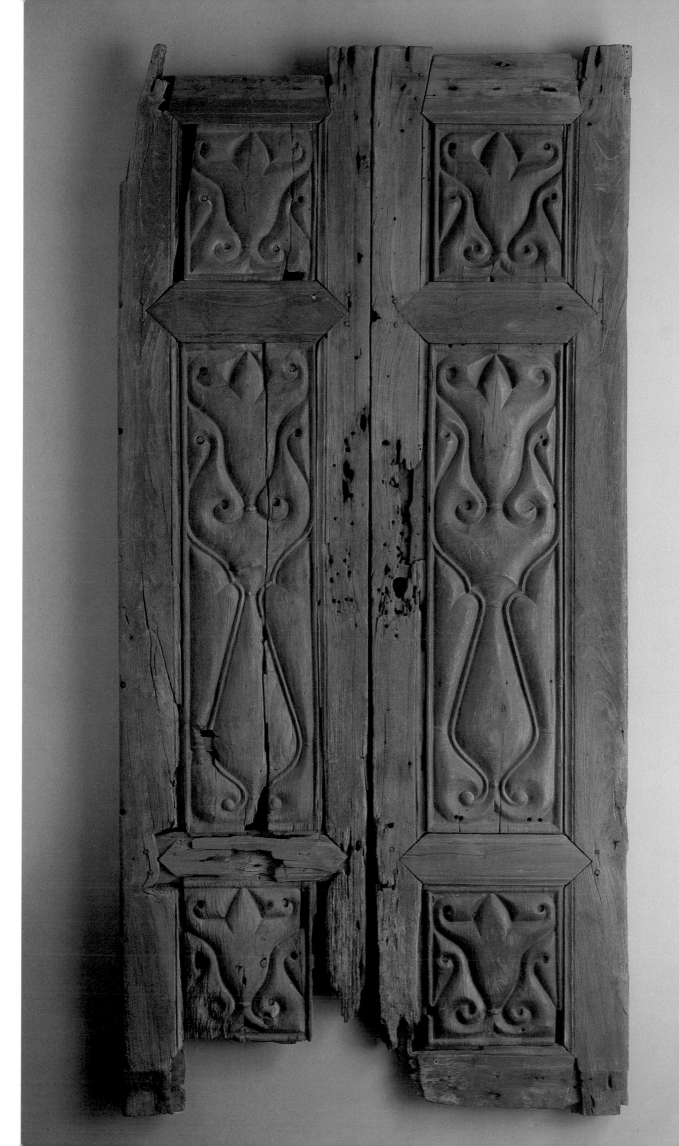

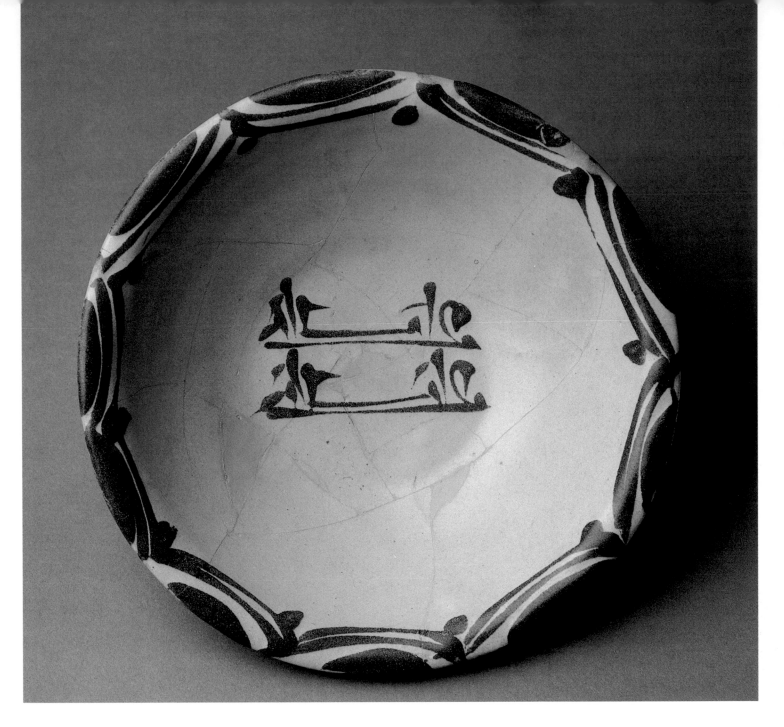

8 Bowl
Iraq; 9th c.
Earthenware, glazed and stain painted;
D. 8 in. (20.3 cm.)
Harris Brisbane Dick Fund, 1963 (63.159.4)

EARTHENWARE BOWL

Ninth-century Iraqi potters, in an attempt to imitate Chinese porcelain, rediscovered a device used much earlier by the Egyptians: tin oxide mixed with a clear lead glaze. This combination, still used by Islamic potters as late as the sixteenth century, provided a fine opaque white surface, which they used for various types of decoration. The cobalt-blue stain-painted decoration on this bowl, consisting of festoons and the twice-repeated Arabic word *ghibtah* (happiness) in Kufic script, was fixed in the same firing as the glaze. This is the earliest ceramic type to employ Arabic inscriptions as the principal decorative device, a feature that was to play a very large part in the repertoire in the centuries to come.

TWO LUSTER-PAINTED BOWLS FROM IRAQ

The technique of luster painting on pottery was one of the greatest contributions of Islamic ceramists to pottery decoration. Originating as a means of decorating glass, it was first employed on pottery in ninth-century Iraq. From there it spread to Egypt, Syria, Iran, North Africa, Spain, and the West. The polychrome luster-painting technique, which is illustrated by the bowl in Plate 9, was extremely short-lived. The influence of Roman and later millefiori glass is evident in the layout of the design as well as in several of the motifs. The bowl in Plate 10 exhibits many of the design characteristics of the monochrome luster-painted wares of tenth-century Iraq: the caricaturelike quality of the seated man holding a beaker in one hand and a flowering branch in the other; the plain border surrounding him and the two birds holding fish in their beaks; the speckled background; the scalloped rim design; and the exterior decoration of a series of three concentric circles evenly spaced around the wall on a field of dashes and dots. The foot bears the Arabic word for "blessing" in Kufic script.

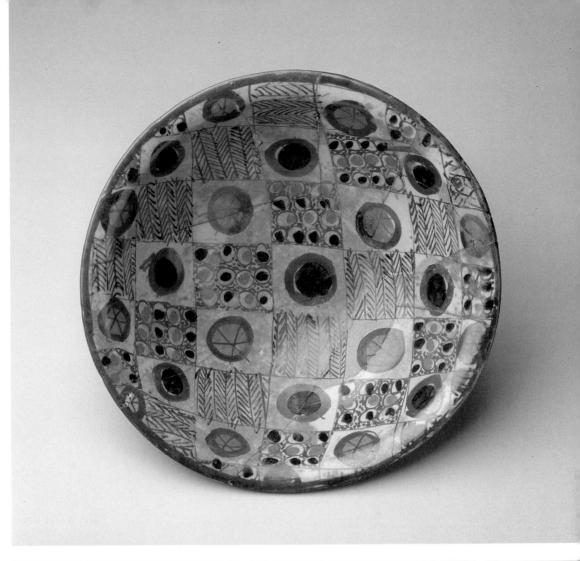

9 Bowl
Iraq; 9th c.
Earthenware, glazed and luster
painted; D. 7¾ in. (19.7 cm.)
Rogers Fund, 1952 (52.114)

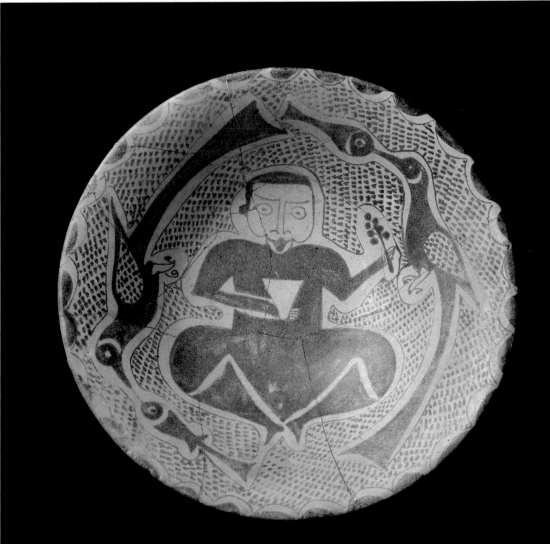

10 Bowl
Iraq; 10th c.
Earthenware, glazed and luster painted;
D. 9⅝16 in. (32.7 cm.)
Gift of Edwin Binney, 3rd and Purchase,
Richard S. Perkins Gift, 1977 (1977.126)

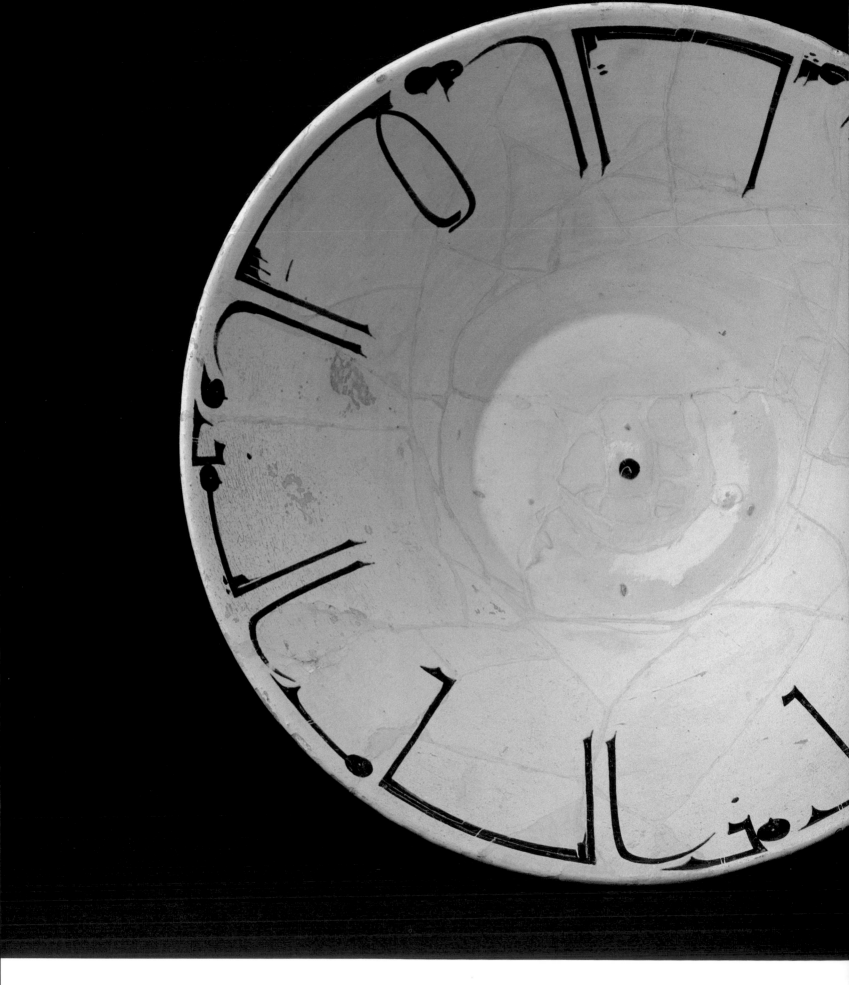

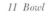

11 *Bowl*
Iran or Transoxiana (Nishapur or Samarkand); 10th c.
Earthenware, white engobe, slip painted, incised and
glazed; D. 18 in. (45.7 cm.) Rogers Fund, 1965 (65.106.2)

BOWL FROM NISHAPUR OR SAMARKAND

During the ninth and tenth centuries, potters in Khorasan
and in the region northeast of the Oxus River in Central
Asia, as well as in Iraq, eastern Arabia, Syria, and Egypt,
employed a new technique to decorate ceramic surfaces.

Like Iraqi inglaze-painted and overglaze luster-painted
pottery, this ware had a plain opaque surface for decora-
tion. The body was covered by a white or colored engobe, a
thin wash of the body material. The design was then painted,
and the piece was glazed and fired.

The important ceramic centers of Nishapur and Samar-
kand in the provinces of Khorasan and Transoxiana, respec-
tively, produced a number of different types of underglaze-
painted ware in their attempts to attain total mastery over
their medium. Perhaps one of the most spectacular proofs
of their achievement can be seen in the clarity of the design
on the unusually large and deep bowl in Plate 11.

The decoration on the interior of this bowl consists of an
Arabic inscription in Kufic: "Planning before work protects
you from regret. Prosperity and Peace." The elegance of the
letters has been enhanced by fine incisions. The perfection
of the design and potting in combination with the size of
the bowl makes this a true tour de force of the potter's art.

OVERLEAF:

BOWL FROM NISHAPUR *(Page 24)*

Another variety of underglaze-painted ware, known as
"splashed sgraffito," bears designs incised through the en-
gobe to the red-clay body and then highlighted with differ-
ent colors. When the designs were covered with a colorless
transparent lead glaze, the colored dots and lines were likely
to run during the firing. The bowl in Plate 12—one of the
most successful examples of "splashed sgraffito ware"—has
a purely Islamic design of a palmette-filled arcade with span-
drels of vegetal rinceaux. The Chinese T'ang "three-color"
ware that inspired this popular group of pottery, and shared
its color scheme of green, aubergine, and brown on a white
ground, may have appeared in the Middle East as early as
the eighth century.

BOWL FROM EGYPT *(Page 25)*

Stylistic and iconographic changes took place in the deco-
ration of luster-painted pottery after this technique was
brought by artists from Iraq to Egypt. In most Fatimid art,
there was an increase in the use of human and animal mo-
tifs that appear more alive than their predecessors.

In the bowl in Plate 13, beneath the bird's right talon and
again on the foot of the bowl is the artist's signature, "Muslim."
Active circa 1000, he is the only Egyptian potter of this pe-
riod who has been placed in a firm historical context.

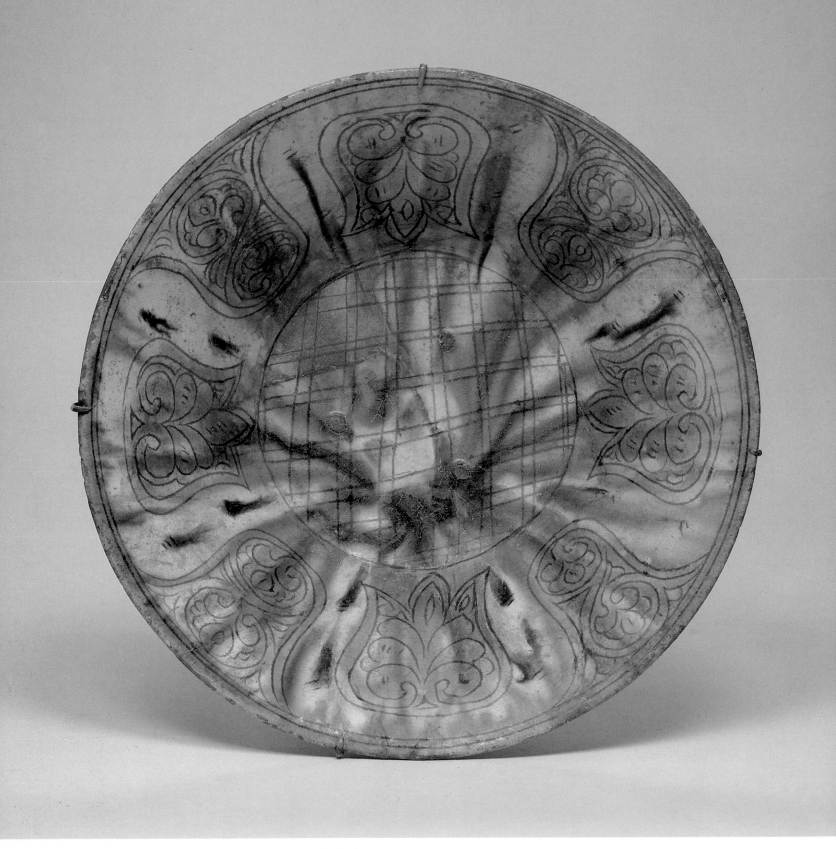

12 Bowl
Iran (Nishapur); 9th–early 10th c.
Earthenware, white engobe, incised, colored
and colorless glazes; D. 10¼ in. (26 cm.)
Excavations of The Metropolitan Museum
of Art, Rogers Fund, 1938 (38.40.137)

Page 23: text

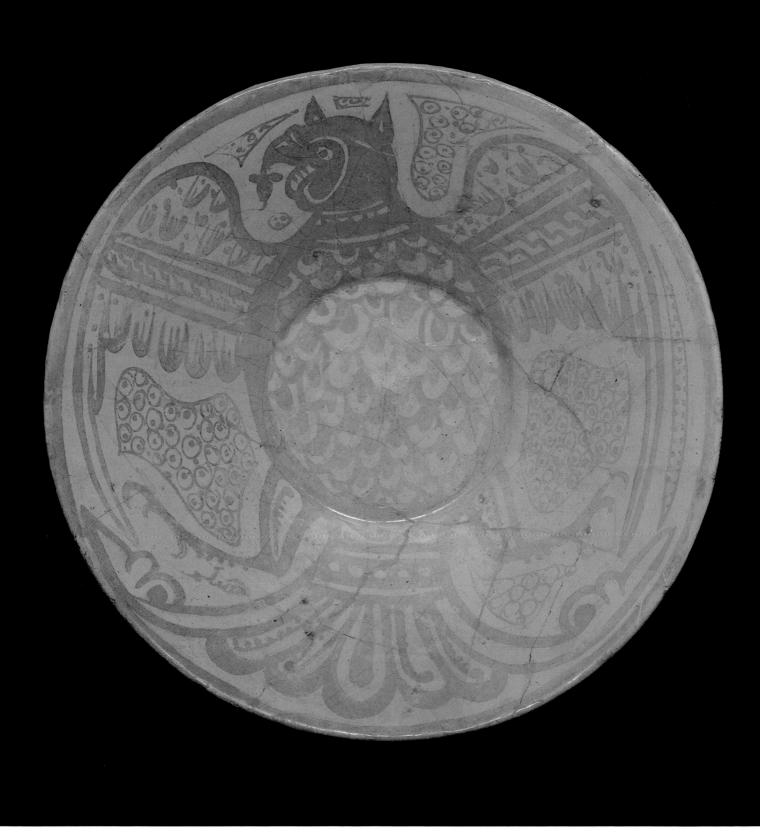

13 Bowl
Egypt; ca. 1000
Earthenware, glazed and luster
painted; D. 10 in. (25.4 cm.)
Gift of Mr. and Mrs. Charles K.
Wilkinson, 1963 (63.178.1)

Page 23: text

Door Panel

From the examples still in situ in Muslim and Christian buildings in Egypt, which were built under the aegis of the Fatimid dynasty (A.D. 969–1171), we know that this deeply carved wood panel was one of a number of identical panels set into a door comprised of two or more leaves.

In this beautiful example, the central design, which is commonly in the form of a split palmette, has been zoomorphized into two horse protomes complete with bridles.

Textile

Arab historians and geographers mentioned the striped textiles from Yemen famed in Islamic lands from the ninth to the fourteenth century. The pattern was formed before weaving by dying and wrapping the warp yarns methodically—a technique called *ikat* or *chiné*, in which the wefts may also be patterned. Made in a limited color range of brown, blue, and undyed cotton, the woven design has arrowheads or lozenges with fuzzy outlines.

Ernst Kühnel, the noted Islamic scholar, has commented on the epigraphy of Yemeni textiles, noting that calligrapher and craftsman seemed to compete in making the text as difficult as possible to decipher. With imagination, one might be able to read the rich, floriated Kufic script as the *basmala*, the introductory benedictory formula with which every chapter of the Koran and every work begins, plus one or two additional words, but the translation is by no means certain.

14 Door Panel
Egypt; 11th c.
Carved wood; 13¾ x 9 in.
(34.9 x 22.9 cm.)
Rogers Fund, 1911 (11.205.2)

15 Textile (tiraz)
Yemen; 10th c.
Plain weave cotton, inscribed in black ink and applied gold leaf; 23 x 16 in. (58.4 x 40.6 cm.)
Gift of George D. Pratt, 1929 (29.179.9)

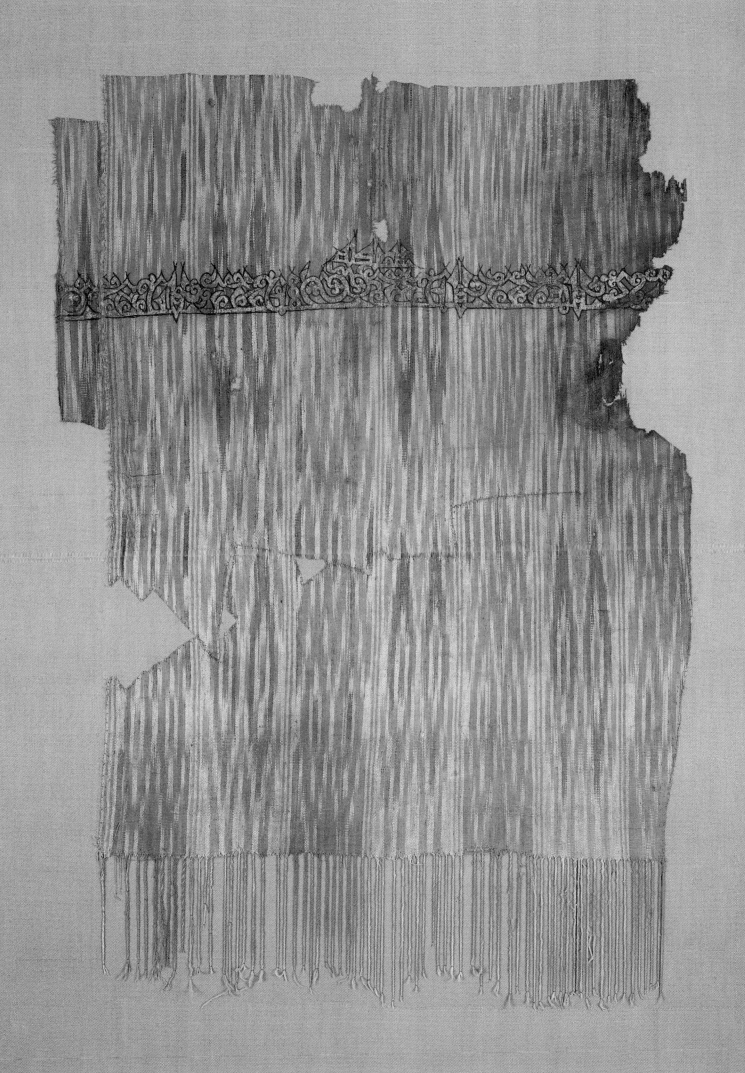

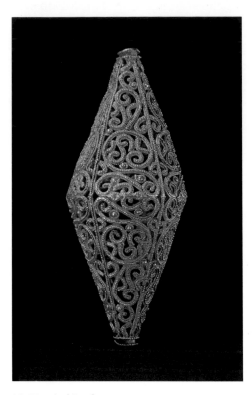

16 Biconical Bead
Greater Syria; 11th c.
Gold, fabricated from wire and strips of sheet,
decorated with granulation; W. 50 mm.
Purchase, Sheikh Nasser Sabah al-Ahmed Sabah
Gift, in memory of Richard Ettinghausen, 1980
(1980.456)

FATIMID GOLD BEAD

This gold bead is an example of the finest and most decoratively complex type of Fatimid goldwork. The quality of the execution of the objects in this group places them in a class of their own. Because its closest parallel was found in Greater Syria, it seems likely that this bead was made there.

Unlike earrings, pendants, bracelets, and rings, beads made during the Fatimid period have survived in very small numbers. There appear to be only five filigree-constructed and granulated beads extant, including this example, and only two shapes, spherical and biconical, are known.

Ivory Plaque

This charming plaque belongs to a group of ivories made in Spain during the reign of the Umayyads. This dynasty ruled from Damascus between A.D. 661 and 750, and when it was overthrown by the Abbasids, its sole survivor escaped to Spain. There he founded a new dynasty in 756, which lasted until 1031.

These ivories are among the Spanish Umayyad dynasty's most outstanding extant artistic achievements. Many are inscribed, so we know that most of them were made for the royal family or its entourage, and also that many were made in the capital, Cordoba, or the nearby town of Madinat az-Zahra, the royal residence.

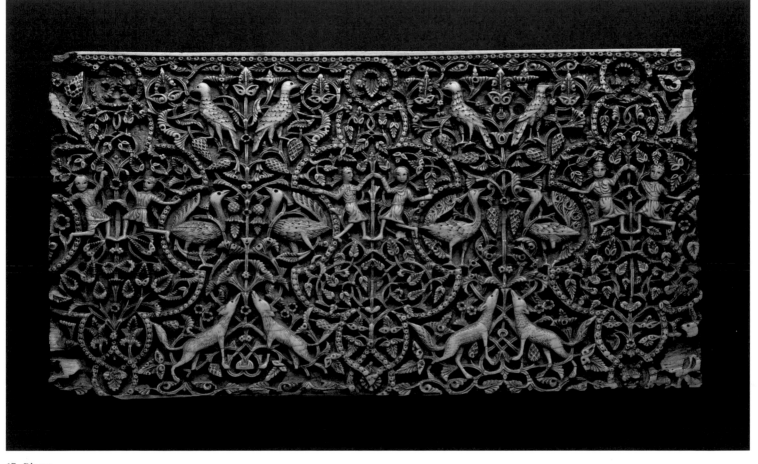

17 Plaque
Spain; 11th c.
Ivory; 4¼ x 8 in. (10.8 x 20.3 cm.)
John Stewart Kennedy Fund, 1913
(13.141)

Because of this dynasty's Syrian roots, it is not surprising that many of the motifs found on these ivories can be traced back to that area. The leaf arabesques seen here are a stylized version of the vine-and-acanthus scroll so popular in late antique ornament, while prototypes for the animated figures can be found on Early Islamic Syrian or Egyptian textiles, where birds, animals, and human beings of similar character are also paired on either side of stylized trees. Indeed, the influence of textiles in general can be seen in the overall design of this piece, in the way the decoration is repeated without change in alternating panels.

Ewer

Glassmakers in the Early Medieval period attempted to imitate relief-cut designs using several different and less time-consuming techniques. This ewer appears to be an example of such copying. The principal decoration, executed in trailed threads, is suggestive of the undulating, stylized vegetal scrolls often executed in the relief-cut technique, which we saw earlier in the beaker in Plate 6. The series of horizontal rings on the neck and body are paralleled on relief-cut glass ewers, as is the shape, except for the pedestal-like modification to the foot and the very sharp return at the bottom of the vessel.

Page of a Koran

This page, which contains the last verses of Sura 48, "The Victory," and the title of Sura 49, is preceded by a short description of the importance of this chapter according to a saying of the Prophet. The page, written in a style similar to the so-called Qarmathian Kufi on rather brittle paper, is interesting because it emphasizes the sentence "Muhammad is the messenger of God" in a highly decorative way by having the shafts end in floral arabesques and heightening them with a little bit of gold. Usually, only the name of God is written in gold, but here, the emphasis is on the role of the Prophet and obedience to him.

18 Ewer
11th c.
Free blown and tooled with unmarvered thread decoration and applied handle and foot, pontil on base; H. at spout 5⅝ in. (14.3 cm.)
Rogers Fund, 1962 (62.172)

19 Page of a Koran
Iran; 11th c.
Ink, colors, gold on paper;
12⅞ x 9 in. (32.7 x 22.9 cm.)
Rogers Fund, 1940 (40.164.2a)

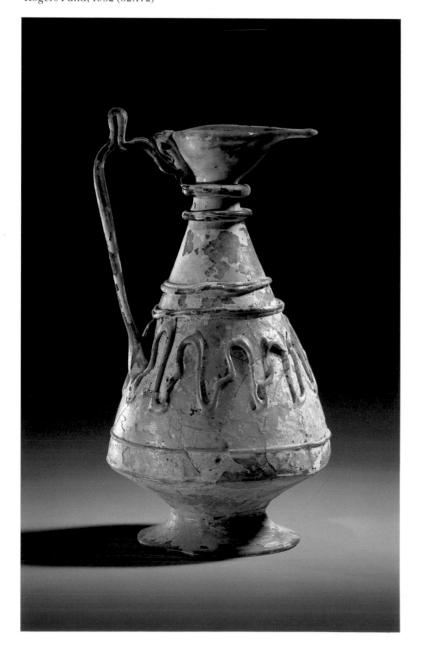

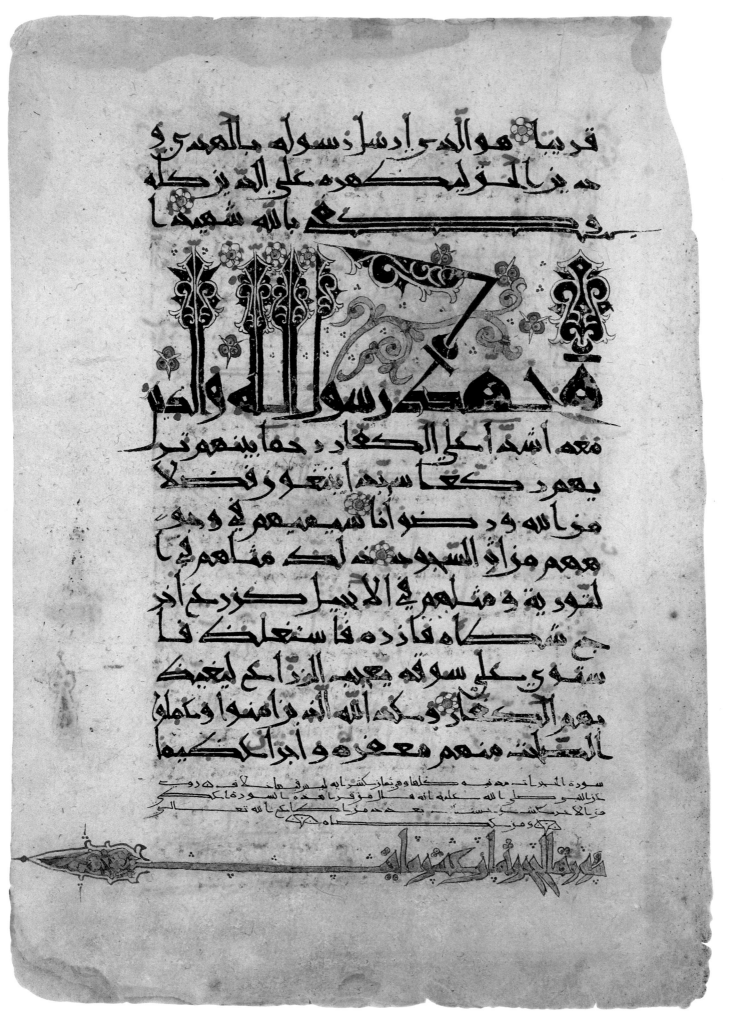

20 Page of a Koran
Iran; 12th c.
Ink, colors, gold on paper;
11¾ x 8¾ in. (29.8 x 22.2 cm.)
Gift of Horace Havemeyer, 1929,
H.O. Havemeyer Collection
(29.160.23)

PAGE OF A KORAN

One of the most famous Koran copies in the world is the one whose script has been called, without any clear reason, "Qarmathian Kufi." It is written on paper, and the pages seem carefully planned. By the late tenth and eleventh centuries, Kufic script had developed into a very elegant style in which the shafts of the high letters were considerably elongated. This elongation was a natural development because Korans in the central and eastern Islamic world were no longer written on broad pages but had assumed the vertical book format. As a result, aesthetic considerations led to an emphasis on high shafts. The letters assumed a more triangular shape and resembled in many respects the decorative Kufi used on ceramics and stone during this period. A number of Koran fragments in this elegant style are extant, but there is only one example in which the background has been carefully ornamented with arabesque scrolls in various colors; there, spiral forms contrast with and highlight the slim letters of the text.

This page contains Sura 5, verse 21. It is remarkable how the calligrapher has inserted the last letters of the closing word into the upper free space at the end.

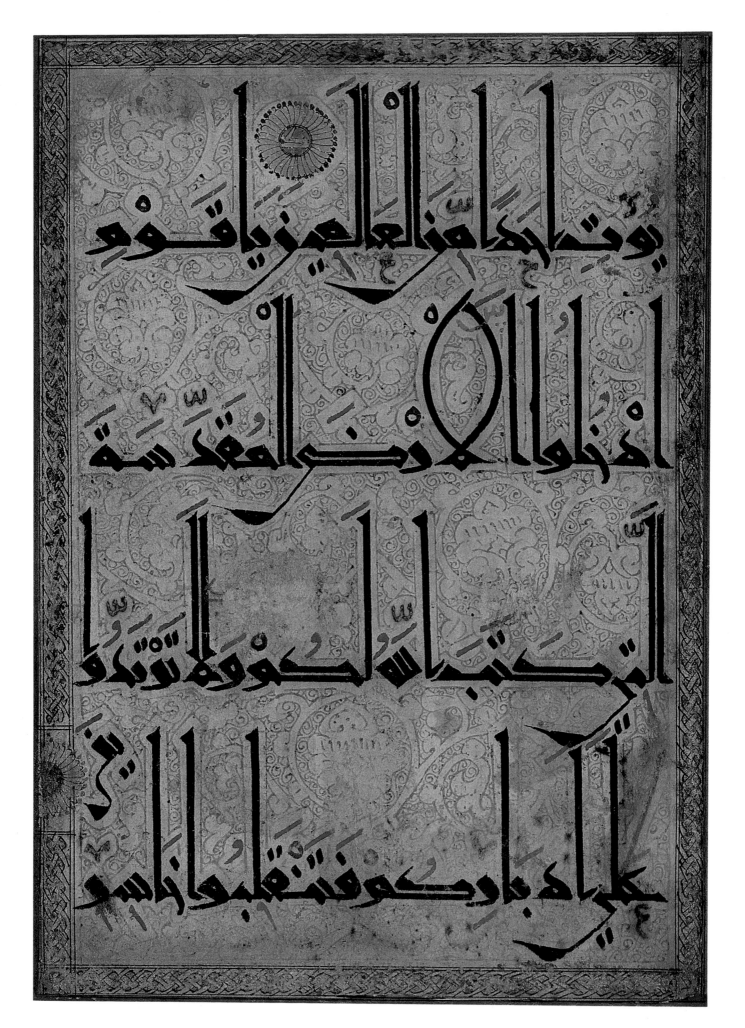

33

CUP

One variety of slip painting under a transparent lead glaze employed in Early Islamic Iran is found during the Early Medieval period on the so-called silhouette ware. Here, it is represented by a cup with a band of gazelles striding across its belly. Modifications to the earlier technique were necessary because of the new body type: in this ware the design was executed with a thinner version of the composite-body material (known as "frit") instead of being painted with a clay slip. The vessel was then covered with a transparent clear or turquoise glaze. In some examples of this type, the whole object was covered with a thick layer of frit; when dry, the frit was incised through to the body, creating a design, or it was carved away, leaving the design in relief.

The most common shapes among silhouette ware are drinking vessels, although bowls are known as well. The stripes on the lower section of this cup and on its short neck are a device popular on these objects.

PREPARATION OF MEDICINE FROM HONEY

Early Islamic illustrated manuscripts were produced primarily in the great political and cultural centers of the Islamic world, such as Baghdad, capital of the Abbasid caliphate (A.D. 750–1258). They were influenced by different pictorial sources depending on their subject matter. Scientific texts were widely translated from the Greek, and illustrations were primarily dependent on Greek and Byzantine prototypes, transformed for Islamic taste by a predilection for the decorative over the naturalistic and by the enlivening element of genre scenes.

One of the most popular scientific manuscripts to be translated into Arabic was a herbal written in Greek in the second half of the first century A.D. by Dioscorides, a physician from Asia Minor in the Roman army. Going back to a scientific tradition developed by the Greeks in the fourth century B.C., these herbals give the name of a plant, its physical description, habitat, and medicinal properties. From the first century B.C. and continuing in the Byzantine period, the Greek tradition of herbal illustrations, which provided the immediate prototype for Islamic herbals, showed the plant, roots, leaves, buds, flowers, and fruit. The Islamic herbals, however, soon developed a stylized manner of illustration, even adding whole genre scenes, as in this example.

Characteristic of the lively and appealing painting of the Baghdad school is the two-dimensionality of the picture, which is emphasized by the neutrally colored leaf itself serving as the background, the bright colors, the sprightliness of the figures—in contemporary local dress, with the addition of halos to set off the heads—and the balance and bilateral symmetry of the composition.

21 Cup
Iran; 2nd half 12th c.
Composite body, underglaze frit painted;
Max. D. 5⅝ in. (14.3 cm.)
Purchase, Joseph Pulitzer Bequest, 1967
(67.104)

22 "Preparation of Medicine from Honey": Page from the Materia Medica *of Dioscorides completed in Arabic by the calligrapher 'Abdullah ibn al-Fadl;* Iraq (Baghdad); 1224 Colors, gold on paper; 12⅜ x 9 in. (31.4 x 22.9 cm.) Cora Timken Burnett Collection of Persian Miniatures and Other Persian Art Objects, Bequest of Cora Timken Burnett, 1956 (57.51.21)

لَا يَشْتَهِى الطَّعَامَ اوْ وَزْ كَانَتْ قُوَّتُهُ تُحَلِّلُ وَصِفْتُهُ عَلَى هَذِهِ الصِّفَهْ

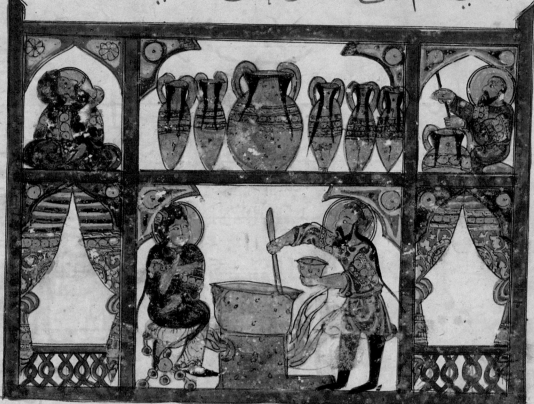

وَدَلْيَا لِلْعَجُوزِ جَوَزْ يُؤْخَذُ مِنَ الْعَسَلِ جُزْءٌ وَنُخَالِطُونَهُ فِي الْعَسَارِ وَطَحَنُونَهُ عَلَى هَذِهِ الصِّفَهِ الَّتِى الذَّهَبِ

اللَّيْنِ ثُمَّ يَرْفَعُونَهُ ع م ع وَقَدْ يَتَطَرَّبْ

فَقَالَ لَهُ أَبُوْمَا إِلَى عَلَى هَذِهِ الصِّفَهِ وَتُؤْخَذُ ثُمَّ الشَّهْدِ فَيُغْسَلُ

بِالْمَآءِ وَيُؤْخَذُ ذَلِكَ الْمَآءُ وَيُرْفَعُ ه وَيَنْبَغِى اذَا شُرِبَ هَذَا الشَّرَابِ انْ

يُصْرَفَ وَمِنَ النَّاسِ مَنْ يَطْحَنُهُ وَمِنْهُ غَيْرُ مُوَافِقٌ لِلْمَرَضِ لِكَثْرَةِ مَا فِيهِ مِنْ

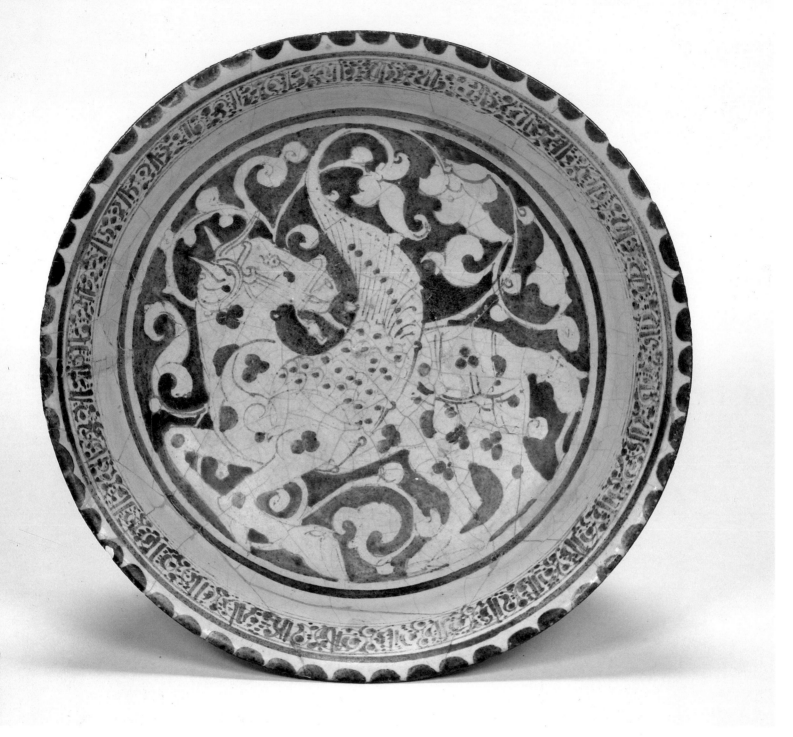

23 Bowl
Iran; late 12th–early 13th c.
Composite body, glazed and
luster painted; D. 8 in. (20.3 cm.)
Rogers Fund, 1916 (16.87)

BOWL

At about the time of the collapse of the Fatimid dynasty in
1171, luster-painted ware was being produced in Iran as
well as Syria. While it seems quite certain that migrating
Egyptian potters were responsible for bringing the technique
to Syria, their role in the appearance of luster-painted ware
in Iran is less clear. Certain features common to both wares
support a connection between Egyptian and Iranian luster,
particularly that associated with the Persian city of Rayy. Of
those features, this Iranian footed bowl exhibits two: a de-
sign reserved on the luster ground (in this case, an "Islam-
ized" Pegasus) and a gadrooned rim.

24 Bowl
Iran; late 12th–early 13th c.
Composite body, stain- and overglaze
painted and gilded; D. 7¾ in. (19.7 cm.)
Henry G. Leberthon Collection, Gift of
Mr. and Mrs. A. Wallace Chauncey, 1957
(57.61.16)

BOWL

In an attempt to increase the number of colors in their palettes, twelfth-century Iranian potters developed a technique now known as *mina'i* (enameled). Stable colors were stain painted in a lead glaze that was rendered opaque by the addition of tin. After a first firing, less stable colors were applied and the object was refired at a lower temperature. This technique enabled the artist to paint in a greater variety of colors with complete control, lending a miniaturelike quality to the designs not found on other pottery types.

Figural designs as opposed to stylized vegetal ones seem to have been preferred by *mina'i* painters: indeed, some of the vessels with figures bear scenes from the Iranian national epic, the *Shah-nameh* (*The Book of Kings*), written by the poet Firdausi between A.D. 975 and 1010. The style of these figures echoes that of those in the few Persian paintings on paper still surviving from this period, and thus *mina'i* ware serves to increase our knowledge of painting of the Early Medieval period.

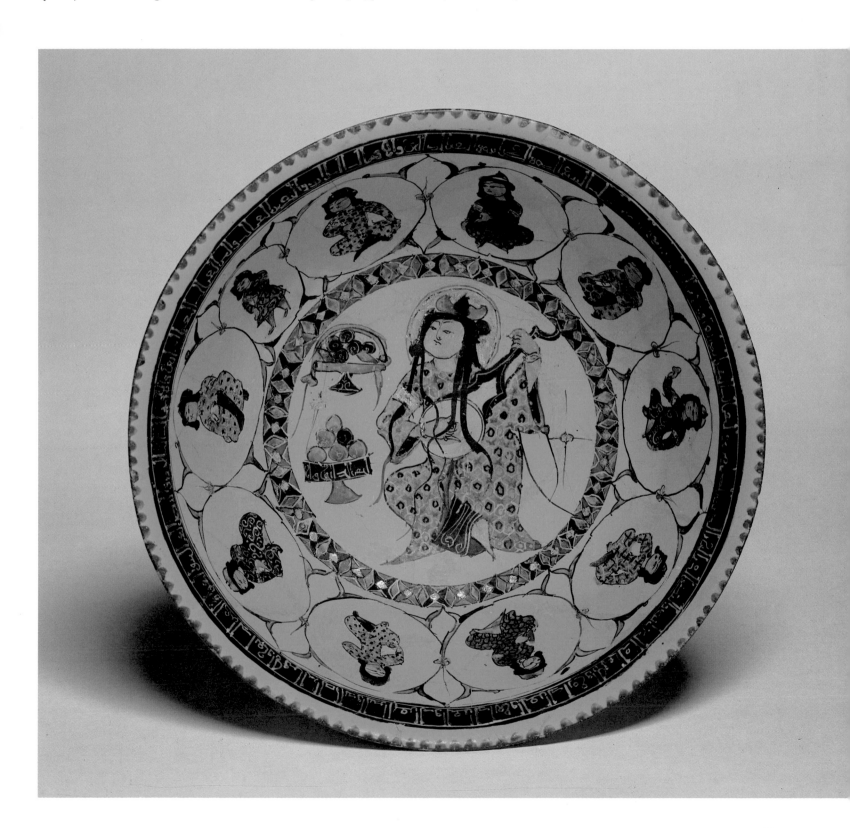

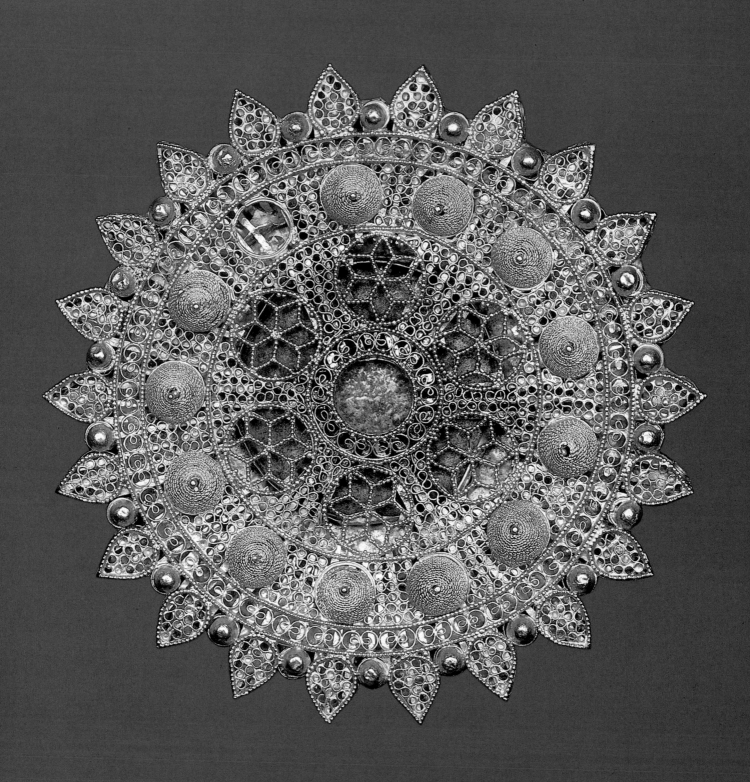

GOLD ROUNDEL

This gold roundel enlarges our understanding of the nature of Medieval Islamic jewelry. An object of marvelous delicacy and beauty, it is important in that it combines features associated with Iran with features previously thought confined to work produced in the Syro-Egyptian region.

Most characteristically Syro-Egyptian is the filigree construction laid on a backing of narrow strips of gold. The strips in this piece, however, are very thin and arranged in a regular radial pattern, whereas in Egyptian and Syrian Fatimid pieces the strips are thicker, they vary in their dimensions, and they are placed strategically to support the filigree but in such a way as to appear haphazard. Because of a denser surface in Fatimid filigree, the backing strips are less visible from the front than they are in the present piece. Another distinction is that Fatimid filigree designs are typically composed of foliate arabesques of doubled twisted wire filling variously shaped compartments, a technique that, combined with the denser surface, gives a heavier and warmer effect. There are, furthermore, no known Fatimid pieces with an element comparable to the solid sheet-constructed back or to the concentric rings of narrow sheet separating front from back.

The original function of this roundel is not known. There is a small hole laterally through each of the points bordering the perimeter through which a wire or string holding a pearl or precious-stone bead was almost certainly threaded. It is unlikely that the piece was a pendant since its design is radially symmetrical, and there is no indication of how it might have been attached; its extreme delicacy would seem to rule out its having been attached to a belt. Possibly, it was sewn onto some article of clothing through the holes in each of its bordering points.

25 Roundel
Iran; 11th c.
Gold, fabricated from sheet and wire and decorated with filigree and granulation, originally set with stone; D. 71.5 mm., Max. thickness 5.6 mm.
The Alice and Nasli Heeramaneck Collection, Gift of Alice Heeramaneck, 1980 (1980.344)

GOLD ARMLET

One of the most important pieces for the study of Early Medieval jewelry in Greater Iran is the armlet reproduced here. Each of the four hemispheres flanking the clasp bears at its base a flat disk of thin gold that was decorated by pouncing it over a coin bearing the name of the Abbasid caliph al-Qadir Billah (r. 991–1031). The late George Miles believed the style of the coins used was that of those minted in the years 999–1000, 1007, and 1028, during the rule of Mahmud of Ghazni, and that they were probably struck in the mint of Nishapur. The gold disks were most probably pounced over relatively new coins, and therefore a dating to the first half of the eleventh century is secure, particularly since this is corroborated by other related pieces.

OVERLEAF:

INCENSE BURNER IN A FELINE FORM *(Pages 40–41)*

One of the largest and stateliest of all Islamic bronze animals, this incense burner in the form of a stylized feline expresses the power of the dynamic Seljuks, a Turkish people from inner Asia who gained control of Khorasan in 1034. From the late tenth century into the late thirteenth, Seljuk dynasties controlled much of the Muslim East. Their art was influential throughout the Islamic world and Europe.

Imbued with Seljuk animal vitality and humor, the head, body, and limbs of this incense burner, which is dated 1181 or 1183, are abstracted into sleekly static forms, powerful but not threatening. A guardian rather than an attacker, the noble beast represents Seljuk art not in its dynamic early phase but at a sophisticated later stage, in which designers and bronze casters devised subtle variations on the existing mode. Exquisitely proportioned ears, eyes, tongue, and whiskerlike ridges are "streamlined," and they are admirable as units as well as in relation to the whole. The pierced body, mask, and tail are adorned with elegant arabesques; and the inscriptions in Kufic letters—bearing the name of the patron, the date (A.H. 577 or 579), and wishes for happiness and blessings—are clearly defined, with no tentative strokes or manneristic flourishes.

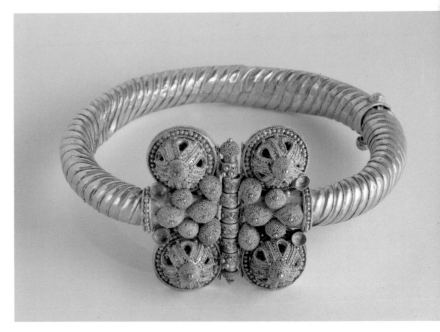

26 Armlet
Iran; 1st half 11th c.
Fabricated from sheet with applied twisted wire and granulation, originally set with stones;
Max. D. 4⅛ in. (10.5 cm.), H. at clasp 50.8 mm.
Harris Brisbane Dick Fund, 1957 (57.88a-c)

27 *Incense Burner in Feline Form*
Iran; Seljuk period, 1182
Bronze; 36 in. (91.4 cm.)
Rogers Fund, 1951 (51.56)

Opposite: detail *Page 39:* text

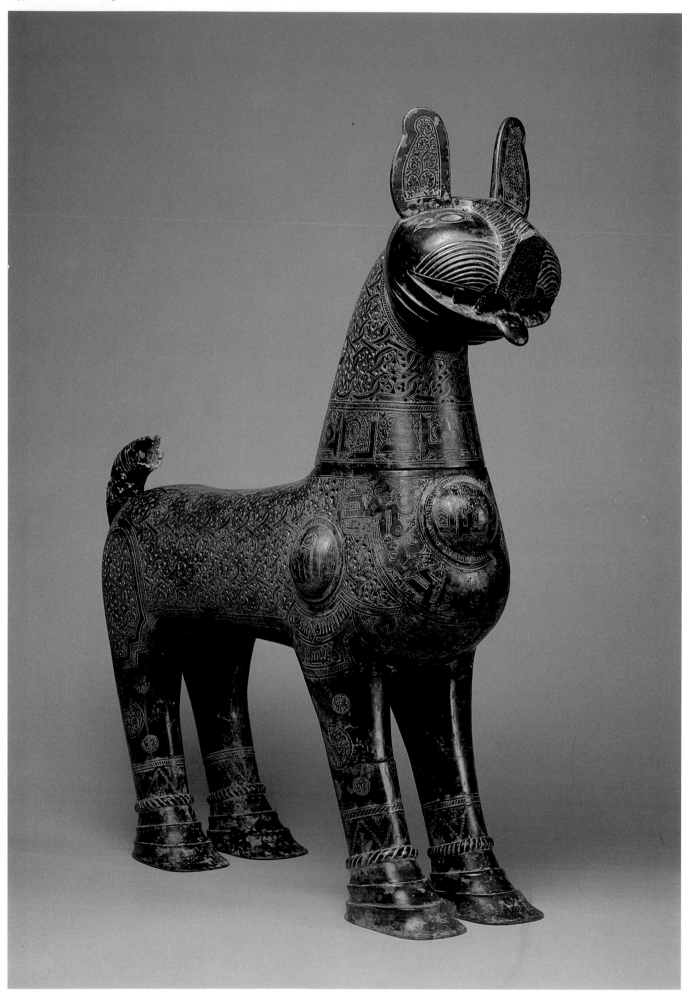

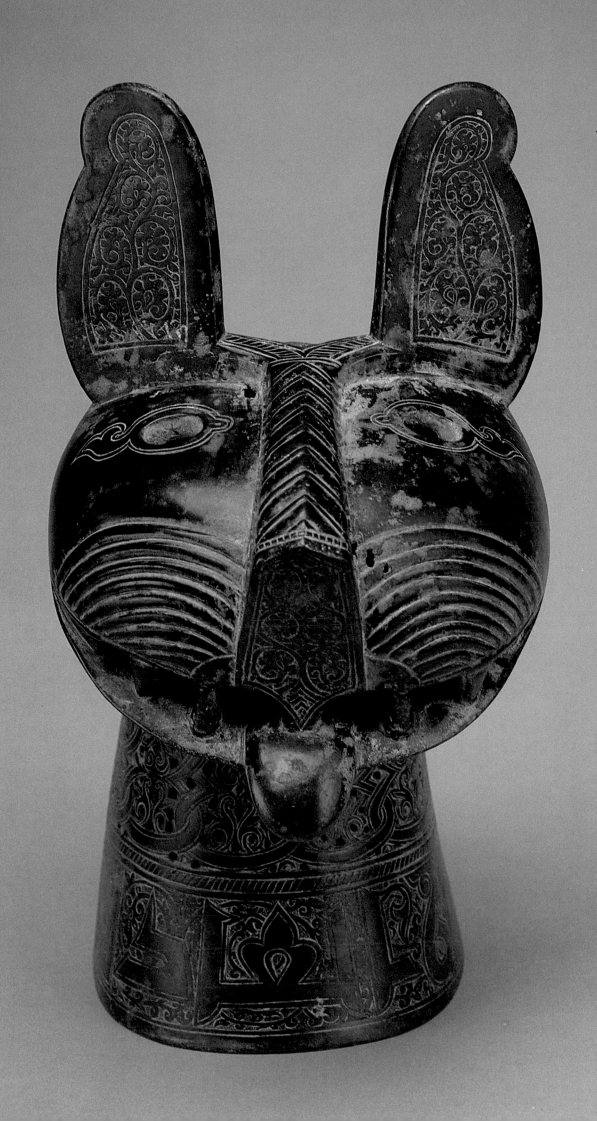

MIRROR BACK

On the outer band of this circular mirror is a simple well-produced Kufic inscription on an arabesque ground, offering a series of good wishes for joy, happiness, strength, victory, and authority to the owner. Next is a frieze, typical of the Seljuk period, of six animals dashing in clockwise rotation on a foliated scroll. A dog stalks a rabbit, whose head is turned back to look at the dog; a dog pursues a fox; and a lion chases a quadruped. A pierced boss in the center, resting on eight lobes, is surrounded by crenellated motifs. The rim is raised and slanted, and there is a flat surface on the back.

The mirror was suspended from a ribbon or string inserted through the knob, following the Chinese style. Other mirrors from this period have handles in the Western tradition.

EWER

This elegant ewer, used for ablutions, is part of a group of similar but not identical vessels attributed to the Khorasan region. The type has a long spout, cylindrical body with either fluted, flat, or angular sides, flattish shoulder and ring foot, and squared handle.

During the twelfth century, inlay work developed into a fine art, adding a splendid finish to simple brass or bronze objects. The exquisitely inlaid surface of this ewer carries a variety of subtle decoration from the spout to the waisted ring foot. On the neck and shoulder, Arabic inscriptions in Kufic and human-headed Naskh scripts express blessings and good wishes to the unnamed owner. Such phrases are found on other vessels in this series and are common in earlier Islamic times on other objects, as are Kufic inscriptions. Human-headed Naskh script became popular only in the second half of the twelfth century and had a relatively short life.

The cylindrical body has twelve flutes decorated with bands of animal-headed scrolls. They surround medallions that contain signs of the zodiac accompanied by a ruling planet. These astrological symbols are frequently found on metalwork, ceramics, and stone sculpture during this period. The flutes are topped by a row of addorsed harpies in relief, a motif also popular during this period. Near the bottom is a row of repoussé birds. A frieze of coursing animals is located on the foot.

28 Mirror Back
Iran; Seljuk period, 12th c.
Cast bronze; D. 7⅝ in. (19.3 cm.)
Rogers Fund, 1942 (42.136)

29 Ewer
Iran (Khorasan); late 12th–early 13th c.
Brass, incised and inlaid with silver;
H. 15½ in. (39.4 cm.)
Rogers Fund, 1944 (44.15)

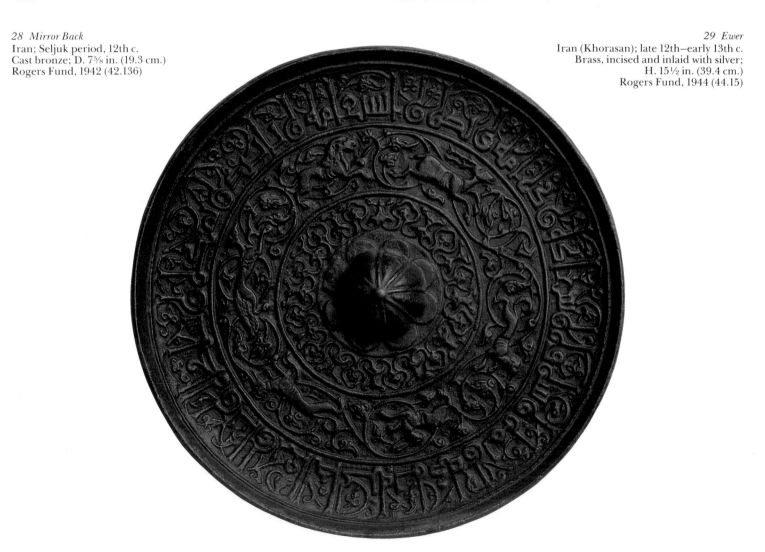

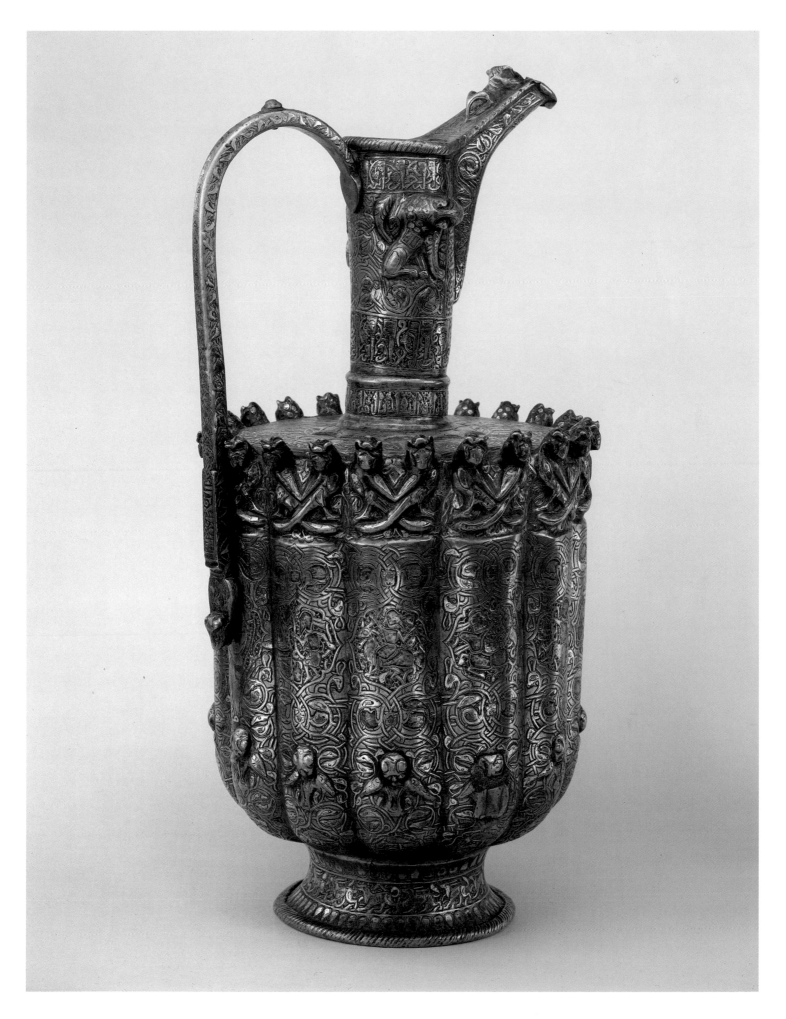

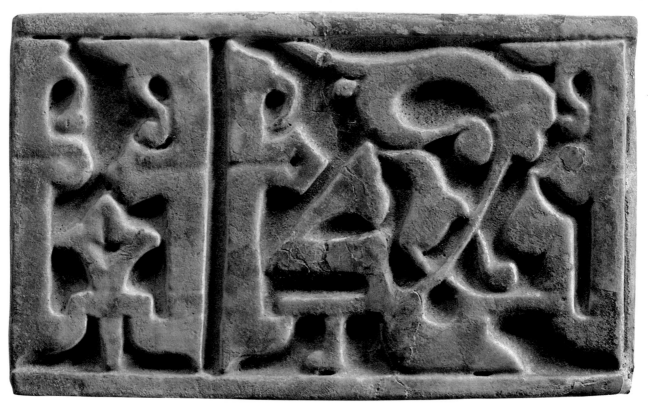

30 Tile
Syria; 12th–13th c.
Composite body, carved and glazed;
10¼ x 6¾ in. (26 x 17.1 cm.)
Gift of Otto H. Kahn, 1910 (10.56.1)

CERAMIC TILE

Designers of calligraphic architectural inscriptions concentrated more on the blessing power of the words from the Koran than on legibility. Often, as in this magnificent section from a series of panels, the artist-craftsman was inspired to such imaginative heights by the curves and angles of the alphabet that his work is virtually impossible to read. This brilliantly composed, marvelously glazed and sculpted relief from Syria contains just such a floriated Kufic script —artistically composed but, unfortunately, indecipherable!

EARLY MEDIEVAL PERFUME SPRINKLER

The undulating threads flanking the lower neck are the only decoration on this beautifully proportioned and aged perfume sprinkler. These handlelike threads, the flattened globular body, and the slender neck with its small opening are all very characteristic of such vessels, which, when shaken, dispensed drops of expensive perfume suspended in a heavy oil base. There is an almost identical sprinkler in the British Museum, and several executed in the marvered-and-combed technique with a similar opening in the body also survive. The shape of the vessel must have been designed to facilitate dispensing the precious cosmetic.

31 Perfume Sprinkler
Early Medieval period
Free-blown and tooled with applied foot and
"handles," pontil on base; H. 10¼ in. (26 cm.)
Purchase, Richard S. Perkins Gift, 1977 (1977.164)

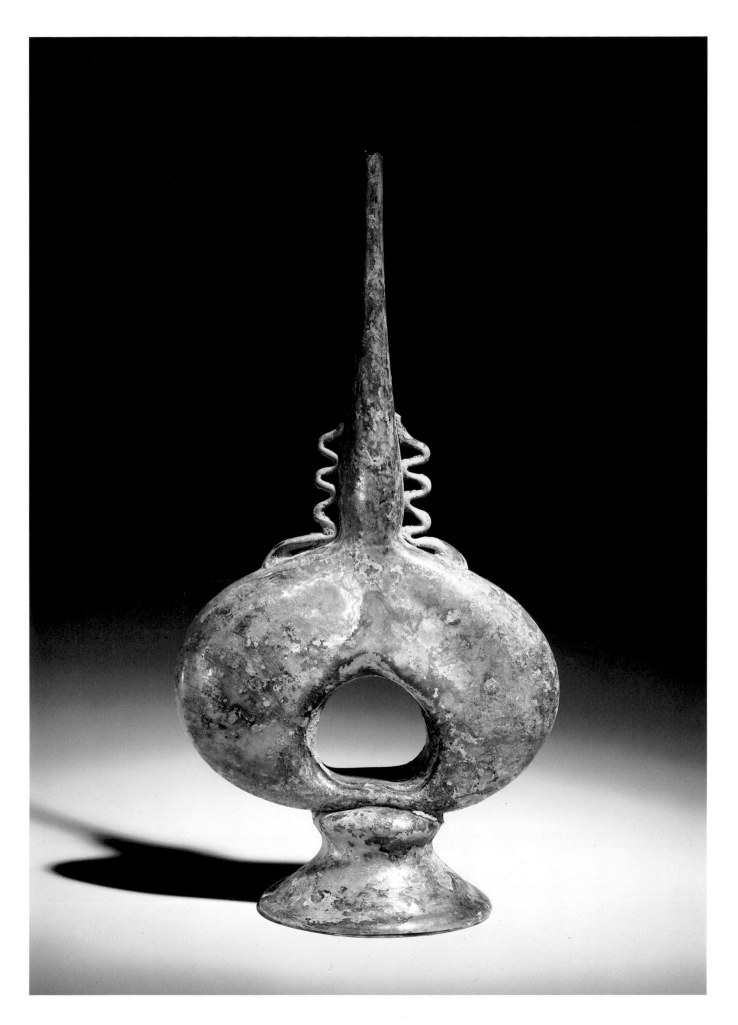

JAR

Syria produced underglaze polychrome-painted ware during the second half of the twelfth and first half of the thirteenth century. These pieces are closely related to those made in contemporary Egypt and Turkey, all of which are customarily decorated with figures, animals, or birds.

The abstract decoration on this jar is unusual for the type, as it reflects the influence of contemporary metalwork in the layout of its design and in the motifs (specifically, the horizontal bands interrupted by large roundels). Costlier metal objects often served as the inspiration for objects in less expensive mediums.

32 Jar
Syria; late 12th–1st half 13th c.
Composite body, underglaze slip(?),
stain painted; H. 9¾ in. (24.8 cm.)
Rogers Fund, 1923 (23.162.1)

BEAKER AND BOTTLE

Decorating glass with trailed threads in a contrasting color was popular in the Early Medieval period, but the variation illustrated by these two vessels seems to have been quite rare. After an initial blowing of each gather, threads—emerald green and clear, colorless for the beaker, and cobalt for the bottle—were trailed on the bodies. Then each object was reblown, causing the threads to become further embedded in the matrix but less so than if they had been marvered. Finally, a coil base was applied to each, and the rim and neck were also decorated with a trailed thread.

This type of beaker appears to have been quite common during the first half of the Early Medieval period but was later replaced by a variety with a more flaring rim that is commonly decorated with enamel painting. Perhaps the type illustrated here should be seen as a link between the early eleventh-century beaker type and that which came into vogue during the late twelfth century. The author knows of no other Islamic bottle of the shape seen here, but it must have been the precursor of a shape seen in a number of enamel-painted bottles of the Mamluk period, such as the type illustrated in Plate 34.

33 Beaker and Bottle
Eastern Mediterranean; Early Medieval period,
11th–mid-13th c.
Free blown and tooled with unmarvered thread
decoration and coil base, pontil on base; H. of beaker
4⅜ in. (11.1 cm.), H. of bottle 4¾ in. (12.1 cm.)
Bequest of Mrs. H.O. Havemeyer, 1929,
H.O. Havemeyer Collection (29.100.83,87)

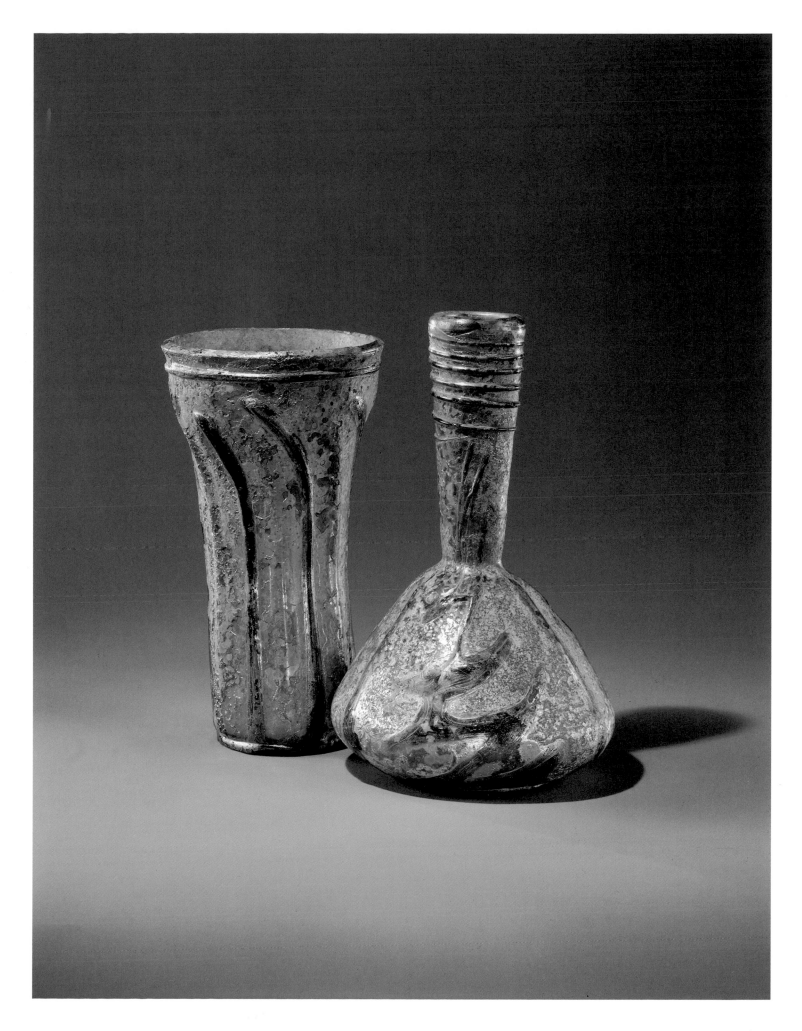

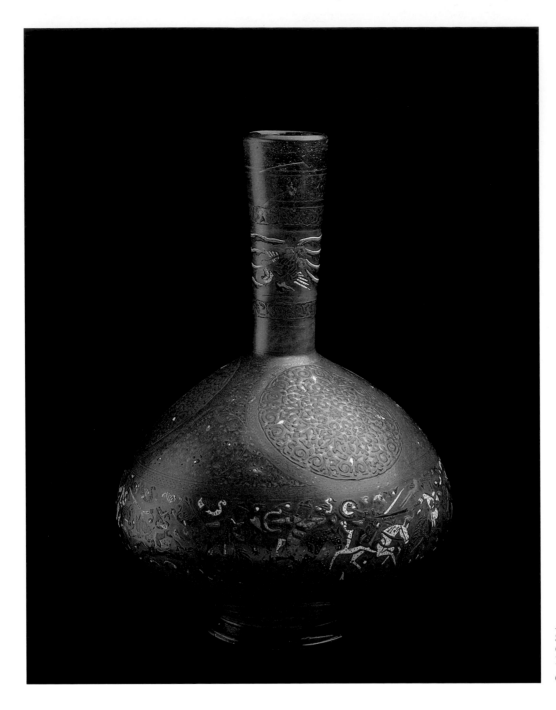

34 *Bottle*
Syria or Egypt; 14th c.
Glass; H. 17⅛ in. (43.5 cm.)
Rogers Fund, 1941 (41.150)

Opposite: detail

MAMLUK-GLASS BOTTLE

The term "Mamluk glass" is almost synonymous with the magnificent enamel-painted mosque lamps that were produced in profusion during the rule of the Mamluk dynasty in Syria and Egypt. However, as witnessed by this graceful bottle, with its elegant shape and surpassingly rich and varied decoration, the artists and craftsmen of that period were capable of using their talents imaginatively and with a breadth of vision that was open to foreign artistic influences and innovations.

Around the neck of this bottle flies the Chinese *feng-huang* (phoenix), which became identified pictorially with the Persian mythical bird, the Simurgh. The long strands of its tail stream around the neck until they touch its face. The shoulders are decorated with two roundels filled with a dense and vibrant arabesque pattern in gold on a blue ground

with enlivening touches of red and white, while in the interstices is a lush floral pattern in gold, again with touches of red, white, and blue. At the area of the greatest bulge of the bottle is a frieze of mounted warriors wielding swords, spears, maces, and bows and arrows.

While the Mamluks were the archenemies of the Mongol dynasty ruling in Greater Iran, they were not impervious to artistic influences from that quarter. The Il-Khanid rulers of Iran were a branch of the same Mongol descendants of Genghiz Khan who established the Yuan dynasty in China, and so at this period Chinese art had considerable impact on that of Iran. The linear drawing of the dense leafy patterns on the sloping shoulders is also indebted to Chinese art while the frieze of horsemen is related to contemporary Persian miniature painting.

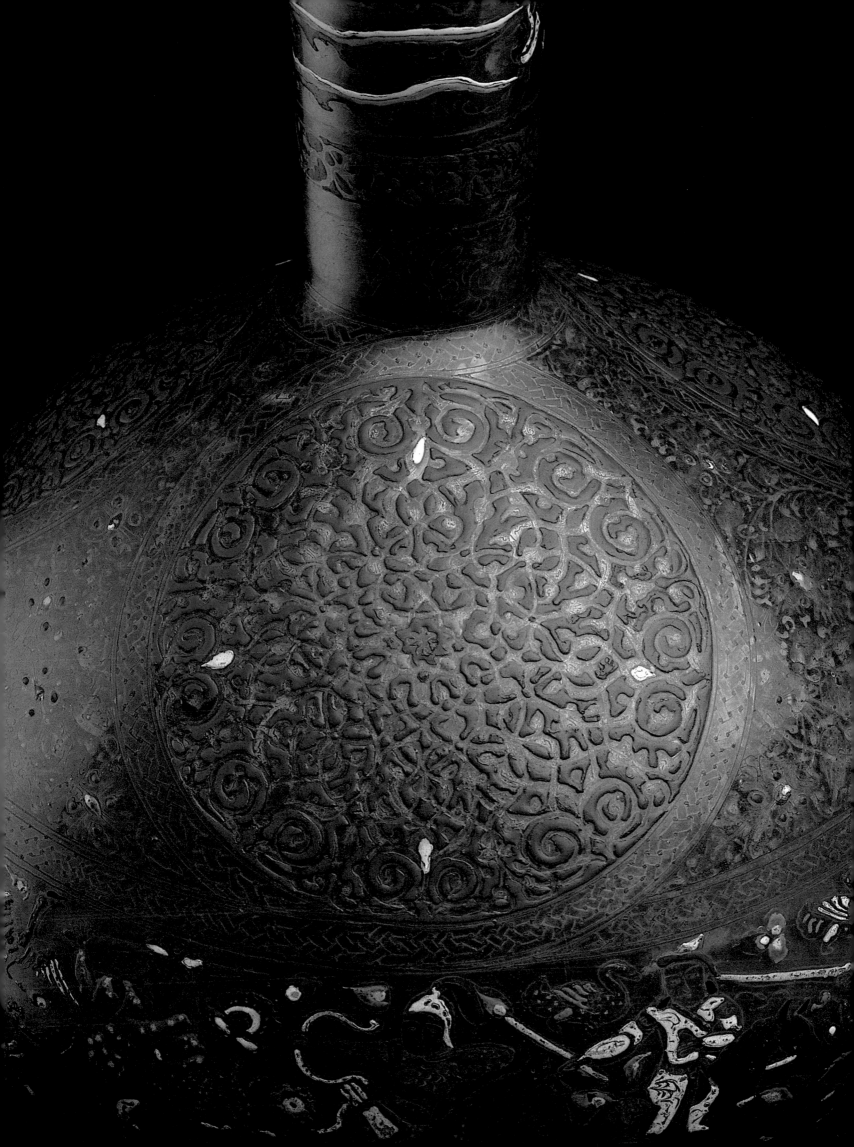

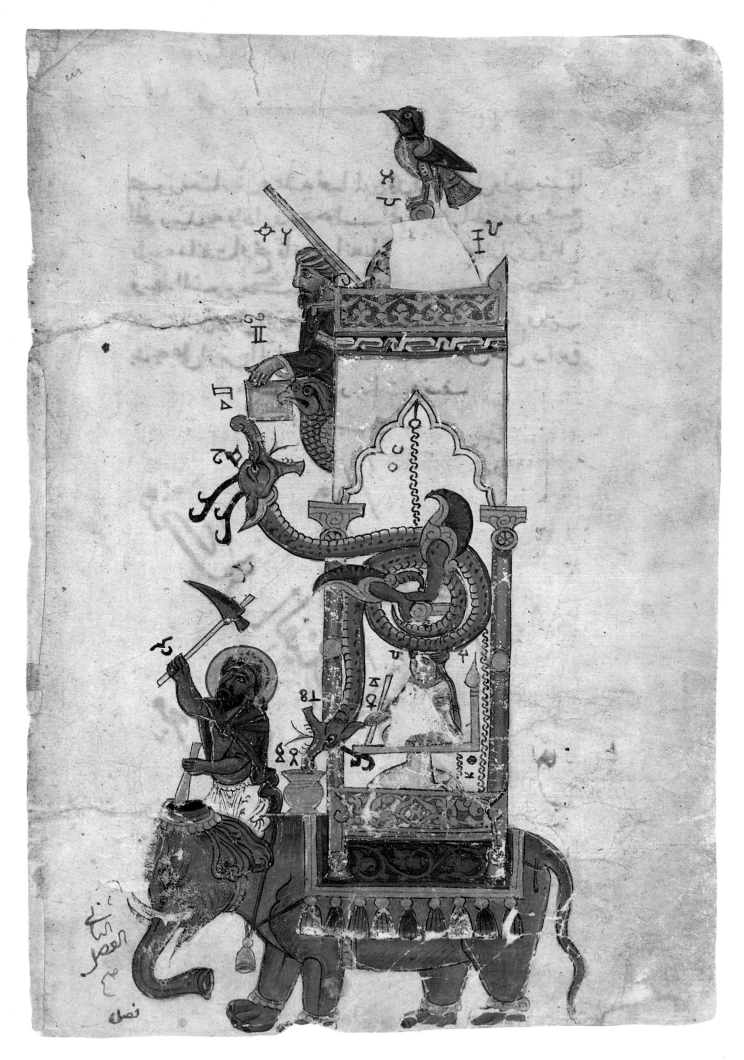

50

ELEPHANT CLOCK

A more playful work than the *De Materia Medica*, also derived from the Greek scientific tradition inherited by Byzantium, is the work about mechanical devices written by an engineer in the service of the Artuqid sultan of Diyarbakr and completed between 1204 and 1205. The *Automata*, as it is usually called, was extremely popular in the Muslim world, particularly among the Mamluks, for whom this manuscript was made in Ramadan of A.H. 715 (December 1315), probably in Syria.

The treatise was divided into six categories: the construction of clocks; the fashioning of vessels and figures suitable for drinking sessions; pitchers, basins, and other things; fountains and perpetual flutes; machines for raising water; and miscellaneous objects. Each section was heavily illustrated and diagrammed. The elephant clock, which belongs to the first category, had the time marked at half-hour periods by the scribe sitting in the howdah. Then the bird at the top of the dome whistled, the figure at the balcony on the left would allow a ball to be released from the falcon's mouth into that of the serpent. The serpent would then discharge it into the vase on the elephant's shoulder. The mahout (elephant driver) strikes the head of the elephant with his ax and then his mallet, the ball then falls onto a cymbal in the elephant's body and comes to rest in a container between its legs. The falcon, serpent, and vases are pairs, changing from right to left with each half hour.

The style of the painting is basically a continuation of that of the Baghdad school, largely unaffected by other artistic influences invading the Muslim world at this period.

35 *"Elephant Clock": Leaf from the* Book of Knowledge of Ingenious Mechanical Devices *of al-Jazari*
Prob. Syria; A.H. 715, A.D. 1315
Colors, ink on paper; 12⅜ x 8⅝ in. (31.5 x 22 cm.)
Rogers Fund, 1955 (57.51.23)

O V E R L E A F :

MOSQUE LAMP *(Page 52)*

Any number of European church treasuries bear witness to the esteem in which the glass of the Muslim world was held in the West. One of the most popular types was the enamel-painted variety, which was often not only mounted in precious metal but also protected in beautiful leather cases. The so-called Goblet of Charlemagne at Chartres and the Goblet of the Eight Priests at Douai are two well-known testaments to the prestige of this enameled glass, much of which found its way to Europe at the time of the Crusades.

In addition to such secular pieces, large lamps for specific religious foundations were a very important part of the predominantly Syrian enamel-painting industry, particularly in the late thirteenth and fourteenth centuries. Commissioned by the sultan himself or his amirs, these lamps are characteristically decorated with the name of the patron and his blazon or coat of arms, as well as with the "Light Verse" (*Ayat al-Nur*) of the Koran (Sura 24, verse 35):

> God is the Light of the heavens and the earth;
> the likeness of His Light is as a niche
> wherein is a lamp
> (the lamp in a glass,
> the glass as it were a glittering star)
> kindled from a Blessed Tree,
> an olive that is neither of the East nor of the West
> whose oil wellnigh would shine,
> even if no fire touched it;
> Light upon Light;
> (God guides to His Light whom He will.)

This early example was commissioned for the mausoleum in Cairo of the amir Aydakin, who died in 1285. His blazon, repeated nine times on this lamp, consists of two addorsed bows on a circular red field—indicating that he had served as *bunduqdar* (bowman) to a sultan.

O V E R L E A F :

PAGE FROM A KORAN *(Page 53)*

This is the penultimate page of a Koran, containing the beginning of Sura 114 in very soft, large Thuluth characters. The chapter heading is in stylized late Kufic letters, as became customary in the later Middle Ages.

Often, not only the frontispiece but also the last two pages of valuable Korans were decorated with arabesque work and colorful floral or geometrical designs. These final pages contain the shortest suras of the Koran, often used in prayer—the last two are especially important in averting evil.

In this manuscript, which can be dated to the thirteenth century and was in all probability copied in Egypt, the final pages are of special beauty, thanks to the lavish use of gold for the lettering and part of the decoration.

36 *Mosque Lamp*
Eastern Mediterranean; ca. 1285
Free blown and tooled with applied
handles, enameled and gilded, pontil
on base; H. 10½ in. (26.7 cm.)
Gift of J. Pierpont Morgan, 1917
(17.190.985)

Page 51: text

37 *Page from a Koran*
Egypt; 13th–early 14th c.
Colors, gold on paper;
20 x 13¼ in. (50.8 x 33.7 cm.)
Fletcher Fund, 1924 (24.146.1)

Page 51: text

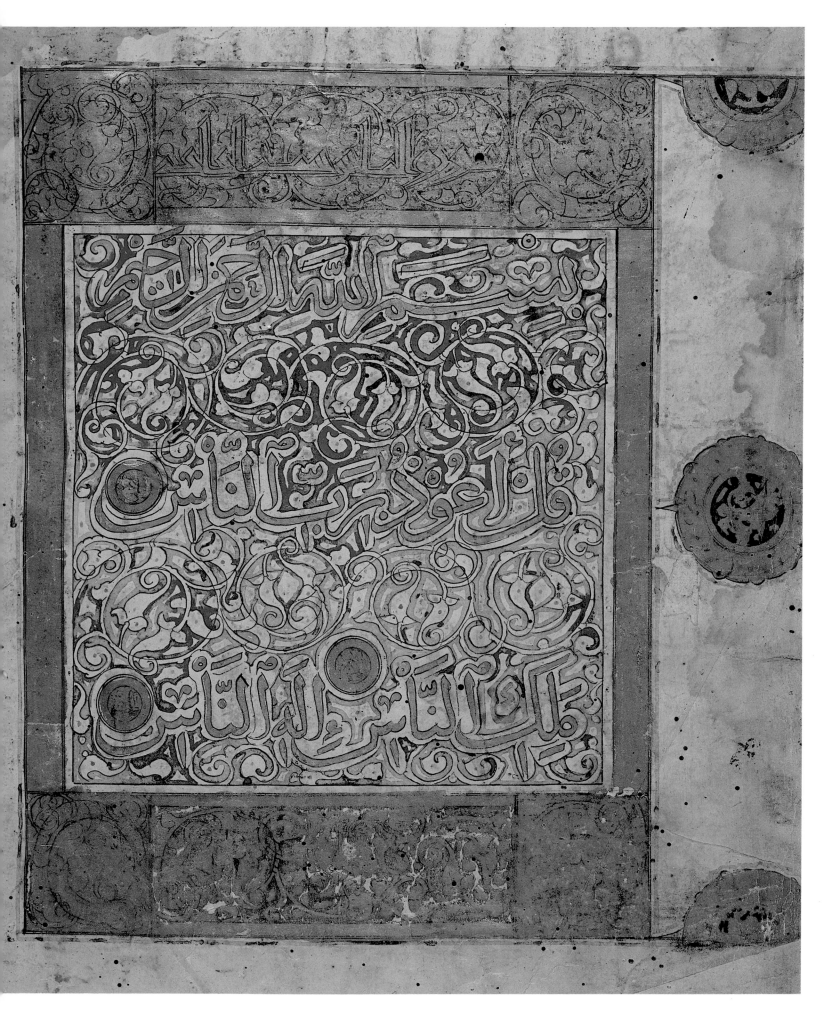

38 *Incense Burner*
(exterior and interior views)
Syria; Mamluk period,
end 13th or beginning 14th c.
Pierced brass, inlaid with gold
and silver; D. 6 in. (15.2 cm.)
Gift of J. Pierpont Morgan, 1917
(17.190.2095a,b)

INCENSE BURNER

Four repeated inscriptions in simple Arabic Thuluth script, typical of Medieval—and especially Mamluk—metalwork are found in the borders where each half of the spherical incense burner is joined. These inscriptions contain the usual blessing formulas for an Arab ruler, beginning with "glory to our lord, the sultan, the ruler, the knowledgeable, the just, the one helped by God, the victorious, the victor." Other formulas have been added: the one on the upper half reads, "the pillar of Islam and the Muslims," and on the lower half, "the . . . of the kings and sultans, the tamer of heathen and" (the word "polytheists" is missing).

Interconnecting rows of medallions decorate the walls, and the surrounding ground is filled with interlocking Y designs. Gimbals in the interior of the vessel contained fragrant resins or incense, which were sprinkled on the lighted charcoal placed in the small bowl. The rings at the top would indicate that the object was probably suspended for hanging or else swung like a censer to disperse the smoke.

BRAZIER

Braziers served a dual purpose, first as portable heaters, but also as portable grills. Following the pattern of other domestic metalware made during this time, this brazier is beautifully adorned wtih patterns inlaid with silver. A flat pan, now missing, would have held the charcoal.

The brazier was made for the second ruler of the Rasulid dynasty of the Yemen, al-Malik al-Muzaffar Shams ad-Din Yusuf I (r. 1250–1295). The brilliant Rasulid dynasty was a prosperous one for two centuries. The country was an important trade crossroads with connections to India, Arabia, and Africa and had strong cultural and commercial ties to the Mamluk kingdom of Egypt.

The brazier is decorated on the sides with a wide band of Thuluth inscriptions in Arabic, placed on an arabesque and leafy scroll. The inscriptions begin with the phrase "glory to our Lord," and continue with the titulature normally used for a Medieval ruler. A band of coursing animals is found under the rim, which has conical finials at the corners. There are intertwined dragon heads between each finial. On the side near the corners are five-petaled rosettes, often described as the blazon or heraldic device of the Rasulid dynasty. Suspension rings, hanging from the mouths of feline heads, were used for rods to carry the heated brazier. Animallike feet support the vessel.

39 Brazier
Egypt; second half 13th c.
Brass, inlaid with silver; Gr. H. 13⅞ in.
(35.2 cm.), Gr. W. 15½ in. (39.4 cm.)
Edward C. Moore Collection, Bequest
of Edward C. Moore, 1891 (91.1.540)

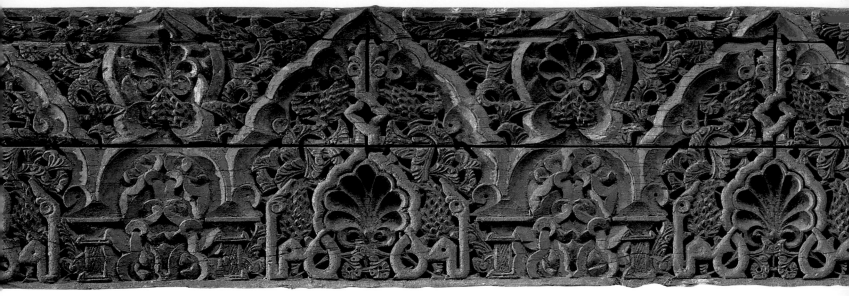

40 Lintel
Morocco; 14th c.
Wood, carved and painted; 121 x 19 x 2¾ in.
(307.5 x 48.3 x 7 cm.)
Mr. and Mrs. Isaac D. Fletcher Collection,
Bequest of Isaac D. Fletcher and Rogers Fund,
by exchange, 1985 (1985.241)

LINTEL

During the Marinid period (1196–1549), elaborately decorated religious schools were built in the major cities of what is now Morocco. One of their principal features was the *sahn*, an open courtyard surrounded by a covered ambulatory, where the students could escape the sun and assemble in groups for religious instruction or simply sit in quiet contemplation. This shaded area was separated from the courtyard by a series of pillars connected by arches. Spanning these were carved and painted rectangular wooden lintels.

The strength and vigor of Arab art in general, and Arab architecture in particular, is embodied in this especially majestic lintel. It carries a design (repeated four and a half times) that consists of a large arch alternating with a smaller arch and still retaining much of its original paint. Each of the large arches contains a calligraphic decoration consisting of the word *yumn* (happiness) written forward and backward on either side of a shell design. The final letter (*nun*) of each pair of words, in both its forward and backward version, frames the shell and interlaces above it in a manner that bisects the large arch itself. The shell design in a reduced form fills the smaller arches. The spandrel and background designs consist of vegetal motifs interspersed with pine cones. The motifs and design layout are characteristic of contemporary decoration in other mediums as well, in Spain and North Africa.

PAGE FROM A KORAN

The Maghribi style of Arabic script is in many ways different from the classical style developed in Iraq and Iran during the tenth and eleventh centuries. There the student learned the exact measurements of each letter and its relation to the first letter of the alphabet and was obliged to repeat single letters for months until he had mastered them in every possible single and combined form. But in the Maghrib, the calligrapher wrote the whole word immediately. Consequently, the relationship between the letters themselves, the thickness of the pen, and the heights of the letters, etc., were partially blurred. Maghribi is easily recognizable by its rather thin, high letters, which sometimes end in buttonlike rounds, and also by the long, swinging endings of certain letters. Vellum was used longer in the West than in the East, and a number of Korans written completely with golden ink are extant. Other copies bear colorful vowel signs and diacritical marks. In this page, two round designs at the margin mark verses, a leaf-shaped decoration bears the word *khams* (five), for the page contains verses 2 to 6 of Sura 39.

41 Page from a Koran
North Africa; ca. 1300
Ink, colors, gold on vellum;
21 x 22 in. (53.3 x 55.9 cm.)
Rogers Fund, 1942 (42.63)

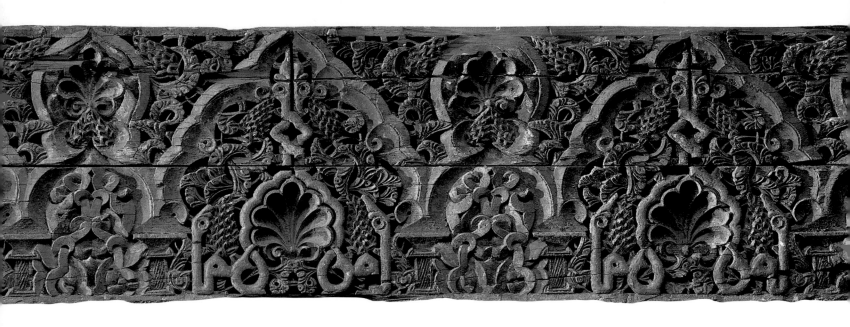

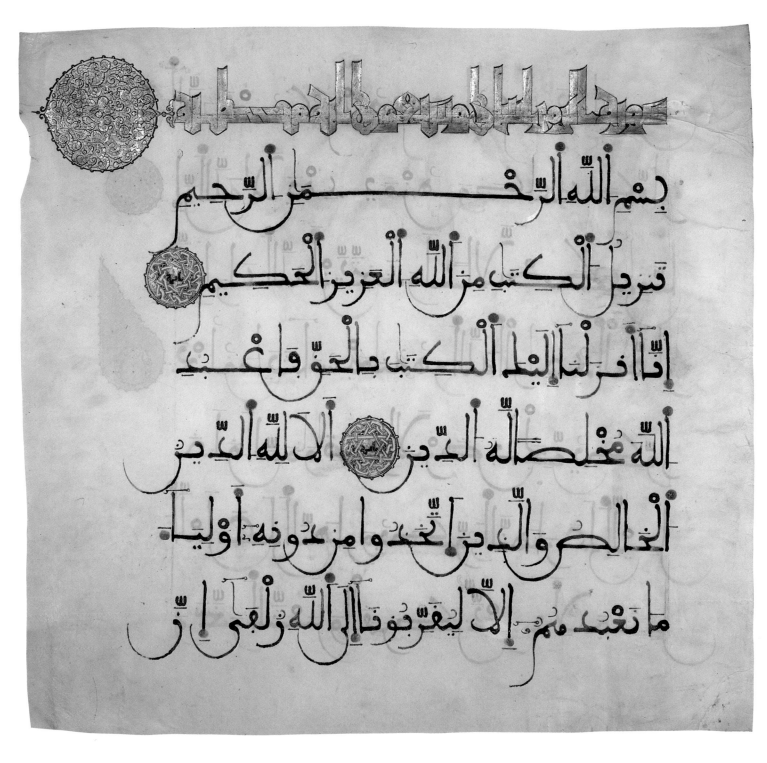

بِسْمِ اللَّهِ الرَّحْمَـٰنِ الرَّحِيمِ

تَنزِيلُ الْكِتَابِ مِنَ اللَّهِ الْعَزِيزِ الْحَكِيمِ

إِنَّا أَنزَلْنَا إِلَيْكَ الْكِتَابَ بِالْحَقِّ فَاعْبُدِ

اللَّهَ مُخْلِصًا لَّهُ الدِّينَ ۞ أَلَا لِلَّهِ الدِّينُ

الْخَالِصُ وَالَّذِينَ اتَّخَذُوا مِن دُونِهِ أَوْلِيَاءَ

مَا نَعْبُدُهُمْ إِلَّا لِيُقَرِّبُونَا إِلَى اللَّهِ زُلْفَىٰ إِنَّ

ELEMENTS OF A GOLD NECKLACE

In the Late Medieval period, Mamluk Syria and Nasrid Spain are better represented by extant jewelry than other regions of the Islamic world. The Nasrid necklace illustrated here consists of four pendant elements, one circular element, and five beads of three different sizes. The pendant and circular elements show a particular indebtedness to Fatimid jewelry in their boxlike construction, their combining of gold and cloisonné enamel as well as of filigree and granulation, and (on the four palmette-shaped elements) the use of gold loops on their edges for stringing pearls or stones. As might be expected, the strong Fatimid influence on Spanish jewelry appears to have begun not in the Nasrid period but in the earlier Spanish Umayyad period, when Baghdad was setting the vogue for most of the Islamic world.

The flat wires are laid on a gold sheet. The background is handled in two ways: it is filled with randomly strewn grains, as on the outer areas of the circular element, and as in the center of the circular element as well as on the four leaf-shaped pendants and four of the five beads, the areas between the flat wires are filled with granules, and the background is, for the most part, punched out.

The elements comprising the Nasrid necklace are not executed as laboriously as the best Fatimid pieces, and the work involved has been further simplified by pouncing a gold sheet over the decorated front side of the pendant to produce a decoration on the back, a peculiarity of Nasrid jewelry. Granulation, however, which does not appear on the Mamluk objects, is an important feature of Nasrid work.

In spite of the Latin inscription on the circular element, which indicates that the necklace was made for the Christian market, the style of each of the elements, as well as the technique employed in the construction of this finest of all Nasrid jewelry pieces, is without doubt purely Islamic and specifically Nasrid. The original arrangement of these necklace elements is not known.

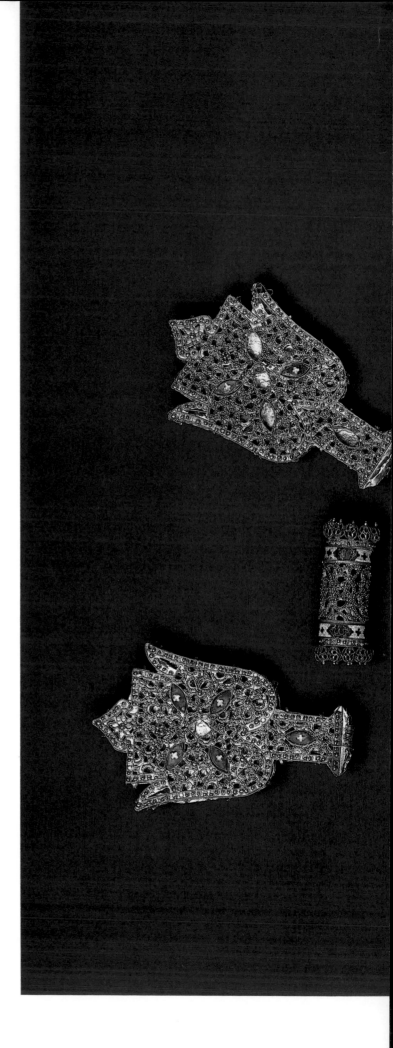

42 Elements of a Necklace
Spain; prob. 15th c.
Gold, fabricated from sheet and wire, pierced,
decorated with granulation and cloisonné enamel;
Max. D. circular element 76.2 mm., L. pendant
elements 82.6 mm.; L. beads 50.8 mm., 38.1 mm.,
25.4 mm. Gift of J. Pierpont Morgan, 1917 (17.190.161)

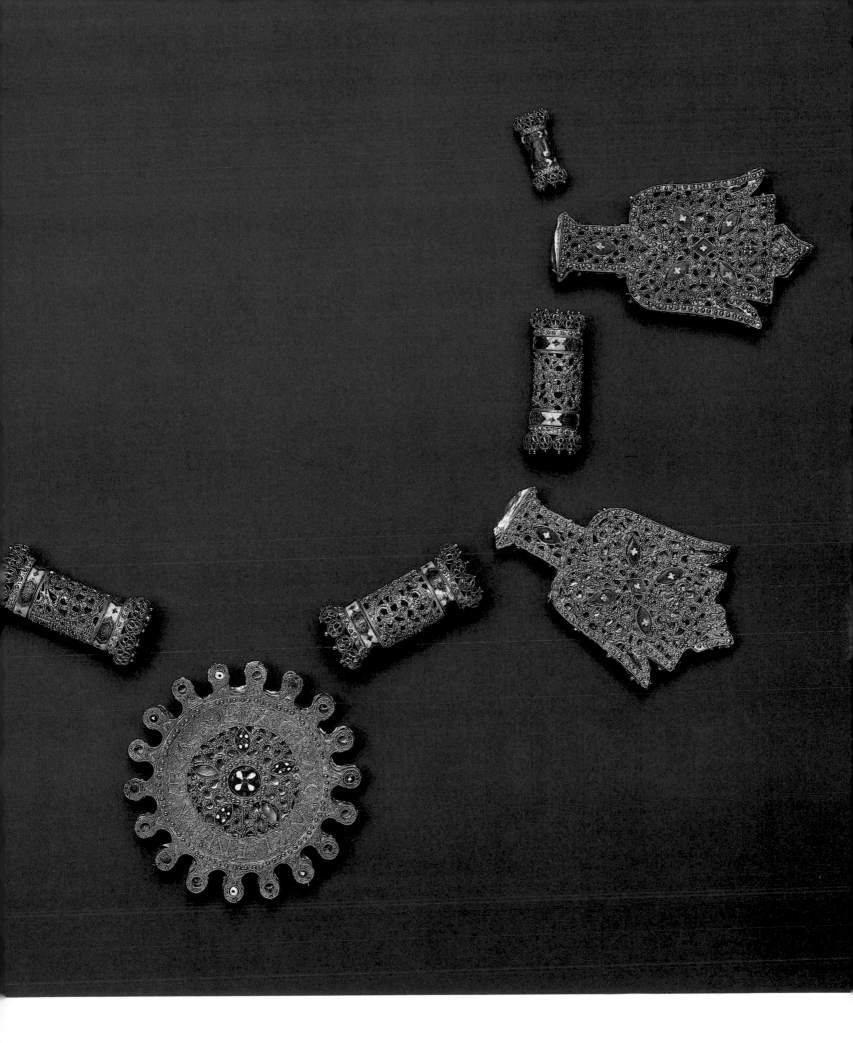

Ax Head

The Mamluk sultans and amirs, probably in imitation of the Varangian (Viking) guard of the emperors of Byzantium, employed a special corps of ax bearers, who accompanied them on ceremonial occasions and into battle.

The cup within a circle decorating the socket of this ax is the blazon of a Mamluk amir and indicates that he was originally a cupbearer to the sultan. Mamluk "heraldry" was not codified to the extent it was in Europe, and it is not possible to attribute this blazon to a specific individual. Axes of this type were often inscribed with the names and titles of the ruler, but unfortunately in this case the Arabic inscription around the blade's rim is too worn to read.

An approximate dating for the ax can be based upon the arabesque design within the roundel. It is in a contour reservé technique, which is exactly paralleled by decorations on sword blades made during the reign of Sultan Qaytbay (r. 1468–1496). For this reason, the ax is dated to the second half of the fifteenth century.

44 Military Standard
Syria; Mamluk period, ca. 1500
Steel; L. 20¼ in. (51.4 cm.)
Bequest of George C. Stone, 1935
(36.25.1961)

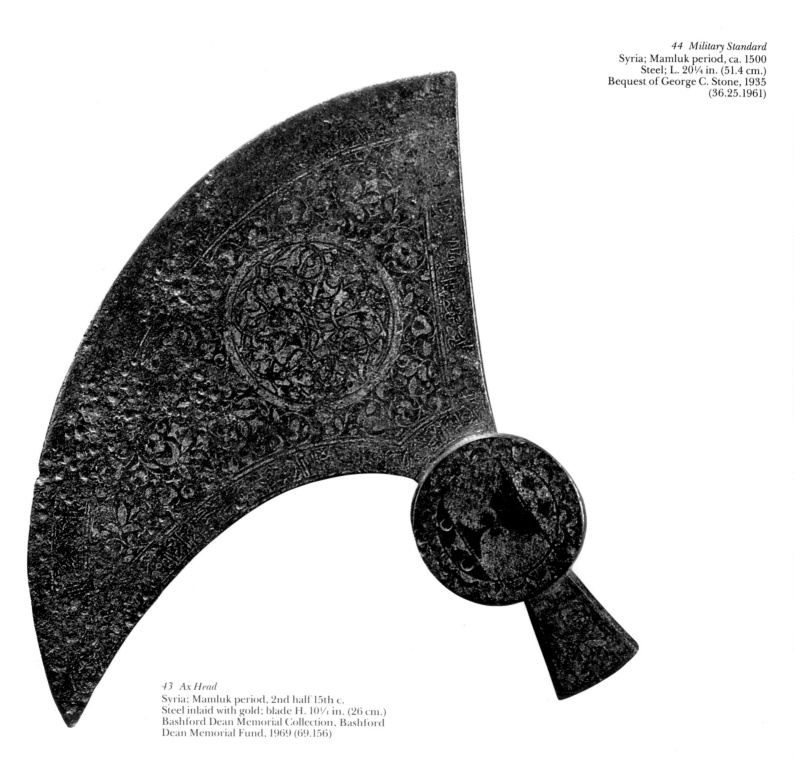

43 Ax Head
Syria; Mamluk period, 2nd half 15th c.
Steel inlaid with gold; blade H. 10¼ in. (26 cm.)
Bashford Dean Memorial Collection, Bashford
Dean Memorial Fund, 1969 (69.156)

MILITARY STANDARD

Standards like this one are called 'alam and were used to identify units of the army in battle and in ceremonial reviews of the troops by the sultan. Many examples from the Mamluk period (1250–1517) have survived, mostly in Istanbul where they were taken as booty after the Ottoman conquest in 1517. These standards are generally inscribed with verses from the Koran and with the names, titles, and often the heraldic blazon of the amir or sultan to whom they belonged. Many also include makers' signatures and specify the region in which the particular amir governed. This means of identification is important because the objects were probably made locally and can therefore be used to isolate local schools of metalwork.

The Museum's example is engraved on either side with intertwining floral designs and cartouches containing inscriptions and the base is supported by two gaping dragons. It is inscribed on one side with the "Throne Verse" from the Koran—the *Ayat al-kursi* (Sura 2, verse 255); and, on the other, with the name and title of the Mamluk amir al-Sayfi Tarabay, who held a governorship in Syria during the early sixteenth century.

OVERLEAF:

MAMLUK CARPET *(Pages 62–63)*

Cairo was first noted in Islamic and European documents as an important carpet-weaving center in the last quarter of the fifteenth century, under the Mamluks, and this type of carpet continued in production probably until the mid-sixteenth century, even after the fall of the dynasty.

This remarkable rug, called the Simonetti Carpet after an earlier owner who exhibited it in the famous Munich exhibition of Islamic art in 1910, reflects the technical, stylistic, and coloristic traits of the Mamluk group. They were woven in square, rectangular, and round configurations, and the main designs are geometrical, inspired by parallel concepts of Mamluk art. The five-unit field in the Simonetti Carpet is less common than the simpler one or three units. Mamluk carpets are distinguished by the limited but rich combination of red, light blue, and green, and sometimes the rarer khaki brown and yellowish beige. They were generally woven in wool, although one outstanding example in the Vienna Museum of Applied Arts is in silk.

There is a great interplay of designs on the Simonetti Carpet, with the usual Mamluk combination of eight-pointed star or eight-lobed rosette radiating into an octagon and then into a square. Each development is emphasized by the constantly changing outlines of the concentric octagons in the square. A lively mixture of forms covers every surface with stars, leaf forms, papyrus plants, lancet leaves, palmettes, chalicelike motifs, cypress trees, vines, tear drops, arabesques, and bead-and-reel motifs. A typical Mamluk border of cartouches and rosettes encloses the field.

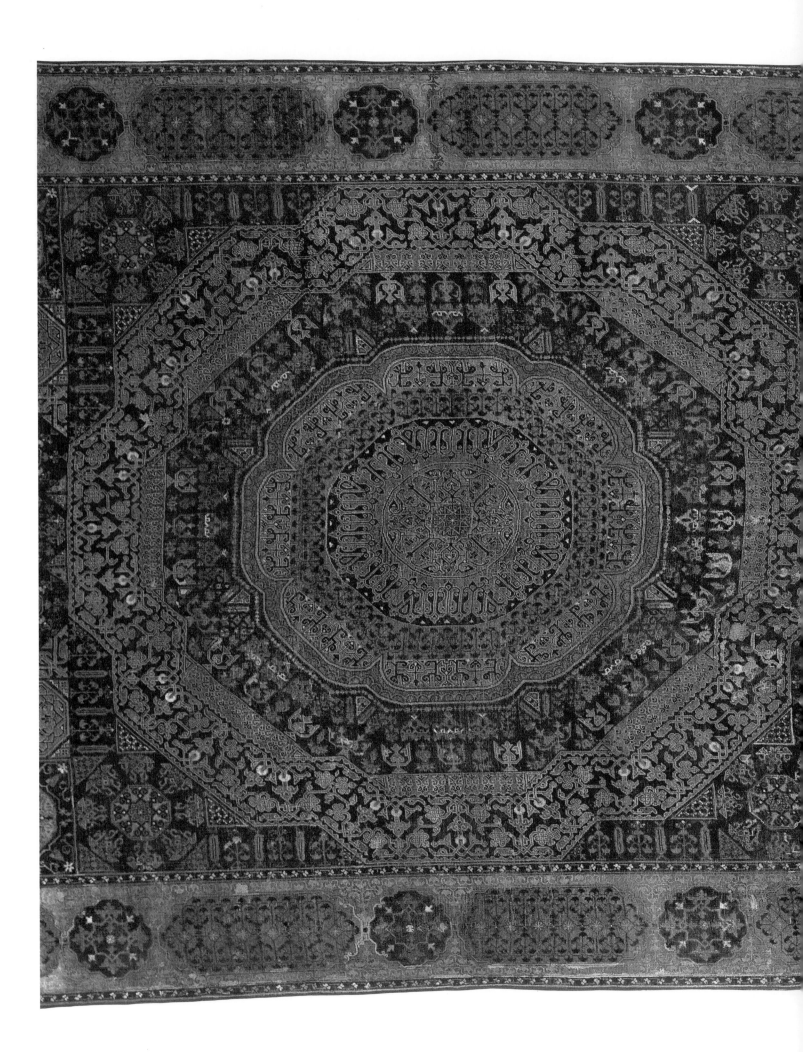

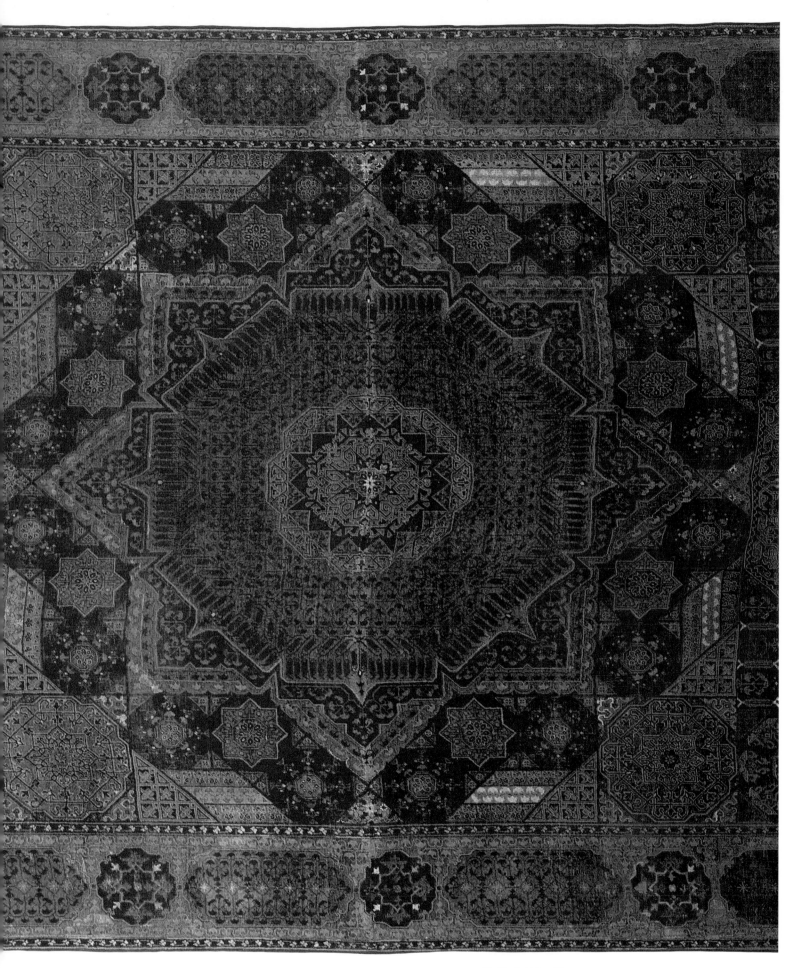

45 Carpet (detail)
Egypt (Cairo); Mamluk period, end 15th or beginning 16th c.
Wool, Senneh knot, ca. 100 per sq. in.; 29 ft. 7 in. x 7 ft. 11½ in.
(9.02 x 2.43 m.) Fletcher Fund, 1970 (1970.105)

Page 61: text

46 Deep Dish (brasero)
Spain; ca. 1430
Earthenware, glazed, stain and luster painted;
D. 17¾ in. (45.1 cm.)
The Cloisters Collection, 1956 (56.171.162)

Deep Dish

The luster-painted ware of Nasrid Spain ultimately owes its existence to the objects produced in that technique in ninth-century Baghdad. Moving westward from Baghdad, first to what is now Tunisia and then to Algeria, the technique appeared subsequently in late eleventh-century Spain, where it gave rise to an important center in Malaga. Production in this city led directly to the so-called Hispano-Moresque luster-painted wares.

This deep dish, or *brasero*, bears witness to the long Islamic tradition behind its production. Its major motifs—the cobalt-blue palmette tree, the pseudo-Kufic designs in the cartouches surrounding the central roundel, and the tightly coiled spirals on the wide flat rim—are all drawn from the Islamic repertoire.

Textile

Under the Nasrids, the last ruling Islamic dynasty in Spain, weavers created a great variety of textile patterns based on a vertical succession of bands bearing geometric and vegetal motifs as well as inscribed designs in Kufic and Naskh scripts. The interplay of line and color, and the forceful combination of gold and red in harmony with black, yellow, white, green, and blue, enrich and enliven a somewhat formal scheme. The patterns recall the tile and painted stucco decorations on the walls of the Alhambra in Granada, the seat of the Nasrid government.

47 Textile
Spain; Nasrid period, 14th–15th c.
Silk, compound weave;
40⅜ x 14¾ in. (102.6 x 37.5 cm.)
Fletcher Fund, 1929 (29.22)

66

PARADE HELMET

This helmet is traditionally said to have been that of Abu 'Abd Allah Muhammad (r. 1482–83, 1487–92), the last Nasrid king of Granada. The Nasrids ruled over the last Muslim kingdom of Spain and are remembered chiefly for their having built the Alhambra. Two other helmets, also European in form but with Islamic decoration, are preserved in the Royal Armory in Madrid. Together, these constitute the only surviving examples of armor from the Nasrid period. The Museum's helmet is of gilt steel elaborately decorated with tooled designs and stylized inscriptions. It is set with cloisonné enamels. This kind of decoration has close parallels with sword fittings and jewelry of the late Nasrid period.

48 Parade Helmet
Spain; Nasrid period, late 15th c.
Steel overlaid with gold and silver and set
with cloisonné enamels; H. 7⅞ in. (20 cm.),
W. 8⅛ in. (20.7 cm.), L. 10½ in. (26.7 cm.)
Purchase, The Vincent Astor Foundation
Gift, 1983 (1983.413)

49 Sword and Scabbard
Spain (Nasrid); late 15th c.
Steel, copper gilt, enamel, scabbard
embroidered with silver; sword: 37½ in.
(95.3 cm.) scabbard: 30¼ in. (76.8 cm.)
Roger's Fund, 1904 (04.3.459ab)

SWORD AND SCABBARD

The ceremonial nature of this sword is evident in the luxurious nature of its fittings and in the use of dragon heads at the tips of its quillons. "Dragon swords" were popular throughout the Islamic world from at least the fourteenth century. Ceiling paintings in the Sala de Justicia of the Alhambra in Granada depict elaborate weapons of this type held by a number of Nasrid princes. Very likely, the one reproduced here was once owned by such a nobleman.

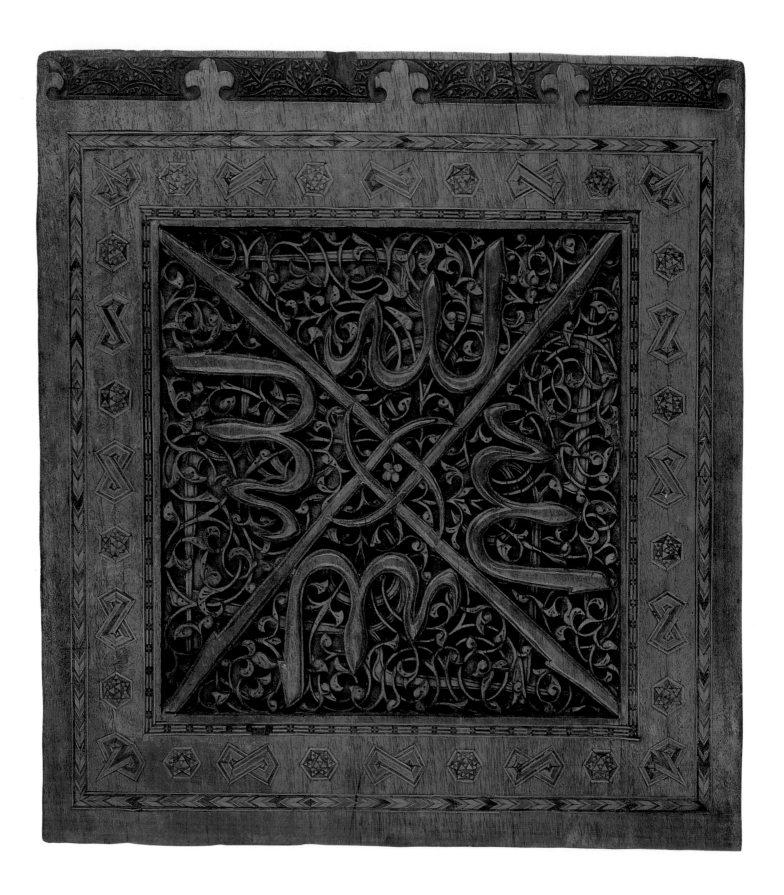

KORAN STAND

This beautiful object tells the viewer a great deal about its own history. It bears an inscription that identifies its patron, who had it made for a *madrasa* (theological college) that he had endowed. The master carver was one Hasan ibn Sulayman from Isfahan, who finished it in the year 1360. A superb fourfold *Allah* in slim, elegant Thuluth covers the upper part of the stand; on the lower part, above a poetically shaped cypress tree, are inscribed the blessings upon the Prophet and the twelve imams. Small quadrangles contain in square Kufi short sentences about God's power and rule.

As the reference to the imams shows, the patron was a Shiite, and his school may have been founded for the propagation of the Shia persuasion of Islam, which, 140 years later, was made the official religion by the Safavid ruler, Shah Isma'il.

50 Koran Stand
West Turkestan; 1360
Wood;
51¼ x 16⅛ in. (130.2 x 41 cm.)
Rogers Fund, 1910 (10.218)

Opposite: detail

For Koran on stand, see Plate 37

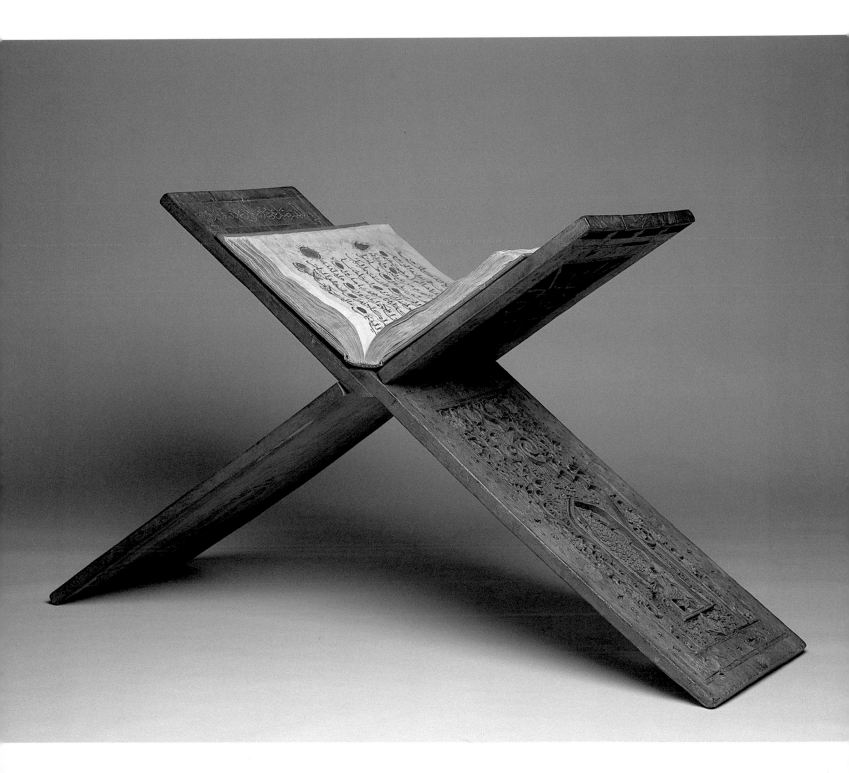

51 *"Pair of Eagles": Leaf from the* Manafi-ye Hayavan
(The Usefulness of Animals) *of Ibn Bakhtishu'*
Iran; beginning 14th c.
Colors, gold on paper; 5¾ x 6³⁄₁₆ in. (14.6 x 15.7 cm.)
Rogers Fund, 1918 (18.26.2)

52 *"Bahram Gur Entertained by the Daughters*
of Barzin": Leaf from a Shah-nameh
Iran; Mongol school, early 14th c.
Ink, colors, gold, silver on paper;
2⅜ x 4¾ in. (6 x 12.1 cm.)
Rogers Fund, 1969 (69.74.6)

70

PAIR OF EAGLES

The Book of the Usefulness of Animals, a tenth-century Arabic treatise written in Baghdad, is the animal equivalent of Dioscorides' *Herbal*. The birds, animals, serpents, fish, and insects are described; their habitat given; their properties, habits, peculiarities noted; and their various uses for mankind catalogued. The treatise was translated into Persian, and an early illustrated Persian manuscript, dated to the late thirteenth century and made in Maragheh in northwestern Iran, survives and is in the collection of the Pierpont Morgan Library. A second dispersed manuscript, to which our leaf belongs, also survives and on stylistic grounds can be placed close to the Morgan manuscript in date and location.

This is one of the earliest manuscripts to show the influence of Far Eastern art. The Mongols had conquered Baghdad and put an end to the Abbasid caliphate in 1258. They settled down as dynastic rulers in Iran but retained ties with their Mongol brethren, the Yuan rulers of China. For the first time, therefore, we see in Persian painting flowers such as lotuses and peonies from the Chinese pictorial repertoire, a softening of the palette to reflect Chinese washes, and the attempt at a calligraphic approach to drawing. And yet, the picture remains rooted in the Islamic painting tradition. There is a two-dimensionality reinforced by the use of the page itself as the background. The standing eagle, the little hills, and the foliage all rest on a ground line at the bottom of the picture, while a conceptual vision of the sky stretches like an inverted canopy across the top of the painting. Most of all, for all their lively and almost intense interaction, the pair of eagles are highly decorative birds, forming a central part of a composition basically designed to please the eye rather than instruct the mind.

BAHRAM GUR ENTERTAINED BY THE DAUGHTERS OF BARZIN

The *Shah-nameh*, the Persian national epic, written by the poet Firdausi in the late tenth to early eleventh century, recounts the history of Iran from the dawn of civilization to the extinction of the Sasanian dynasty at the hands of the Arab invaders. History blends with myths and legends.

In this epic, Bahram Gur, the Sasanian ruler Bahram V (r. A.D. 420–438), is the ideal king; a great hunter, a great lover, a lavish host, and a fearless warrior. In the episode illustrated here, Bahram's favorite black falcon, a gift from the emperor of China, has flown away while out hunting and has been tracked by the shah to the estate of a local landlord, Barzin. There he finds his lost falcon and is entertained in the garden by Barzin and his three daughters, as depicted in the miniature. The shah is so delighted with the daughters and their talent for playing the harp, singing, and dancing that he asks for their hands in marriage.

This enchanting miniature exhibits an indigenous pictorial spirit that has inhaled a light breath from the Far East. There is a grassy ground line studded with flower heads along the base of the picture. It also encircles the garden pool, which in turn is drawn from a bird's-eye view for conceptual clarity. The trees, with their twisting branches and patterns of individual leaves, look more like compositional fillers than integral landscape elements. In a less developed pictorial phase, the figures would all be placed along the ground line, but here there is an attempt to place them in space even if the sky and ground planes are not differentiated. The maiden on the far side of the pool seems to dance precariously at its rim. The dense floral patterning of the costume with the inclusion of peony blossoms and the soft pastel palette are the result of influences from China.

بهمن بزد سنگ بر او ولستان
من آن برکزیده نام باد آورد
بشيد رو یک روی آهنی بفر
شتربک تابوت کرد نه تخت
همه خسته روی وهمه کنده موی
همان آموزخود وخفتان او
تهمتن بشد سوی ایوان خویش
حروشی برآمد زایوان بزار
سوی کشتاسب کای ای اکد

بهمن بزد سنگ بر او کلستان
که کی چون او شود تاجدار
ای بدکنه پند ازروزگار
ردبای ارفت کرد نش کفن
جلی اشتر سیاوزو رستم کين
بریدش شاه ویک اسب سیاه
بزدند درزفت درند کشاه
نگون شد سر وتاج کشتاسباه

پیش اور دزکین اسفندیار
کی حشرلا زا ببند بخار
خوشتان روی نامدار انجمن
زبان افروخته زدسای جم
نشون همی برد بشن شاه
بماند نهان بدلان بجایکا
نگون شد سر وتاج کشتاسباه

بیابد رستم زنگ کای کان
بکشته دونسی ردبای چین
زپیروزی بشریاد افسرا
جب ورداست وخشری فنرا
درس اندر آبنجه کریین
بهرکان همی جون دل شاه
بخاک اندر آمد سرو مغفرش
بیداخت هرکی ای کلام مهی

او را در تابوت اسفنديار

بیالود تیغ وفیالوی بکیش
برابل ورشی بکشتن ندهی
جاکه شد بدمادر درزآوراهران
زنان ازبشوتن درزآوبخند
آیا بدیکد سنک خورشتین

جهان راهمی داشت زوابهترین
بوزکاه تاج معوی زنهی
برهنه سرویای وبرزدکده بخاک
کهن ازتنک تابوت ابرکشان
سرنک تابوت زراماز کرد

بزرکان ایران زرفته خشم
برتن زاز اختربی زنم باد
بتن برهمه جامه کرده خاک
تن کشته اردودما زمای
بنوی یکی موه آغاز کرد

زارم کشنای نبست جشم
برنی طلااختری رنم باد
خروشان روی شیاد خاله
رفتند بکشتن ایول نا اوی
شتون همی زفت کدان شاه
شنون نعوت شد میان زنان
جوخواه رش یام ادرزش روی

جانسفندیاری توازبهرتن
برانخاک شیکاج وندلان اوی
ببیشت تابوت واسب سیاه
خروشان ومکوت ازرد زبار
بد بند بریشک روشین

53 *"The Funeral of Isfandiyar": Leaf from a* Shah-nameh
Iran (Tabriz); ca. 1330–35
Colors, gold on paper; 8⅝ x 11⅜ in. (22 x 28.9 cm.)
Purchase, Joseph Pulitzer Bequest, 1933 (33.70)
Below: detail

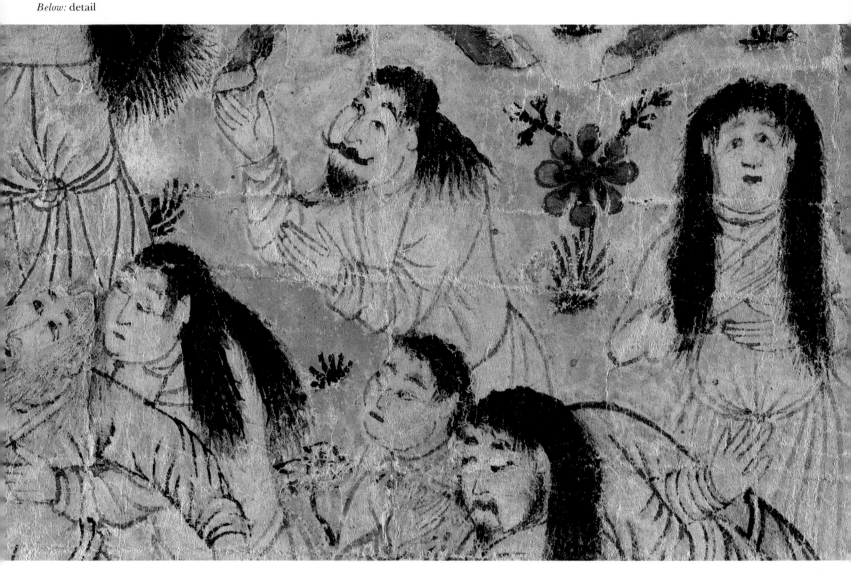

THE FUNERAL OF ISFANDIYAR

The *Shah-nameh* ranks among the most frequently illustrated works of literature in Persian culture, particularly in the fourteenth and fifteenth centuries. In the miniatures that survive in this particular manuscript, there is a discernible preoccupation with death. The deaths seem to be the result of fate, but at a deeper level, they are linked to the ambitions, betrayals, intrigues, sacrifices, and loyalties that are inexorably bound to the role of rulers. The transitory quality of life and inevitability of death are also threads that link the illustrations with what appear to be the preoccupations of a particular patron, possibly Ghiyath ad-Din, the son of the vizier of the Il-Khanids, Rashid ad-Din, who was executed in 1318. Having managed to put his own royal candidate on the throne, Ghiyath himself became vizier in 1328, and was in turn executed in 1336.

The miniature in Plate 53 illustrates the funeral of Isfandiyar, one of the great prince-heroes of the epic, slain by the hand of Rustam, the greatest warrior-hero in the poem, in a duel that neither, by a combination of circumstances, character, and fate, could avoid. The artist has vividly depicted a Mongol royal funeral: The coffin, carried by mules, is topped by the costume and accoutrements of the deceased, preceded by his mount, with the saddle reversed. The mourners, with unadorned garments and uncovered heads, are tearing their hair and robes as they lament. A close look at the individual faces reveals the multiplicity of ethnic types that made up the population in this period of northwest Iran, the center of Il-Khanid culture and power. The prominence of calligraphic lines in the drawing and the wash colors reveal the impact of Chinese artistic influences, as does the shape of the clouds beneath the arc of the sky. The three geese are derived from the Buddhist tradition with which the Mongols had frequent contact; they were thought to transport the soul to heaven.

BOWL

Chinese influence during the Late Medieval period was not confined to iconography. Chinese celadon-glazed wares were highly valued and imitated in Iran and in Egypt, although their color was only rarely duplicated successfully.

The decoration on the interior of this bowl—three fish encircling its base—closely parallels that on the Chinese prototypes. The hemispherical shape of the bowl, its low narrow foot, and the radiating petal patterns in relief on the outside reflect the shape and exterior decoration of the celadon-glazed petal-backed bowls from the Lung-ch'uan kilns. The shape was found among bowls of various decorative techniques during the late thirteenth and early fourteenth centuries, especially in Iran.

TILE

Luster-painted tiles generally appear to decorate mosques and tombs in Iran. Records indicate that this dated tile and others from the same now-dispersed frieze came from the shrine of 'Abd as-Samad in Natanz. It has been attributed as the work of Yusuf, the last recorded luster potter from the prominent Abu Tahir family in Kashan, a city in central Iran.

The Koranic inscription, formed by molded blue relief letters, is in Arabic Naskh script; it is placed on a rich brown luster ground on an opaque white glaze. Birds inhabit the leafy ground and are frequently found on such tiles. It is unusual to have the heads defaced, though, and probably it is the result of an act of iconoclasm.

54 Bowl (two views)
Iran; 1st half 14th c.
Composite body, applied(?) decoration
and glazed; D. 11¼ in. (28.6 cm.)
Gift of Mrs. Horace Havemeyer, in
memory of her husband, 1959 (59.60)

55 Tile
Iran (Kashan);
Il-Khanid period, dated March 1308
Composite body, molded, glazed, luster
painted; 14¼ x 14½ in. (36.2 x 36.8 cm.)
Gift of Emile Rey, 1912 (12.44)

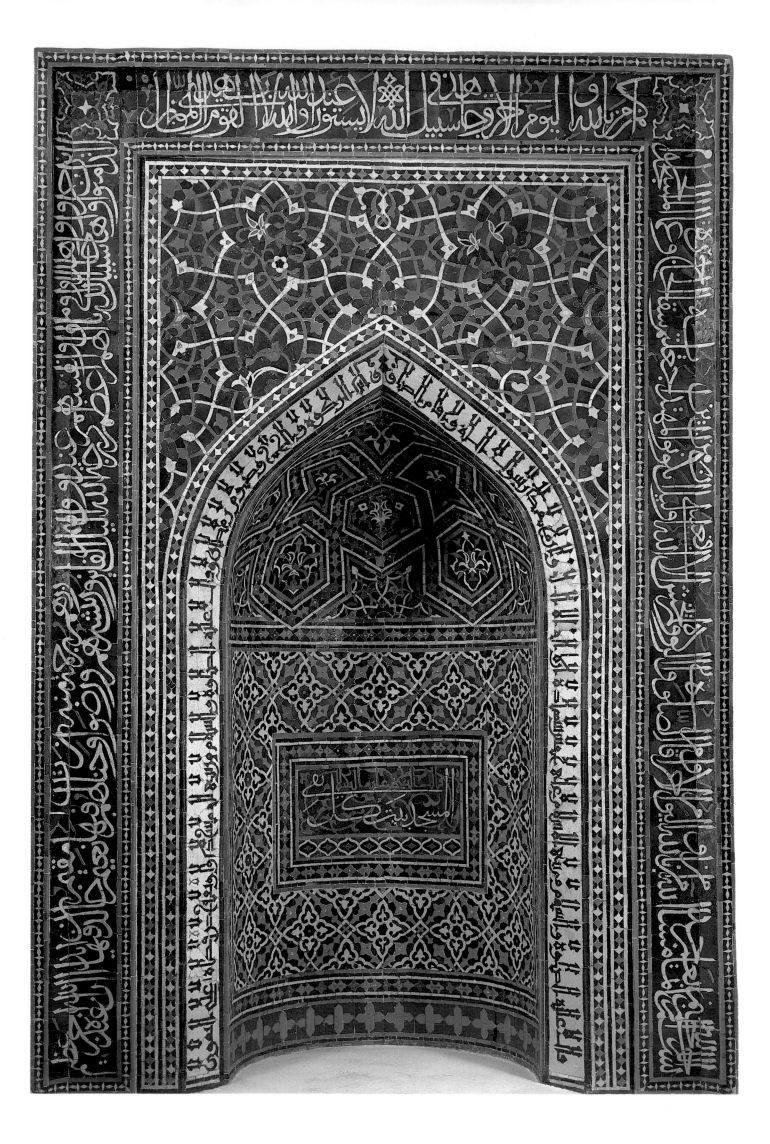

PRAYER NICHE

This prayer niche (*mihrab*) from Kashan is extraordinary not only for its fine tile work but also for its variegated inscriptions. The outer panel contains in bold Thuluth characters a Koranic saying (Sura 9, verses 18–22) that speaks of the duties of the faithful and the heavenly recompense of those who build mosques. The actual niche is surrounded by a hadith in a Kufic-like style in which the five Pillars of Islam are enumerated: profession of the faith, ritual prayer, alms tax, pilgrimage to Mecca, and fasting during the month of Ramadan. Another hadith in the center of the niche states that "the mosque is the house of every pious person." The introductory formula and the four texts are each done in a different style of calligraphy.

56 Prayer Niche
Iran; ca. 1354
Composite body, glazed; 11 ft. 3 in. x 7 ft. 6 in.
(3.93 x 2.89 m.)
Harris Brisbane Dick Fund, 1939 (39.20)

TOMBSTONE

This tombstone in the shape of a prayer niche is dated "4. Muharram 753" (February 22, 1352). It was made for a spiritual guide, Mahmud ibn Dada Muhammad al-Yazdi, who is described with high-flown titles, such as "mightiest shaykh," "connected with the Lord," and "perfect spiritual guide of eternal rank."

The epigraphy on this tombstone of whitish limestone is impressive: the outer border contains Sura 112, the profession of God's Absolute Unity, in an elegant, slightly foliated Kufi on an arabesque ground; the second panel gives the name, qualities, and date of death of the master in good, very rounded Thuluth; and the inner border contains Sura 3, verse 18 and part of verse 19 in square Kufi. The square in the upper part above the niche has the profession of faith in its Sunni form in quadrangular Kufi, and the inscription inside the niche quotes, in the same style, Sura 40, verse 16: "And to whom belongs the kingdom today? To God the One, the Overpowering." Thus, the central sentences of the Muslim faith are inscribed in this stone, reminding the visitors of the truth that everything on earth must perish, and only God's reign endures throughout eternity.

The stone bears a small signature of the master, which, however, cannot be read due to some lacunae in the text.

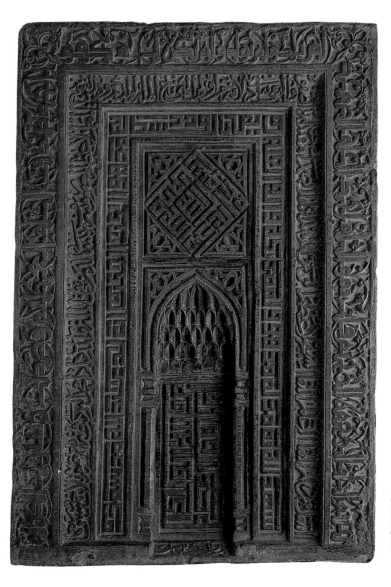

57 Tombstone
Iran; A.H. 753/A.D. 1352
Limestone; 32¾ x 21¾ in.
(83.2 x 55.2 cm.)
Rogers Fund, 1935 (35.120)

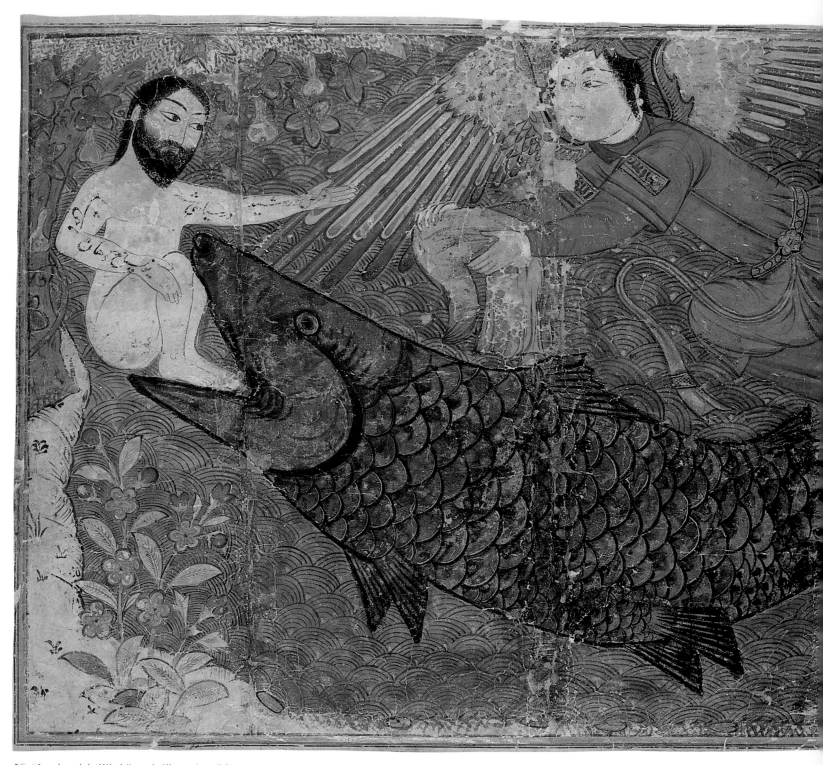

58 "Jonah and the Whale": prob. Illustration of the
Jami 'al Tavarikh (Universal History) *of Rashid ad-Din*
Iran (prob. Tabriz); ca. 1400
Colors, gold on paper; 12⁹⁄₁₆ x 18¹⁵⁄₁₆ in. (21.9 x 48.1 cm.)
Purchase, Joseph Pulitzer Bequest, 1933 (33.113)

JONAH AND THE WHALE

Together with the Medieval Islamic tradition of grandly proportioned illustrated histories, there was a parallel tradition of monumental paintings on cloth or paper that were held aloft while the story or poem was recited to a spellbound audience. Since there is no text accompanying this painting, it probably belonged to the latter category. While the story of Jonah and the whale, referred to in the Koran, was popular in the Islamic world, this picture was probably based on illustrations of Rashid ad-Din's famous history, which, following the pattern of Islamic historiography, began with Adam and finished with the author's own contemporary world. Rashid ad-Din was a vizier of the Il-Khanids in the early fourteenth century and a great scholar and patron of the arts as well.

In this painting, the whale, actually in the form of a carp, is in the act of disgorging Jonah onto the shore under a gourd vine. This scene can also be found in Western Medieval illustrated manuscripts. The sea with its neatly overlapping arcs of waves is, like the carp, derived from Chinese prototypes, but there is nothing Far Eastern about the spirit of the painting. The curving body of the fish fills the center of the composition, while the massive angel above it runs through the air with spread wings, seeming to emphasize God's power and dominance over the world. Jonah, submissively reaching for his clothes, reveals his awareness that his fate is dependent on the beneficence of the Lord. The core of Islam, submission to the will of God, is dramatically brought forth in this appealing picture. The artist has employed the bright palette, strong outlines, and decorative details basic to Persian painting.

OVERLEAF:

FRONTISPIECE OF QAZWINI'S COSMOGRAPHY
(Pages 80–81)

Qazwini, who died in 1283, was the first author to compose a cosmography in Arabic, and his work was copied time and again in the Islamic world. This frontispiece to his work, *'Aja'ib al-makhluqat*, contains the name of the author and the title of the work in two roundels surrounded by some of the mythical creatures with whom the work deals. A Persian verse in powerful Thuluth script also indicates the subject matter of the book: the first things created were Intellect and Soul, then the sphere, the four elements, and finally the mineral, vegetable, and animal kingdoms.

The quality of writing and the fine arabesque decoration suggest that the manuscript must have been copied for a high-ranking patron. Most probably, the page belongs to a Qazwini manuscript dated 1421, which was produced in Shiraz during the reign of Prince Ibrahim Mirza (d.1433), the artistically minded grandson of Tamerlane, who himself was an excellent calligrapher.

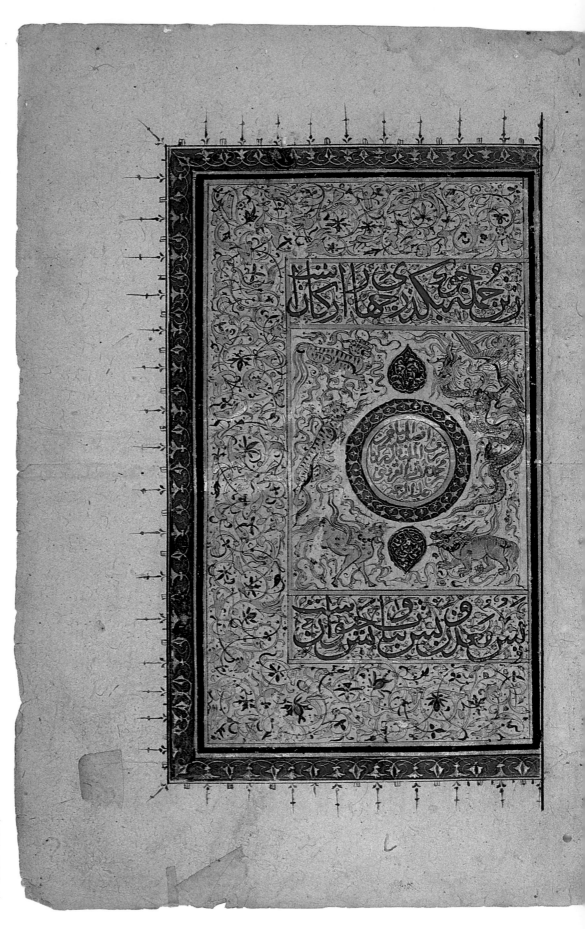

59 Frontispiece of Qazwini's
'Aja'ib al-makhluqat (Cosmography)
Iran; 1414–35
Ink, colors, gold on paper; overall,
9⅛ x 12⅛ in. (23.2 x 30.5 cm.)
Fletcher Fund, 1934 (34.109)

Page 79: text

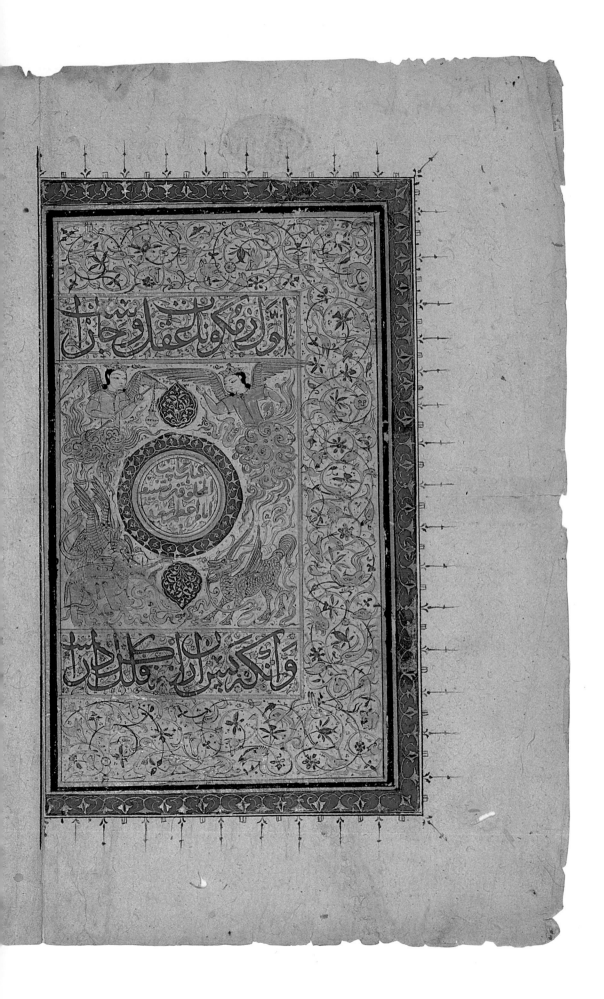

THE EAVESDROPPER

The subject matter of this idyllic scene may resemble a fairy tale, but the scene reflects the sort of garden pavilion setting actually enjoyed by the Timurid princes in their capital of Herat in Khorasan (the eastern Iranian province partly in present-day Afghanistan). The gardens often had a variety of trees bordering their walls; part of the garden was kept wild and filled with a variety of fruit trees, shrubs, flowers, and whenever possible, running water. The Timurids then constructed pavilions within these serene spaces and used them for both leisure and official pursuits.

The tale illustrated here recounts the strange adventures of a youth who found himself locked out of a surpassingly beautiful garden he owned. From within, he could hear music, singing, dancing, and laughter. After he had suc-
ceeded in breaking in and had proved that he was indeed the owner, the beautiful nymphs he found there led him to an attic from which he was permitted to gaze upon them as they frolicked in the pool, danced, and sang. In the end, and only after a number of mysterious mishaps, he was permitted to marry one of the nymphs and live happily ever after in the garden. In the Museum's miniature, the youth can just be seen peeping from an upper window.

This story was told to Bahram Gur by one of the seven princesses from the seven climes of the world with whom he had fallen in love after looking at their portraits and had later married. He visited each one on a different day of the week. The story illustrated here was told by the Persian princess in the White Pavilion on Friday.

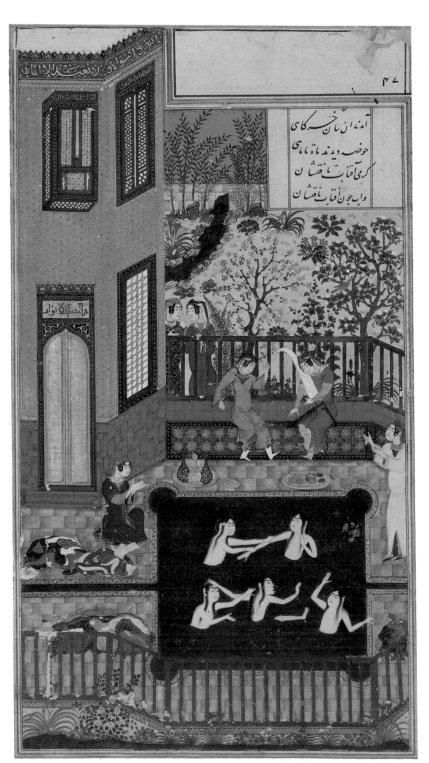

60 "The Eavesdropper": Leaf from the Haft Paykar
(Seven Portraits) *of the* Khamseh (Quintet) *of Nizami*
Iran (Herat); ca. 1426
Colors, gold on paper; 9 x 5 in. (22.9 x 12.5 cm.)
Gift of Alexander Smith Cochran, 1913 (13.228.13 f.47a)

61 Bowl
Iran; 2nd half 15th c.
Composite body, underglaze painted and
incised; D. 12⅜ in. (31.4 cm.)
Mr. and Mrs. Isaac D. Fletcher Collection,
Bequest of Isaac D. Fletcher, 1917 (17.120.70)

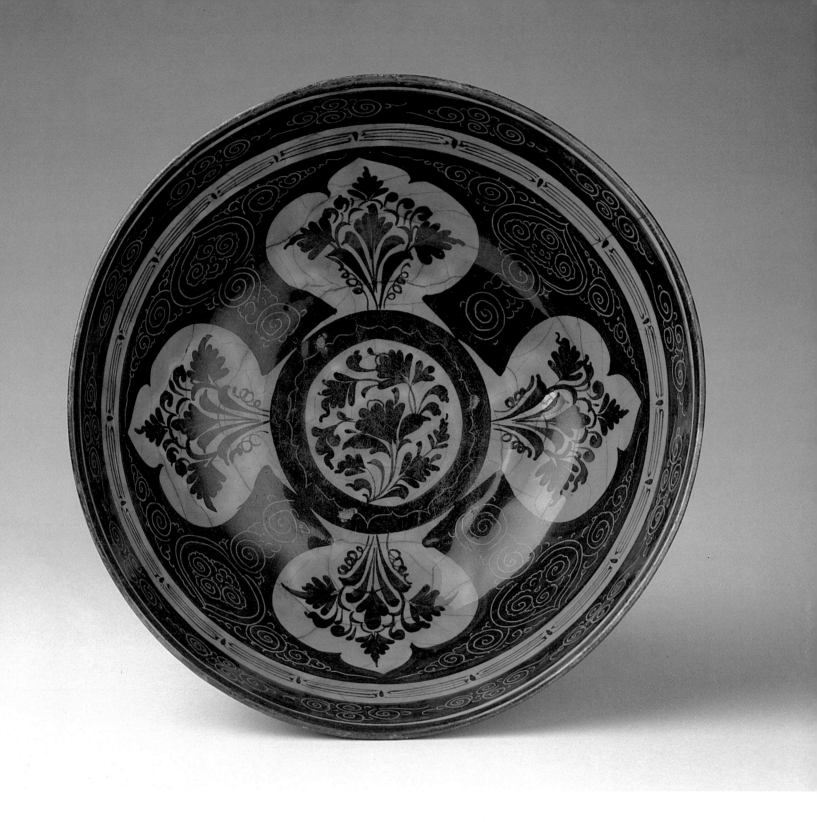

BOWL

This hemispherical bowl belongs to a series of wares made from the second half of the fifteenth through the seventeenth century and now known as Kubatchi, from the name of the town in the Caucasus where many of these pieces were found in the nineteenth century. This bowl is one of a rare early group in the series characterized by a design of ogee panels encircling a central roundel—all of which bear vegetal motifs—reserved on a black ground distinguished by incised, predominantly spiral designs. A brilliant turquoise glaze covers the entire bowl. The four known dated pieces of this group range from 1469 to 1495. They constitute the only three-dimensional ceramic objects that can be securely placed in fifteenth-century Iran.

LOVERS AND ATTENDANTS IN A LANDSCAPE

Under the Mongol and Turkman dynasties, Tabriz was a major crossroads of trade for merchants from China, Central Asia, Europe, and India. Because of this, Chinese bronzes and textiles, European prints, a Hellenistic bronze mirror, Byzantine and Indian textile patterns all provided motifs to Tabriz artists.

In this miniature, the boldly ornamental flowering tree and plant (seen in the lower right) and the dragons and phoenixes embroidered on collars and shoulders were based upon Ming patterns. The Tabriz artist, however, entirely transformed them, surcharging the forms and thus abandoning traditional Chinese harmoniousness. Although under the Aq-Qoyunlu Sultans Uzun Hasan (r. 1457–78) and Ya'qub (r. 1478–90) Tabriz painting is as marvelous as that of Herat under Sultan Husayn Bayqara, it is far more excessive, visionary, and audacious. Whereas the restrained and cerebral Timurid master Bihzad of Herat disposed his penetratingly observed, portraitlike figures logically in space, the freely expressive Turkman artist—probably Shaykhi or Dervish Muhammad—painted far more broadly and floated his lively but unspecific characterizations in a dramatic never-never land.

62 *"Lovers and Attendants in a Landscape"*
Iran (Tabriz); ca. 1480
Opaque watercolor on silk; 8½ x 11⅞ in.
(21.6 x 30.2 cm.)
Cora Timken Burnett Collection of Persian Miniatures and Other Persian Art Objects, Bequest of Cora Timken Burnett, 1956
(57.51.24)

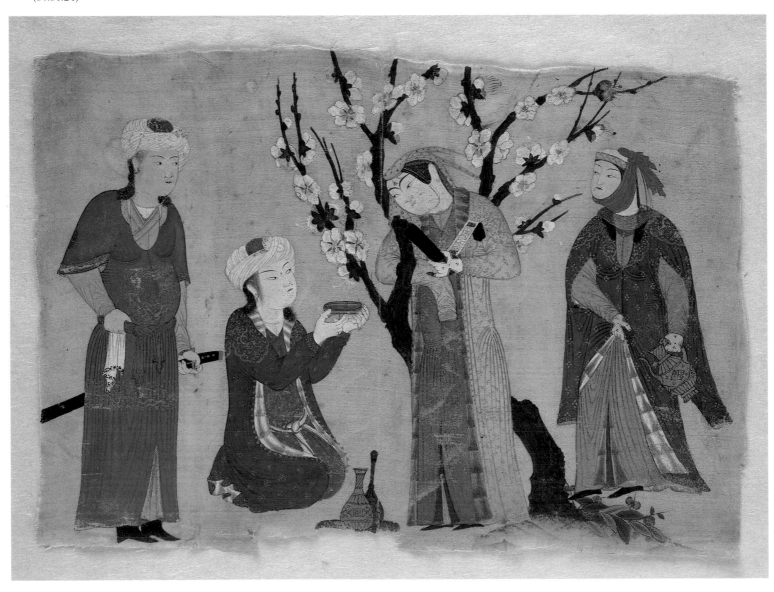

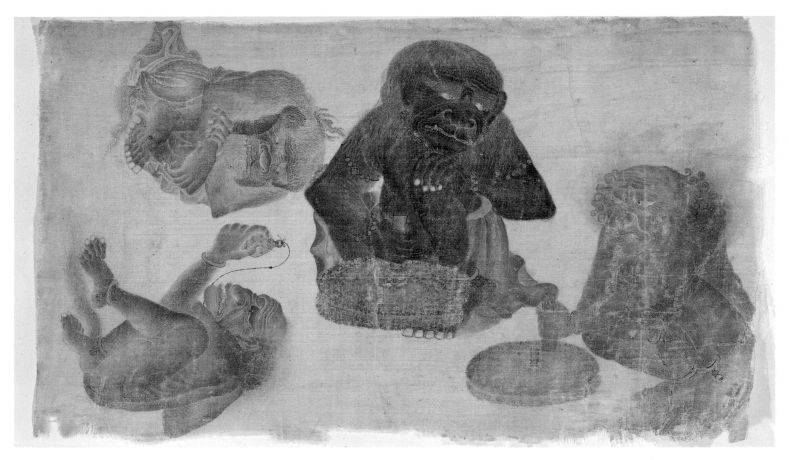

63 *"Four Captive Demons"*
Iran (Tabriz); ca. 1465
Opaque watercolor on silk;
7¹⁵⁄₁₆ x 13⅜ in. (20 x 34 cm.)
Harris Brisbane Dick Fund,
1968 (68.175)

O V E R L E A F :

FOUR CAPTIVE DEMONS

Should one laugh or flee on seeing these apparently captive but gloweringly dangerous jinn (fire-born evil spirits)? Reluctantly attending to daily chores, they might be wild slaves of the elegant lovers seen in the preceding picture, which is traceable to the same tradition and was painted on almost identical silk. Exemplifying the attraction of an orderly elite to the lowly and chaotic, these wrinkled, spooky, and hirsute creatures, capable of shamanistic exorcisms, represent the city's fascinating heterogeneity.

The germinant art of the cosmopolitan Aq-Qoyunlus of Tabriz spread far in time and space. It greatly enriched not only the ornament and figural painting of the Safavid successors at Tabriz—and through them influenced Mughal art—but also provided talent and ideas to the Ottoman Turks and to the Indian sultanate of Golconda, a cadet branch of the Turkman house in the Deccan. Golconda, in turn, sparked continuations of the Turkman style in Rajasthan well into the nineteenth century.

SHIRT OF PLATE AND MAIL AND HELMET *(Pages 86–87)*

Armor and helmets of this type were popular in Anatolia, Iran, and the Caucasus from the fourteenth to the sixteenth century; surviving examples are inscribed with the names of Ottoman, Aq-Qoyunlu, and Shirvani rulers. A Venetian ambassador to the court of an Aq-Qoyunlu who ruled from 1457 to 1478 wrote that they wore armor made of "iron in little squares and wrought with gold and silver, tacked together with small mail." In addition to the helmet and shirt, a warrior would have been equipped with arm and leg guards and would have been mounted on a horse protected by a bard of mail and plate armor.

It is often difficult to determine where specific pieces were crafted, but these examples are probably Iranian. The helmet is signed by Ustad (master) Husayn and, in addition to a series of generalized royal titles, is also inscribed with part of a verse by the poet Sa'di.

The large helmet was designed to be worn over a turban or with considerable padding, and originally it was fixed with an aventail of mail that covered the warrior's entire neck and face so that only his eyes were visible behind this cloak of iron. Perhaps it is for this reason that warriors thus armed are described as looking like young lions.

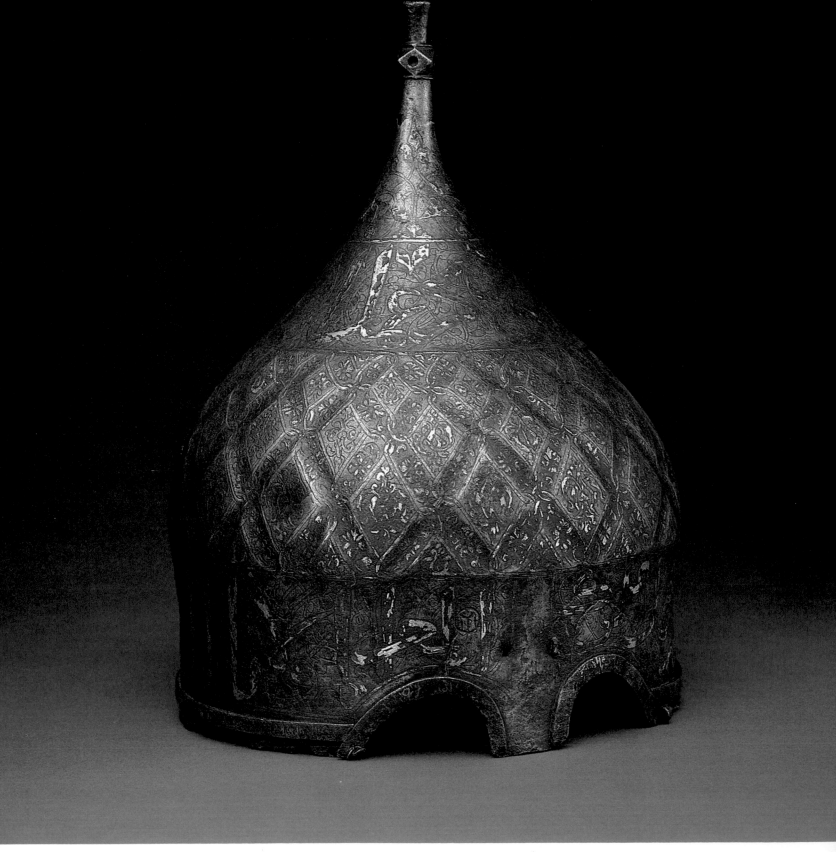

64 *Helmet*
Anatolia or northwest Iran; 2nd half 15th c.
Steel or iron; H. 12¾ in. (32 cm.)
Rogers Fund, 1904 (04.3.215)

Page 85: text

65 *Shirt of Plate and Mail*
Anatolia or northwest Iran; 2nd half 15th c.
Steel, gold, silver; overall H. 31 in.
(78.7 cm.), waist plate: H. 10½ in. (26.7 cm.)
Rogers Fund, 1904 (04.3.456a,b)

Page 85: text

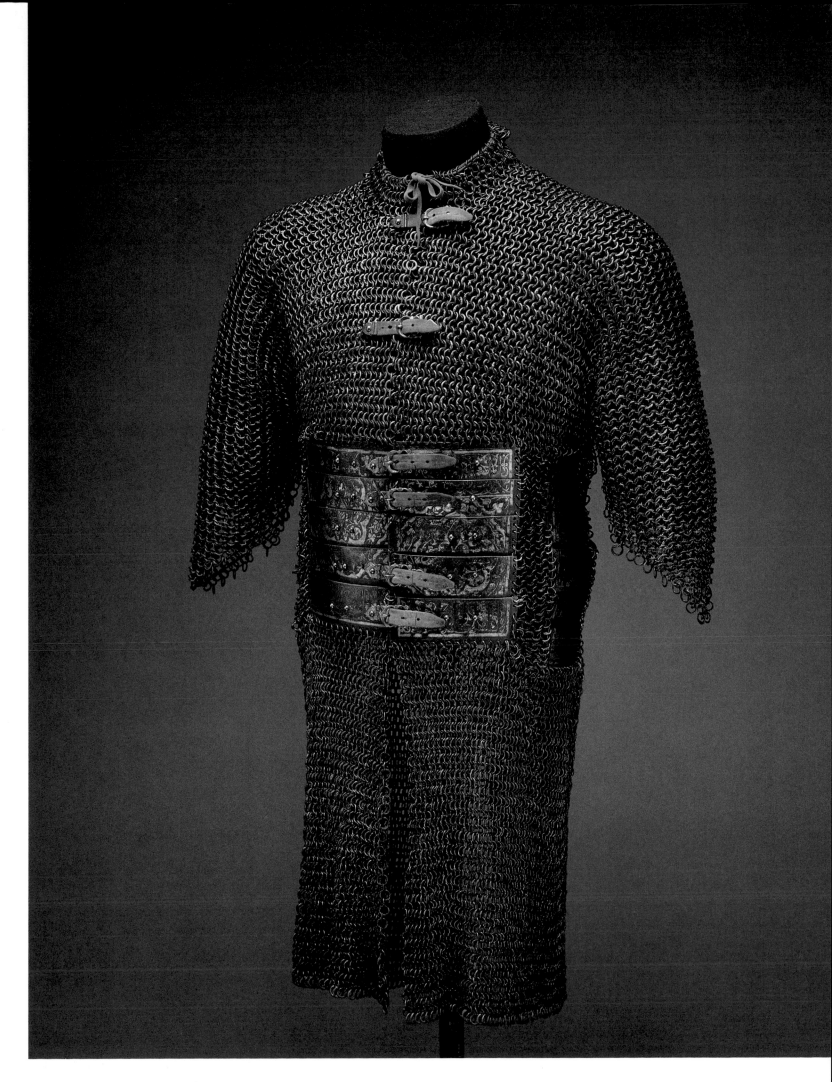

GOLD RING

The cast gold and jade seal ring illustrated here may have developed out of a type of ring current in Early Medieval Iran since they have several important features in common: the technique of casting followed by a significant amount of chasing; shanks that have zoomorphic terminals and are decorated on two levels; and a lozenge adorning the exterior center of the shank. Miniatures of the Late Medieval Period attest to the fact that rings with a large bezel whose lower section is in the form of an inverted cone were in vogue at that time. The great similarity of the dragons, here flanking the bezel, to those on the handles of a series of brass and jade jugs dated or datable to the fifteenth century and the first quarter of the sixteenth, provides further evidence for the dating of the ring to this period. Additionally, the inscription on the sealstone contains a prayer to 'Ali, son-in-law of the prophet Muhummad, that appears on several objects of the later fifteenth century and early sixteenth. The type of sealstone in this ring represents the earliest Islamic group made of jade, and is associated with the fifteenth-century school of jade vessel manufacture perhaps at Herat.

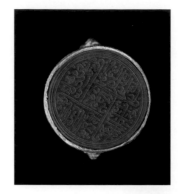

66 Ring (two views)
Iran or Transoxiana; early 16th c.
Gold, cast and chased,
set with nephrite sealstone;
H. 1⅜ in. (3.5 cm.), D. 1 in. (2.5 cm.)
Rogers Fund, 1912 (12.224.6)

67 Quillon Block
Samarkand; Timurid period, ca. 1450
Nephrite;
1¹⁵⁄₁₆ x 4 x 1⅛ in. (5 x 10.2 x 2.9 cm.)
Gift of Heber R. Bishop, 1902 (02.18.765)

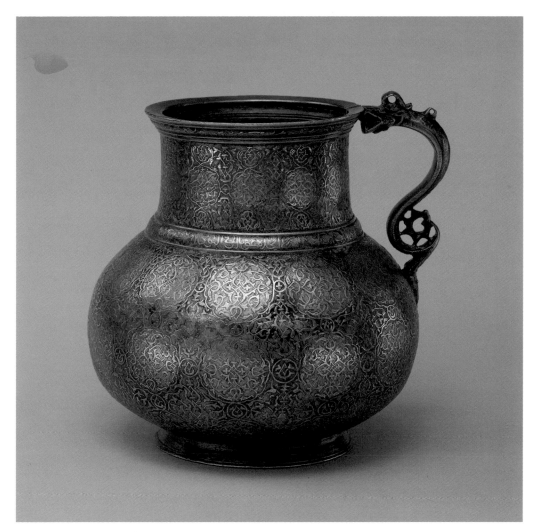

68 Jug
Iran (Khorasan, prob. Herat); Safavid period, early 16th c.
Cast brass, inlaid with silver and gold, black paste;
H. 5½ in. (14 cm.), D. of top 3⅝ in. (9.2 cm.)
Edward C. Moore Collection, Bequest of Edward C. Moore,
1891 (91.1.607)

QUILLON BLOCK

The quillon block is that part of a sword hilt that runs horizontal to the blade, protecting the hand from a cutting blow. This example would originally have been fitted to a faceted grip of nephrite and to a small slightly curved blade. Several sabers of this type are preserved in the Topkapi Saray Museum in Istanbul; and all were probably made at Samarkand in the court workshops of the Timurid ruler Ulugh Beg (r. 1417–49). Jade carving was well developed at his court, and the finely carved dragon heads were no doubt executed by a master craftsman working in the Chinese style. Dragons were a popular motif for Islamic craftsmen at this time and can be interpreted as symbols of royal or even divine power.

Although they are particularly apt when used on a sword hilt, they were also carved on a variety of other objects. One can be found on a tankard made for Ulugh Beg, now in the Gulbenkian Collection in Lisbon.

JUG

Pot-bellied drinking jugs with this easily recognizable shape were a feature of the Herat school under Timurid rule in the second half of the fifteenth century, and also under the succeeding early Safavid period. The features of these jugs are the globular belly resting on a ringfoot, and the cylindrical neck separated from the body by a torus molding, and accented by the molded top. Many jugs still retain their distinctive dragon-shaped handle as well as a small rounded cover. In this example, fine inlays of floral and vegetal scrolls and rows of lobed medallions decorate the surface. A blackish substance highlights the finely hatched ground. An Arabic inscription in cursive Naskh contains an invocation to 'Ali.

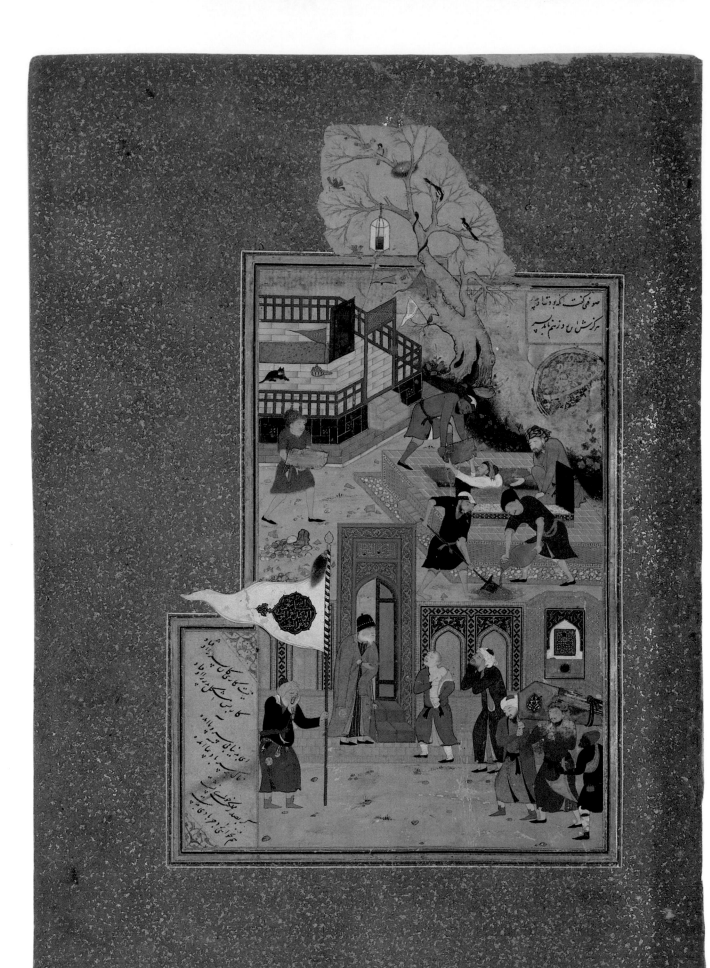

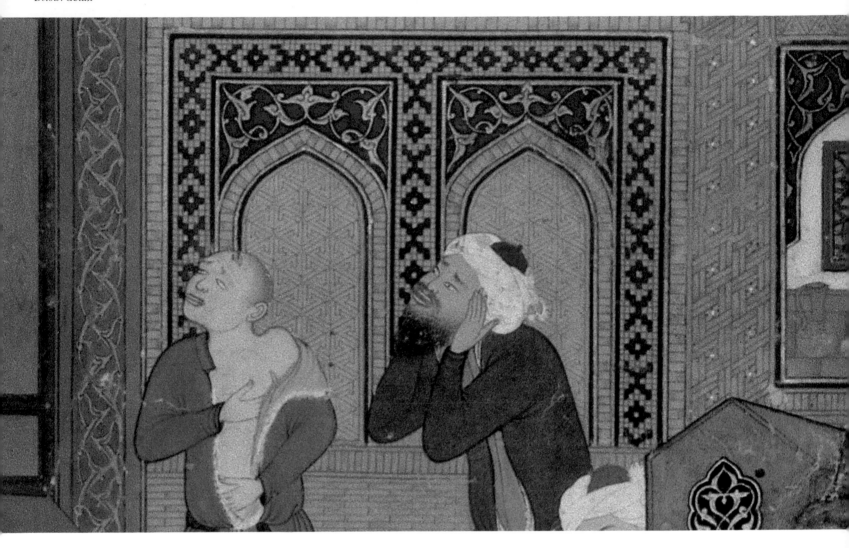

A FUNERAL PROCESSION

Whereas painting under Prince Baysonghur had been much concerned with court ceremonial and royal ways, under the last Timurid to rule in Iran, Husayn Mirza Bayqara, and the school of the great painter Bihzad an interest in the natural world and everyday life was added to the artistic repertory without in any way diminishing the perfection demanded of this miniature world.

Like many other mystic poets, 'Attar (d. ca. 1220) wrote primarily about the yearning of the mystic to become one with God, but he added a wealth of anecdotal material to elucidate and illuminate the meaning of the mystic experience. Here he writes of a son grieving at the coffin of his father. A sage tells the son that his father had suffered the same experience at his own father's death. When it comes to death, said the sage, the glories of this world are as meaningful as holding the wind in one's hand. In illustration of this touching passage, the artist has depicted just the sort of burial ground in widespread use in his native Khorasan dur-

ing the fifteenth century and has given a detailed rendition of a funeral in progress and the preparation of the grave site. There are some extraordinary tombs in the Islamic world, such as the Gur-i Amir, tomb of Timur in Samarkand, or the Taj Mahal in Agra, usually consisting of a domed edifice. But in much of Khorasan a simpler practice prevailed. Tombs were simple structures on a platform, left deliberately open to the sky, but generally within a walled enclosure, and frequently surrounding or in close proximity to the shrine of a saint.

In drawing, coloring, and composition, the rendering of figures, architecture, and landscape setting, this painting is a superb example of the school of Bihzad and was probably painted by the great master himself. As can be seen, the painting has been carefully remounted on a colored gold-sprinkled leaf. This was done around 1600, when the manuscript was refurbished as a gift to the family shrine at Ardabil by the Safavid ruler Shah 'Abbas the Great.

The *Divan* of Sultan Husayn Bayqara

This unusually appealing manuscript in Chaghatay Turkish was copied at Herat for its royal author, Sultan Husayn Bayqara, the last great Timurid ruler, a notable poet, statesman, and patron of the arts and literature. The superb Nasta'liq script is the work of Sultan Husayn's most gifted

calligrapher, Sultan-'Ali of Mashhad, who completed it in 1500, six years before Herat and its ruler fell to Shah Isma'il, founder of the Safavid dynasty.

The joyous borders are masterpieces of ornamental painting. If not attributable to the great painter Bihzad, they are

nonetheless unique in their lyrical washes of color and vigorously lyrical design. Among the more stunningly inventive are several pairs of zoomorphic fantasies. Boldly rhythmic, with surprising animal, bird, and dragon masks, they bring to mind the incident often described in Muslim literature related to Alexander the Great: Supposedly, during the course of his apocryphal Eastern adventures, Alexander came upon the oracular talking tree, the *waqwaq*, from the foliage of which sprouted masks similar to those seen here, warning him against trying to conquer India.

70 Double Page from the Divan *of Sultan Husayn Bayqara*
Iran; 1500
Ink, colors, gold on paper; 10½ x 7¼ in.
(26.7 x 18.4 cm.)
Purchase, Richard S. Perkins and Margaret Mushekian Gifts, 1982 (1982.120.1)

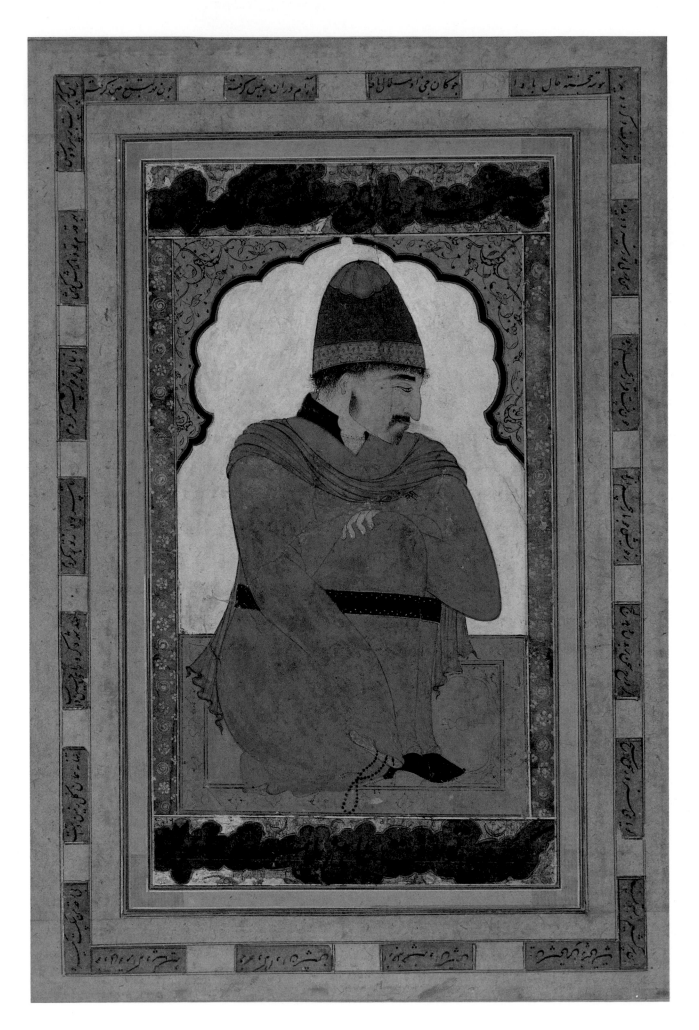

PORTRAIT OF A SUFI

Portraits as telling as this are rare in the Turko-Iranian tradition, which usually avoids piercing completeness. Impelled by the sitter's evident spiritual power—or by the patron's guidance—the artist has focused upon his muscular, compact body and singular profile, tracing every sinuous curve of eye, nose, mouth, and curling hair, and defining him as scholarly, intellectual, and devout. The very existence of the miniature implies that this intense man telling his prayer beads was revered at court, while his pointed cap identifies him as a Sufi. His eminence and dignity bespeak orthodox affiliation; and it is likely that he was a Pir, an elder of a Sufi order, probably of the Naqshbandis, a strictly orthodox Sufi order to which most of the members of the Herat and Central Asian aristocracy belonged.

This remarkable portrait is in the style of the Uzbek school of Bukhara, where Sultan 'Abd ul-'Aziz (r. 1530–40)—a rival to the Safavids in the realm of the arts as well as in politics—employed followers of the wizardly artist Bihzad, whose influence is evident in the polished and exacting view of the world presented here. Color, line, ornament, and pose indicate that this picture is probably by Shaykh-Zadeh, a pupil of Bihzad at Herat who carried the Timurid style to Safavid Tabriz, where he painted and also taught younger artists before joining the ateliers of the Uzbek sultan. Shaykh-Zadeh was greatly talented and original, and his influence was felt in Mughal and Deccani India. As represented here in the only portrait believed to have been painted by him, he was a man of extraordinary personality.

71 "Portrait of a Sufi" prob. by Shaykh-Zadeh
Central Asia (Bukhara); ca. 1535
Colors, gold on paper; 11⅛ x 7⁹⁄₁₆ in. (28.3 x 19.2 cm.)
Cora Timken Burnett Collection of Persian Miniatures and Other Persian Art Objects, Bequest of Cora Timken Burnett, 1956 (57.51.27)

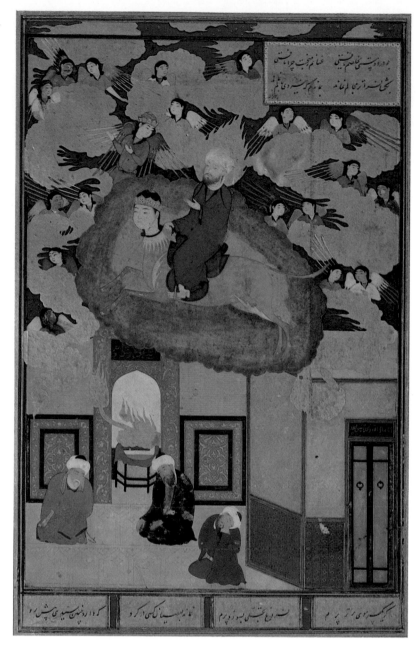

72 "The Night Journey of Muhammad on His Steed Buraq": Leaf from the Bustan *of Sa'di, copied by calligrapher Sultan-Muhammad Nur*
Central Asia (Bukhara); 1514
Ink, colors, gold on paper; 7½ x 5 in. (19 x 12.5 cm.)
Purchase, Louis V. Bell Fund and Astor Foundation Gift, 1974 (1974.294.2)

THE NIGHT JOURNEY OF MUHAMMAD

The Mi'raj or Night Journey of the Prophet on his human-headed steed in an angel-filled sky had become, during the fifteenth century, part of the standard pictorial repertoire and often appeared as an illustration for the first poem of the poet Nizami's *Khamseh (Quintet)*. This version differs from the usual rendition in that the angels in their curling clouds are considerably smaller in scale than the figure of Muhammad who appears to move in his own space, separate from theirs. This phenomenon brings him in closer proximity to the mosque and the figures within it, the second and most unusual part of the composition. The three holy men are in a deep mystic trance, which not only enables them to envision the scene above them but has such spiritual power that the Prophet is actually drawn nearer to them. Adding to the feeling of religious intensity is the holy light, resembling flames, emanating from the Koran on a stand in a rear wall niche.

The Uzbek dynasty with its headquarters in Bukhara was the inheritor of the late fifteenth-century Herat style of painting of the school of Bihzad. Some Herati artists were taken there by force following the overthrow of the Timurids after the death of Husayn Bayqara in 1506, and some came voluntarily after the recapture of Herat and the defeat of the Uzbeks at the hands of the fledgling Safavid ruler Shah Isma'il who made his kingdom a Shiite state, which led to the emigration of a number of the Sunni community. The fineness of drawing, color, and composition are all attributes of the Herat style, while the architectural simplicity of the mosque suggests that this painting is an early product of the Bukhara school.

95

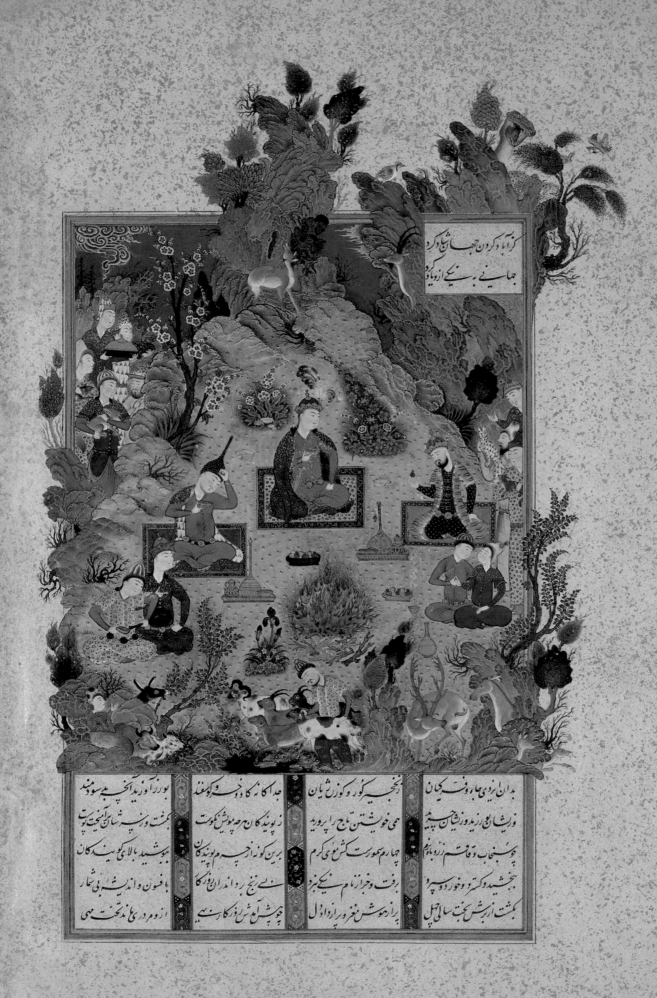

THE FEAST OF SADEH

In the upper corner of this lively miniature a comical bear is hurling a rock at a snow leopard—an allusion to the subject of this illustration in the grandest of all royal copies of the *Shah-nameh*, prepared at Tabriz between about 1520 and 1535. Shah Hushang, one of Iran's legendary rulers, sighted a hideous apparition and hurled a rock at it. The creature vanished and the royal missile struck a boulder. Sparks flashed, so impressing Hushang that he initiated fire worship. That evening, he assembled his courtiers and their animals, discoursed on the potentialities of fire, and—using the newly discovered fire for cookery—celebrated the feast known ever since as Sadeh.

Sultan-Muhammad painted this humorous but visionary picture in about 1522 for the first Safavid ruler, Shah Isma'il (r. 1501–24) and his young son, Prince (later Shah) Tahmasp (r. 1524–76). It exemplifies the artist's variant on the Turkman style of Tabriz, a new mode befitting the spirit and tastes of Shah Isma'il, who was related to the Aq-Qoyunlu royal family and who admired the work of their artists. When Tabriz became his capital in 1501, he took possession of the magnificent Turkman manuscripts and albums, which provided inspiration and motifs for the Safavid style that was forming under the shah's greatest artist.

73 "The Feast of Sadeh": Leaf from The Houghton
Shah-nameh *attrib. to Sultan-Muhammad;* Iran; ca. 1520–22
Ink, colors, silver, gold on paper;
w/o borders 9½ x 9¹⁄₁₆ in. (24.1 x 23 cm.)
Gift of Arthur A. Houghton, Jr., 1970 (1970.301.2)

This page: details

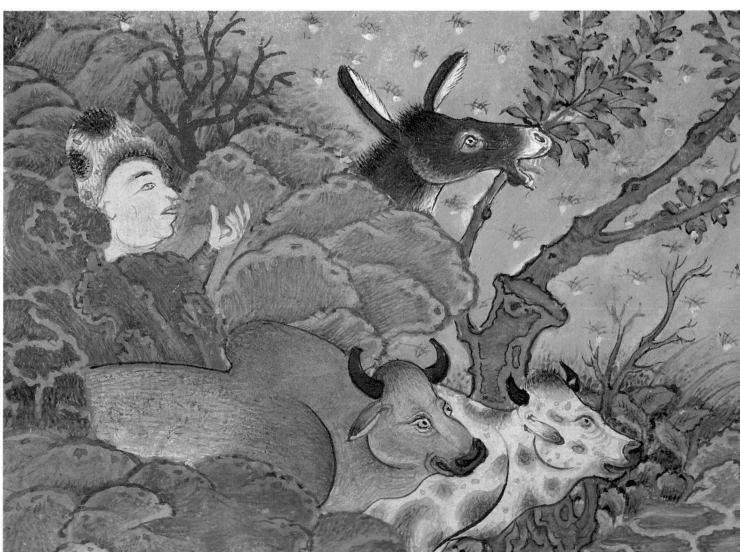

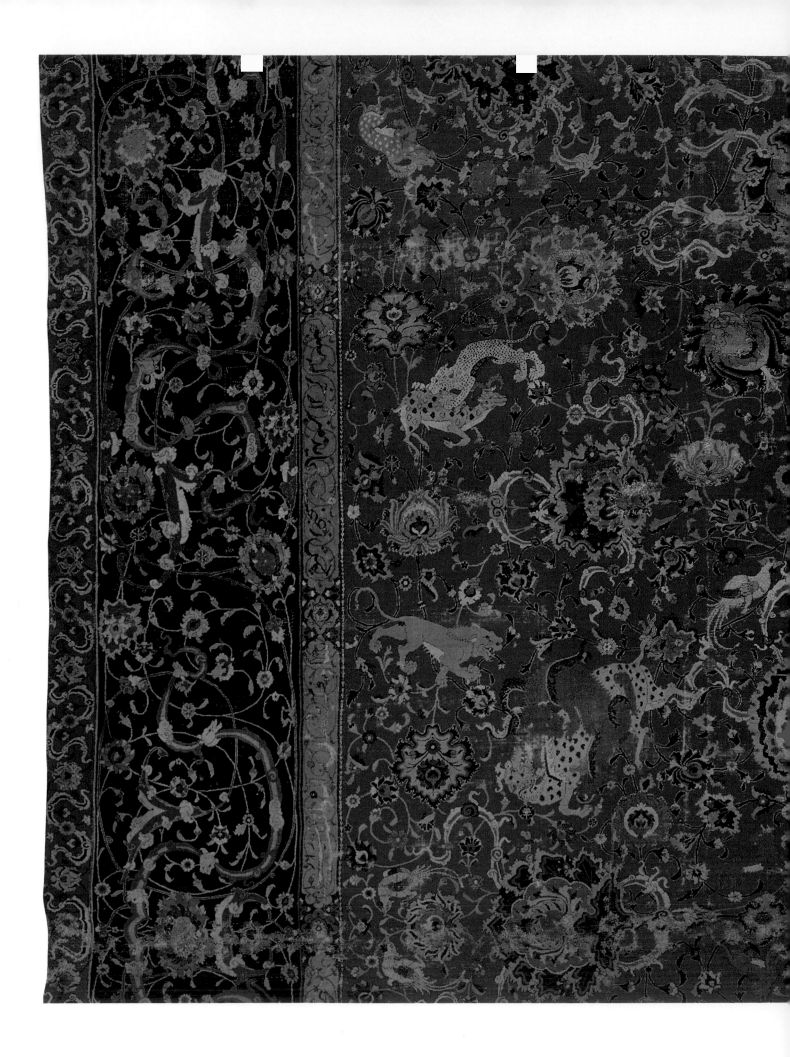

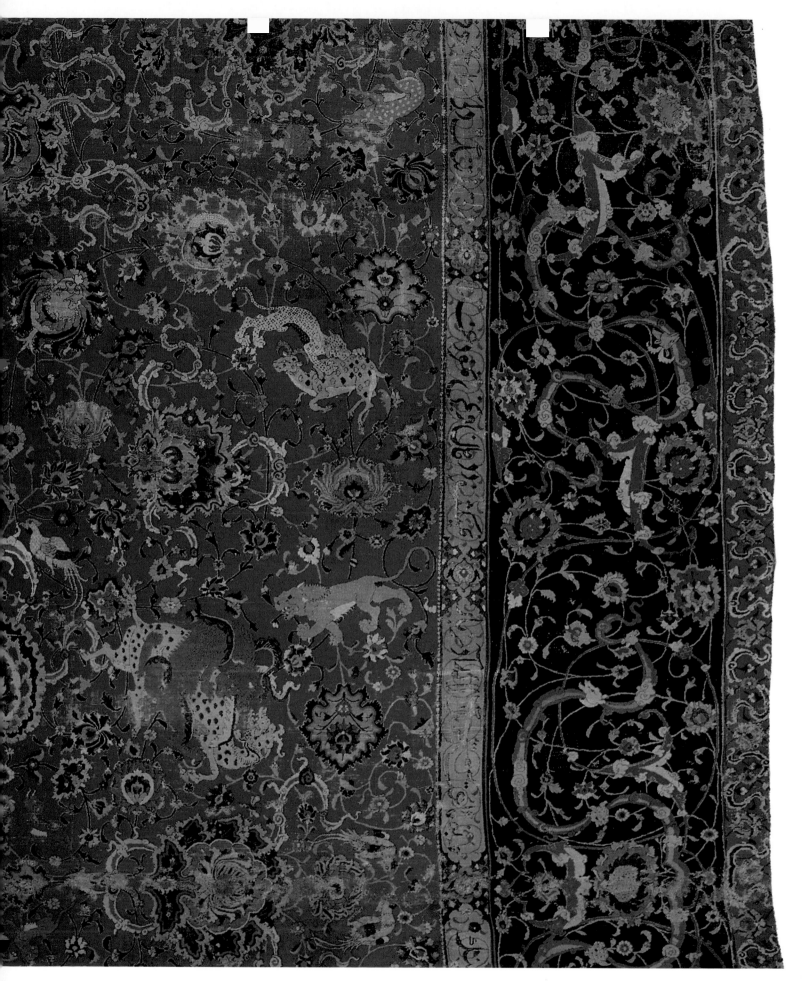

74 The Emperor's Carpet (detail)
Iran (prob. Herat); mid-16th c.
Silk warp and weft, wool pile, ca. 320 Senneh knots
per sq. in.; 24 ft. 8 in. x 10 ft. 10 in. (7.51 x 3.3 m.)
Rogers Fund, 1943 (43.121.1)

Page 100: text

THE EMPEROR'S CARPET (Pages 98–99)

The Emperor's Carpet is probably one of the most complex of a group attributable to eastern Iran, and specifically to the province of Khorasan. The type is recognizable because of the red field, the blue or blue-green border with touches of yellow, the pattern of elaborate floral devices, scrolls, arabesques, and in the earlier pieces, animals. Pairs of carpets were made; a mate to this one is in the Museum of Applied Arts in Vienna.

Court artists, designers, skilled weavers and dyers, and ancillary helpers cooperated to make this carpet one of the glories of weaving. Characteristically, the carpet combines refined arabesques and scrolling vines with cloud bands, and floral wonders with dynamic representations of fabulous beasts and animals and pairs of pheasantlike birds. The pattern is directional and focused. In the center, four large palmettes in a lozenge-shaped formation guide the underlying system of dark-blue spirals, regulating the placement, direction, and size of the complex floral and leaf elements, the cloud bands, blossoms, and buds. A secondary vine system intersects the primary one. The cross-axial system shows symmetrical repeats, vertically and horizontally, in each quadrant of the carpet. Natural and fabulous beasts writhe in combat, *ch'i-lins* (mythical beasts of Chinese origin), dragons, lions, and buffaloes, felines, mouflons, spotted deer, tigers and lion masks are also seen. The border contains an overlapping scroll. In it, various animal heads, large arabesques, cloud bands, flowers, and blossoms interlace. A floral scroll with palmettes and cloud bands fills the outer guard band, and the inner one contains poetic verses in Naskh eulogizing the beauty of a garden in spring.

Certain symbolic aspects of the design have been noted by scholars, especially the comparison to a springtime garden with its allusion to the Garden of Paradise. The verses would tend to reinforce a mundane as well as an otherworldly interpretation of the garden motif. Animal combats are ancient symbols in the Near East and would tend to imply certain cosmological overtones, but any exact royal or religious interpretation of these design elements awaits a definitive explanation.

MEDALLION FROM A TENT WALL

Hunting was a favorite pastime for Persian rulers. It emphasized the masculine qualities of valor, manliness, might, and skill, to add glory to the prince. Hunting was also a metaphor; the idealization of the ruler who searched for greater human and spiritual knowledge in the allegory of the hunt. This was a theme long used in Persian literature. And, above all, hunting prepared men for the role of war, in which the mettle of the man was ultimately tested.

Persian textiles and carpets have used the theme of the chase and capture, adapting delicate scenes from Iranian paintings to a much larger format. Here the rider is seen courageously attacking a lion, showing his true bravery by dominating the king of the beasts, a worthy opponent for a prince. Another hunter lets an arrow fly at his prey amidst a flower-strewn landscape; and a lion savages a quadruped, while an onlooker and small animals watch the violent spectacle in amazement.

This textile once decorated the walls of a lavish tent that might have been erected near the hunting grounds, or in a palace or garden. A successful hunt usually concluded with a feast held in a sumptuous setting.

75 Medallion from a Tent Wall
Iran; Safavid period, mid-16th c.
Cut velvet in satin weave foundation with
supplementary wefts in twill, silk; flat metal strips;
Max. L. 23⅝ in. (60 cm.), Max. W. 18 in. (46 cm.)
Fletcher Fund, 1972 (1972.189)

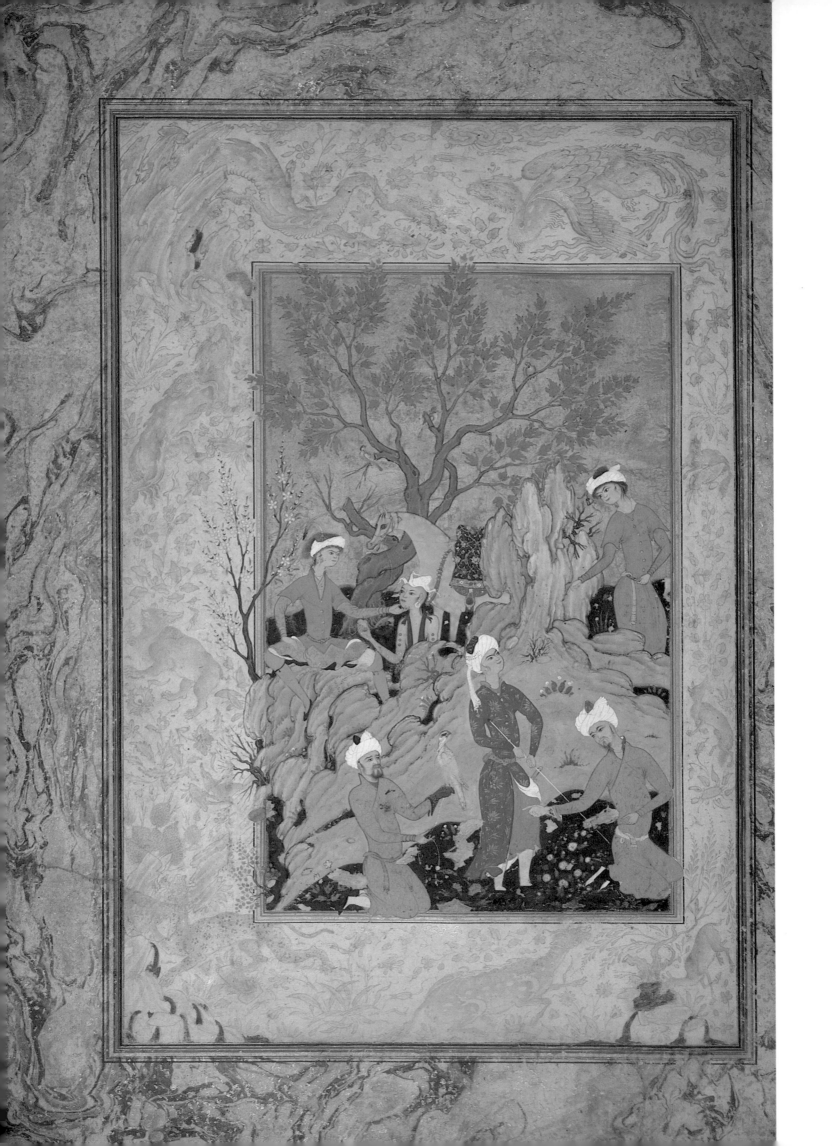

*76 "A Princely Hawking Party":
Half of a Double-Page Manuscript
attrib. to Mirza-'Ali;* Iran; 1570–80
Colors, gold on paper; with borders
14¾ x 9¾ in. (37.5 x 24.8 cm.)
Rogers Fund, 1912 (12.223.1)

Right: detail

A Princely Hawking Party

Set in superbly marbled outer borders and inner ones en-
livened by a fantastic "zoo" of dragons, phoenixes, and other
beasts drawn in gold, this mannered miniature was the left
half of a large double-page composition now shared with
the Museum of Fine Arts, Boston. It was probably painted
as the frontispiece to a great manuscript jointly commis-
sioned by two remarkable patrons, Shah Tahmasp (r. 1524–
76) and his nephew and son-in-law, Sultan Ibrahim Mirza,
who was given access to the shah's artists between 1556 and
1564, but was then exiled for his wild behavior until 1574,
when he was again welcomed at court.

The wind-swept trees, suggestively "melting" boulders,

and louche gathering are characteristic both of the mood of
Shah Tahmasp's court in 1574 and of the later style of Mirza-
'Ali, the son of Sultan-Muhammad. He was trained at Tabriz
when the eastern (Timurid) and western (Turkman and
early Safavid) wings of Iranian painting met and merged at
the court of Shah Tahmasp under Bihzad of Herat and
Sultan-Muhammad of Tabriz, both of whose styles influ-
enced him. Like his dynamically composed earliest pictures
—contrasting with the restrained naturalism of the middle
phase—this very late one reveals Mirza-'Ali's delight in ex-
cess. In 1576, soon after this picture was finished, the shah
died, and his successor ordered Sultan Ibrahim's execution.

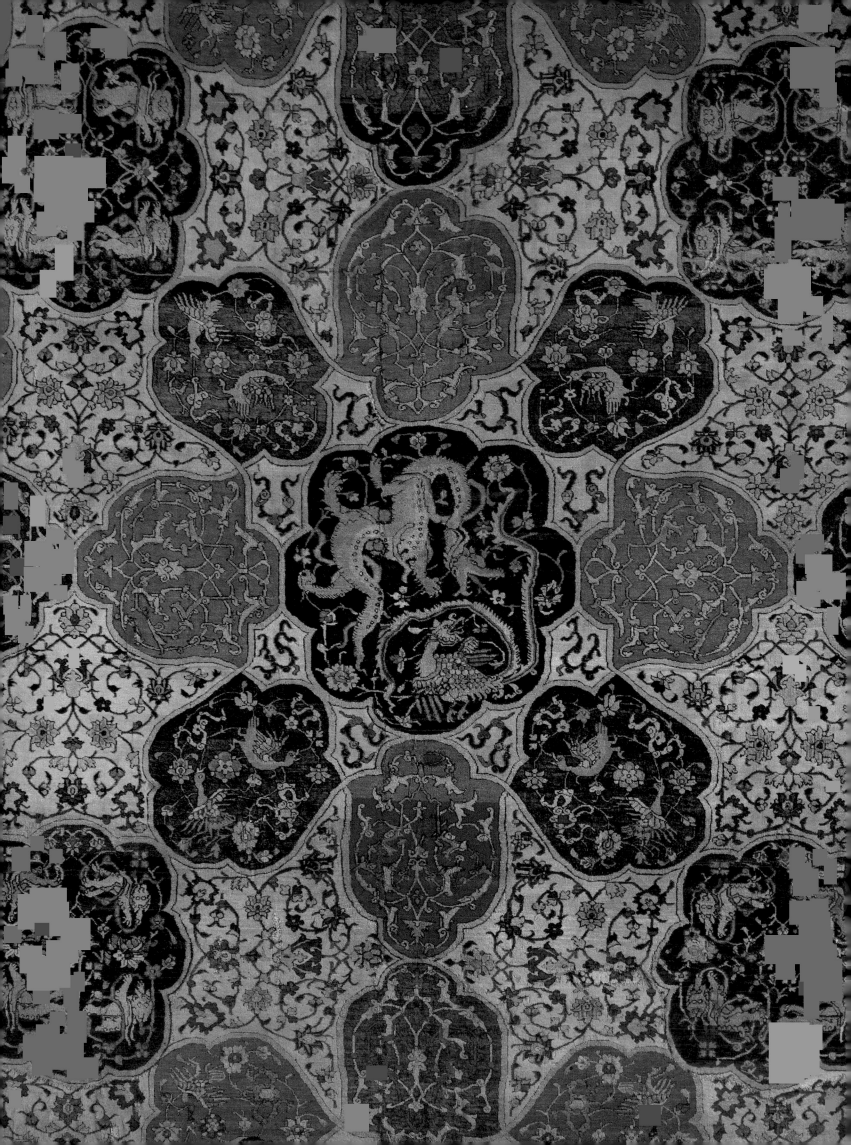

CARPET

Geometric patterns graced the earliest surviving Islamic carpets and are most suited to the grid system of interlocking warps and wefts used as the foundation for a knotted pile carpet. The intermediate development between the earliest examples attributed to Anatolia and Safavid carpets is unfortunately as yet undocumented, but Islamic carpets from the Safavid period in Iran in the sixteenth and seventeenth centuries also reflect complicated geometric designs.

The designs and isolated motifs on this carpet are indebted to the art of the book and to the artists who created the magnificent Persian manuscripts surviving in museums and libraries today. The delicacy of the illuminated leaves seen in these manuscripts is evident even though presented in a much larger format on this carpet. The individual motifs and rich colors symbolize the richness and brilliance of the art created under the patronage of the Safavid rulers.

The pattern in the field of the carpet is based on an eight-pointed star system, although the type has been categorized as a "compartment" or "cartouche" rug. At the center of the radiating star and in medallions in the border are two mythical beasts of Chinese origin, the Simurgh, modeled on the Chinese *feng-huang* (a phoenixlike bird), and a dragon whirling in combat within an eight-lobed medallion. The arms of the star contain either an arabesque or pairs of ducks flying amid floral scrolls. The mythical beast *ch'i-lin*, also of Chinese origin, is found in the octofoil off one point of the stars. The ground in the field shows arabesques and cloud bands, and in the border, scrolls with flying ducks. Multilevel designs of floral scrolls, cloud bands, and arabesques decorate the cartouches in the border, and the guard stripes in typical Safavid style.

77 Carpet (detail)
Northwest or central Iran; Safavid period,
1st half 16th c.
Silk warp and weft, wool pile,
ca. 550 Senneh knots per sq. in.;
16 ft. 4 in. x 11 ft. 2 in. (4.97 x 3.4 m.)
Frederick C. Hewitt Fund, 1910 (10.61.3)

TEXTILE

Closely related to illustrations in popular literary works of Safavid Iran are some of the representations found on the superb figural silks and velvets of the same period. This design may have been adapted from an episode in the life of the great warrior Rustam, narrated in the *Shah-nameh*. Rustam had captured the youthful lord Ulad, bound his hands in a lasso, and ordered Ulad to lead him to the evil White Div. Generally, the story line is followed in this depiction, but the bound prisoner with his droopy mustache presents a figure more comic than tragic. Incongruously, a child, riding pillion, clutches the end of the saddle for support. Perched in the colorful plane tree is the Simurgh. Here, the bird may denote an auspicious guardian figure.

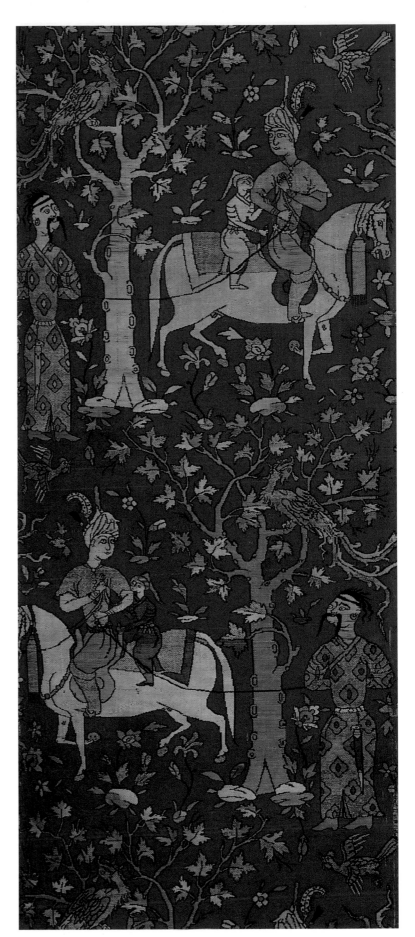

78 Textile
Iran; Safavid period, 2nd half 16th c.
Silk and metal-wrapped yarns, satin and twill weave interconnected; 47½ x 26½ in. (120.7 x 67.3 cm.)
Purchase, Joseph Pulitzer Bequest, 1952 (52.20.12)

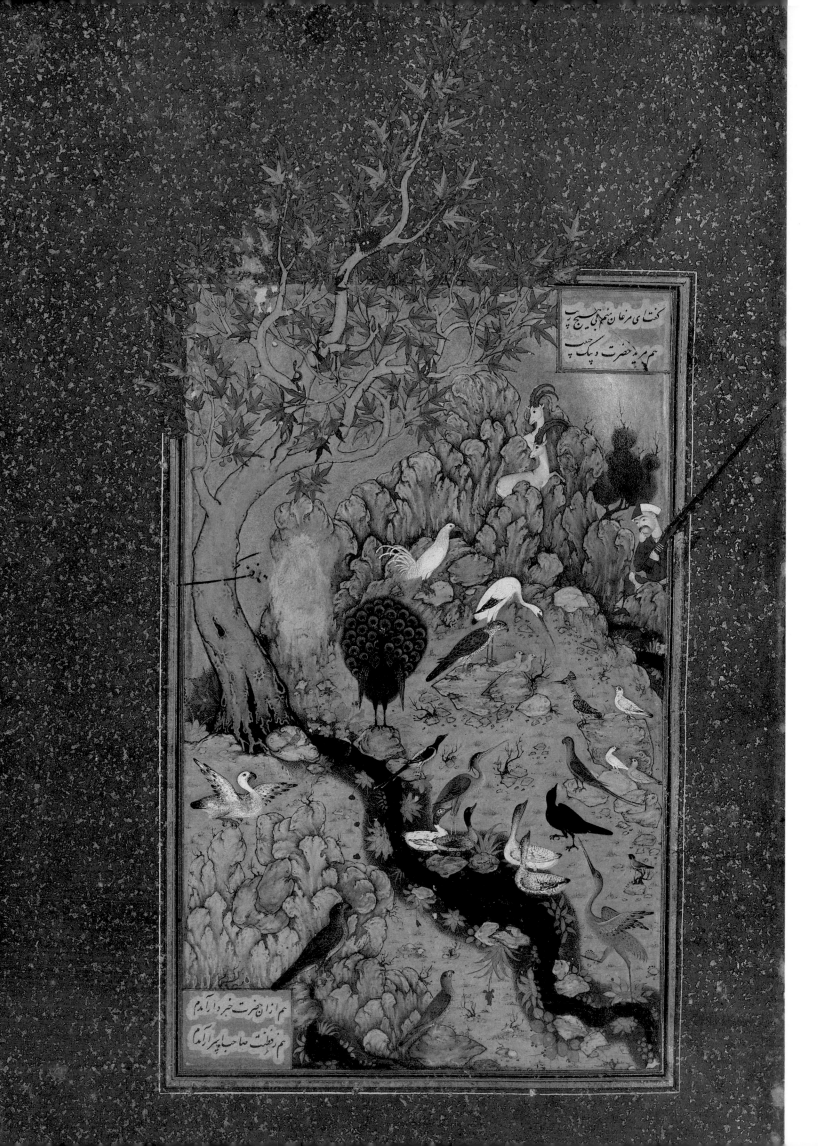

79 *"The Assembly of the Birds" by artist Habib Allah:*
Leaf from the Mantiq al-Tayr
(Language of the Birds) *of Farid ad-din ʿAttar*
Iran (Isfahan); Manuscript compiled 1486 in Herat,
rebound and 4 miniatures added ca. 1600
Colors, gold on paper; 10 x 4½ in. (25.4 x 11.4 cm.)
Fletcher Fund, 1963 (63.210.11)

THE ASSEMBLY OF THE BIRDS

This particular painting illustrates the beginning of the mystic allegory that is the theme of the *Mantiq al-Tayr* (*Language of the Birds*). Here, the birds have assembled, led by the hoopoe, who exhorts them to set off on a pilgrimage in search of the Simurgh. The main theme of ʿAttar's poem is the Sufis' attempt to become one with God. This is accomplished by annihilation of the self, which is insubstantial, in order to become absorbed in the only true substance, God's being. Of the innumerable birds that set out on the perilous journey of the mystic's path, only thirty survive. When they reach their final destination, they discover in ecstasy that they are identical to the Simurgh, which means "thirty birds."

Of the eight miniatures in this manuscript of the *Mantiq al-Tayr*, four were painted in Herat at the time the manuscript was produced, that is, sometime close to 1486. The other four were added to the blank spaces left in the manuscript at the order of the Safavid ruler Shah ʿAbbas I, whose capital was at Isfahan, around 1600. At that time, he also had the pages containing the paintings remounted on gold-flecked colored paper. New illuminated opening pages and a new binding were prepared, and the splendidly refurbished manuscript was presented to the family shrine at Ardabil.

The distinguished artist, Habib Allah, has made a brilliant job of painting a miniature beautifully in tune with the fifteenth-century paintings of the manuscript, and also with the spiritual content of the poem. The birds have gathered in an ideal landscape of soft-hued rocks, a cascading stream, and a graceful plane tree to give them shade while casting no shadow. The artist, however, could not resist adding a human being to his picture, and so a hunter peers at the scene from the upper-right corner, proudly clutching the latest model in seventeenth-century guns.

O V E R L E A F :

BOOKBINDING FROM A MANUSCRIPT OF THE *LANGUAGE OF THE BIRDS* (Pages 108–109)

The long-established Islamic tradition of decorative bookbindings had its most elaborate phase under the Safavid dynasty. The style, however, was adapted from the splendid production of luxury bindings of the preceding Timurid period, during which, master craftsmen, probably with the assistance of designers and artists, elaborated on the traditional techniques of earlier Islamic bindings. A distinctive Timurid style developed with the skilled use of small individual stamps combined with skillfully cut patterns or filigree designs placed on brightly colored ground, usually found on the doublure or lining of the inner side of the cover. The use of figures and animals was extensive.

This bookbinding is an excellent example of the most common and widespread type of Safavid binding with its use of a centralized design of medallions, quadrants, and extensive panel stamping. The vertical format had been customary for Islamic book covers since the tenth century. The covers are joined to a spine, and a fore-edge flap connects to the pentagonal envelope flap, always tucked under the left side of the top cover. The field pattern was created by the use of a mold, as can be seen by the dividing line across the binding. First, one half of the binding was stamped, and then the mold was reversed, forming a mirror image of the design in the other half. Surrounding the scalloped ovoid medallion, a popular shape from the sixteenth to the twentieth century, are rich floral motifs, arabesques, and cloud bands, all covered with gilding. Conventionally, the decoration of the doublure has an entirely different decorative program. Overlapping medallions contain delicate filigreed patterns placed on orange, blue, green, or brown grounds. The borders have a common decoration of large corner pieces and rows of cartouches alternating with a quatrefoil, a typical sixteenth-century development.

80 Bookbinding from the Mantiq al-Tayr
(Language of the Birds)
Iran (Isfahan); Safavid period, ca. 1600
Tooled and stamped leather on paper,
pasteboards, parchment, paper, colors,
gold; 13 x 8½ in. (33 x 21.6 cm.)
Fletcher Fund, 1963 (63.210.76)

Page 107: text

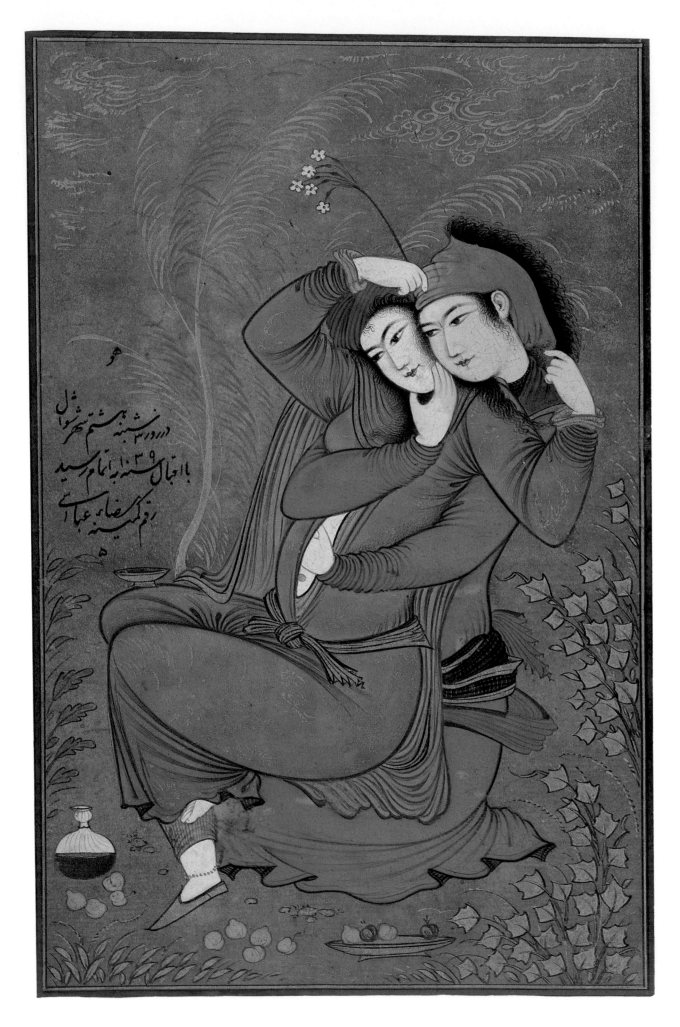

110

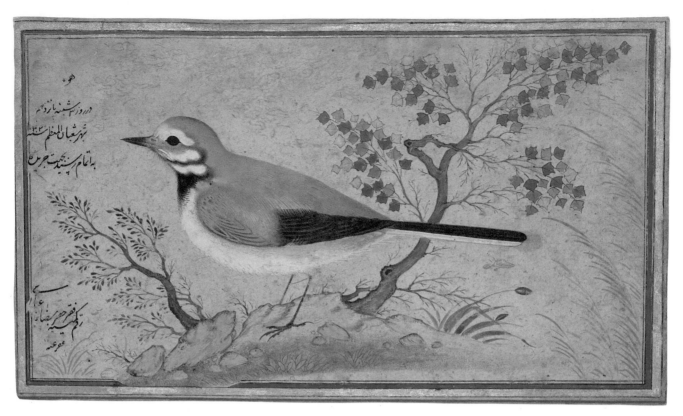

81 "Courtly Lovers" by Reza-ye 'Abbasi
Iran; 1630
Colors, gold on paper; 7⅛ x 4¹¹⁄₁₆ in.
(18.1 cm. x 11.9 cm.)
Purchase, Francis M. Weld Gift, 1950
(50.164)

82 "Study of a Bird" by Reza-ye 'Abbasi
Iran; 1634
Ink, colors, gold, silver on paper;
3⅞ x 6⅞ in. (9.8 x 17.5 cm.)
Purchase, The Louis E. and Theresa S. Seley
Purchase Fund for Islamic Art and Rogers
Fund, 1985 (1985.2)

COURTLY LOVERS

Reza was trained during the later sixteenth century in the royal Safavid workshops under such artists as Shaykh-Muhammad and Mirza-'Ali. A bold—even revolutionary—innovator, he broke away from the academic tradition, developing a dashingly calligraphic style in keeping with the developing taste for album miniatures and drawings instead of illustrations. For respite from the atrophying refinements of the court, he sought the company of such lowly types as wrestlers, who nourished the artist's talent. But they also brought criticism, which would have damaged Reza's career had not his brilliance been recognized. On becoming the favorite painter of Shah 'Abbas (r. 1581–1628), he changed his signature from Aqa Reza to Reza-ye 'Abbasi.

His passionately entangled lovers, whose impassive faces loom like paired full moons, must have seemed more erotic to the Safavids than to us. It was painted toward the end of Reza's middle phase, shortly before he shed many traces of discipline in favor of calligraphic flights of fancy. The deeply saturated colors of the costumes and still life glow against a dark brown ground, but the golden flourishes of the flowers, trees, and clouds look ahead to Reza's final manner, which occasionally descended to facile virtuosity.

STUDY OF A BIRD

This gentle, sad bird caught at a moment of stasis seems to ponder Reza's flowing Nasta'liq inscriptions. Like the artist's lovers, sprawled in a languorous pose before becoming actively amorous, the perfectly balanced bird looks as if he is about to hop. Enhancing his monumentality, he is the only stable shape in the composition, which is tugged right and left by two sharply angled trees whose leaves resemble an arabesque of fireworks. Like the rocky hillock, they are drawn with reed-pen and brush in banks of rhythmical strokes, tokens of Reza's surging virtuosity.

Few studies of flora and fauna are known in Safavid painting before the seventeenth century, when they were inspired by Indian precedent. As compared to the sensitive naturalism of Mughal animal studies commissioned by Emperor Jahangir (r. 1605–27) Reza's bird appears anthropomorphic, poignant but ornamental. The firm outlines of the bird attest to Reza's rigorous training: The picture is both charming and thought provoking. It appeared in one of the albums of calligraphic specimens and miniatures that were in demand not only by Shah Safi (r. 1629–42) and members of his court but by a new, broader social range of patrons, some of them wealthy merchants. "Humble" Reza prospered.

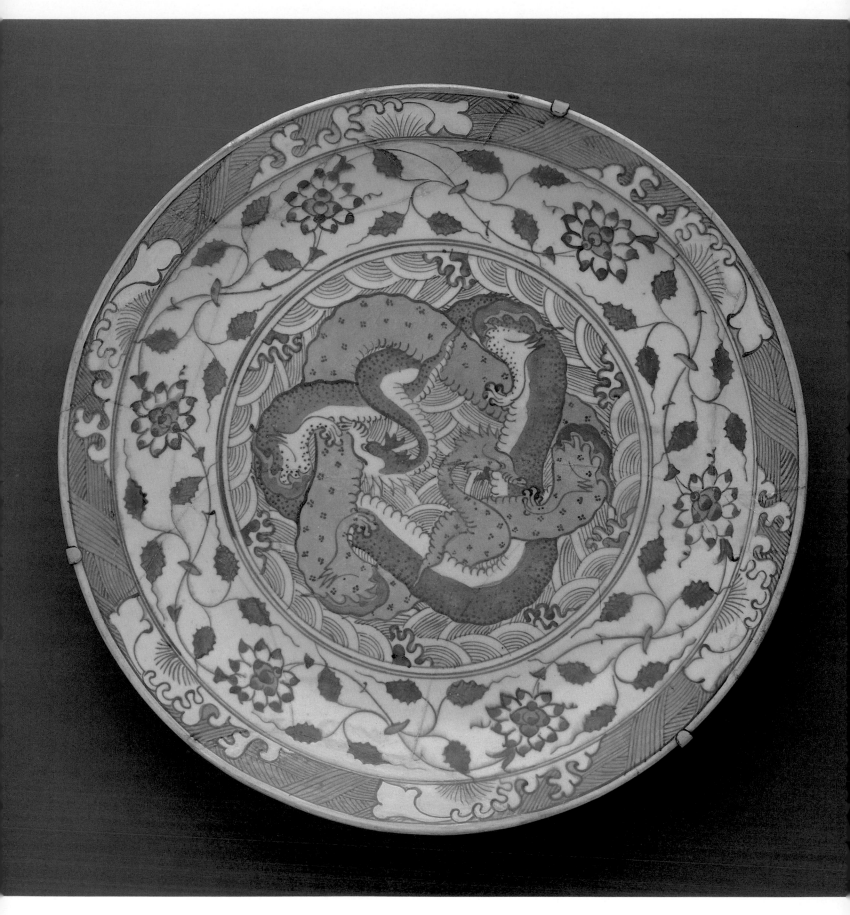

83 Dish
Iran; 17th c.
Composite body, underglaze painted;
D. 17¼ in. (43.8 cm.)
Harris Brisbane Dick Fund, 1965
(65.109.2)

DISH

The strong influence that Chinese blue-and-white porcelain began to exert on Islamic ceramics in the late fourteenth century persisted for at least the next two hundred and fifty years. The artist of this large Persian dish selected and adapted elements of Chinese blue-and-white porcelain of various dates for his decoration—such as the design on the cavetto, the dragons, and the concentric wave pattern. The "tassel mark" on the foot of the dish, in imitation of a Chinese reign mark, or *nien-hao*, suggests a seventeenth-century date because it is very similar to marks found on other Iranian bowls attributed to this time.

POLONAISE CARPET

When, in 1878, a carpet similar to this one was exhibited in Paris, it was assumed that the coats-of-arms woven into the rug were Polish and that the rug was made in Poland. It was later recognized that this group, distinguished by a silk pile and metallic brocading, was Persian, made during and after the reign of Shah 'Abbas I, beginning around the end of the sixteenth or early seventeenth century. The name, however, persisted, and more than two hundred examples still bear the name. Many pairs of the type, as here, also survive.

The type of design on this carpet has its roots in earlier Iranian carpets, but the rich silk pile, highlighted with gold and silver brocading, and muted but lively colors, signaled a change from the past. The tightly controlled overall pattern of compartments formed by overlapping cartouches in orange, yellow, red, green, and brown on a silver-and-gold brocaded ground is adorned by floral and leaf-vine systems with palmette motifs.

Reports of European travelers mentioned the capital city of Isfahan as the center of Safavid court production. Probably many of the finest examples of Polonaise carpets were produced there for local patrons or on orders from the shah as special gifts or as commissions for export. The richness and elegance of the Polonaise carpets reflect the current taste of the wealthy Iranian court, and also the Baroque taste of Europe, where they were particularly admired.

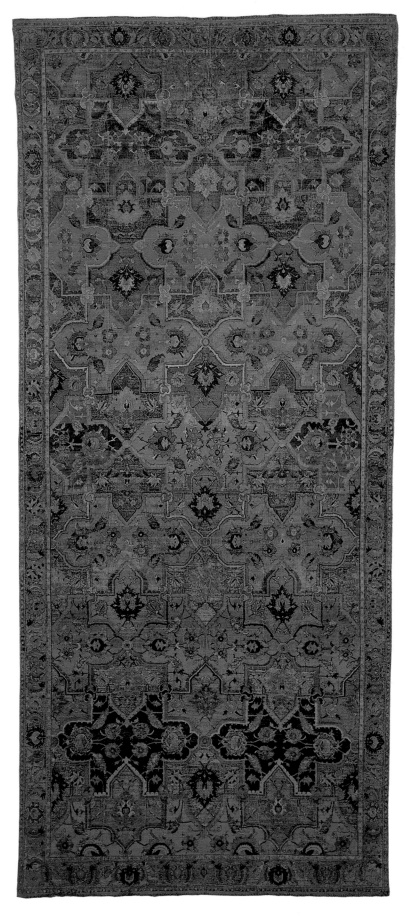

84 Polonaise Carpet
Iran (Isfahan or Kashan); Safavid period, 1st quart. 17th c.
Silk pile, metallic brocading, cotton warp,
cotton and silk wefts, ca. 378 Senneh knots per sq. in.;
13 ft. 1 in. x 5 ft. 7 in. (4 x 1.7 m.)
Gift of John D. Rockefeller, Jr., 1950 (50.190.1)

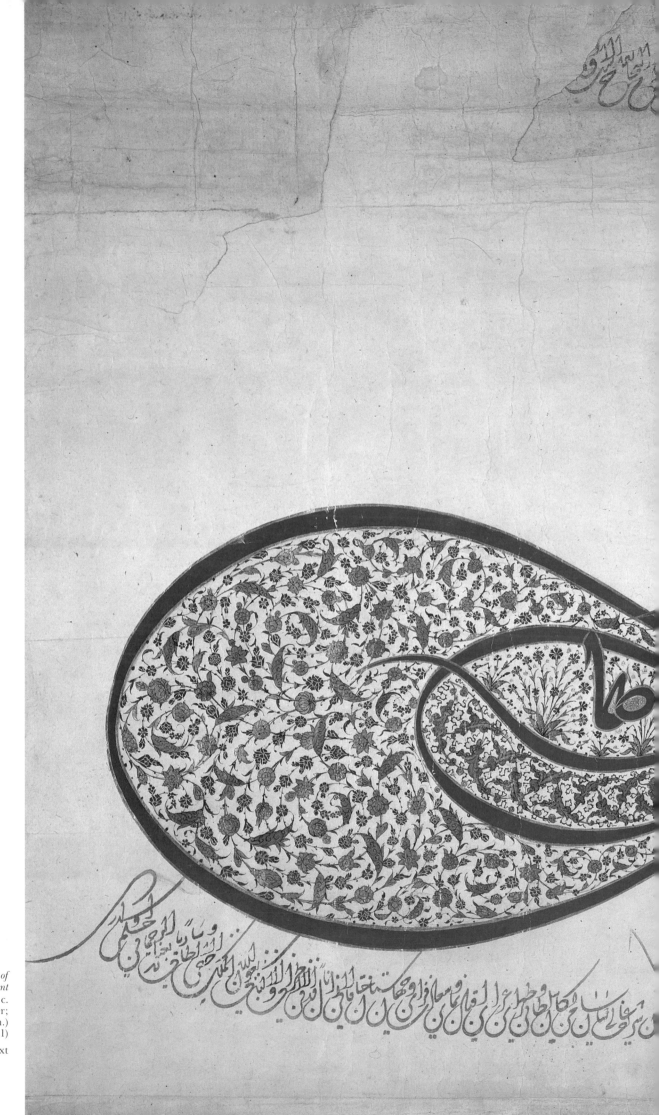

85 *Tughra of*
Sultan Suleyman the Magnificent
Turkey; mid-16th c.
Gouache, gold leaf on paper;
20½ x 25⅜ in. (52.1 x 64.5 cm.)
Rogers Fund, 1938 (38.149.1)

Page 116: text

TUGHRA OF SULTAN SULEYMAN THE MAGNIFICENT

(Pages 114–115)

The tughra, the "handsign" of the Ottoman emperor, is the most characteristic part of an official document. From early days, it had been customary for a royal decree to be headed by a large, decorative form of the ruler's name, sometimes with benedictions. The forms of such headings varied; in India and Egypt, for example, they have a fencelike shape created by the prolongation of the shafts of certain letters. The Ottoman tughra, however, is characterized by three verticals and a larger oval loop at the left side, which usually contains a smaller oval. This form has been explained as deriving from the sultan's handsign (thumb and three fingers) but also as a remembrance of the three yak tails that form the sign of power in Central Asian society. Whatever the origin, the Ottoman tughra soon developed into a veritable work of art; the actual name of the sultan and his father's name, together with a blessing, were written by one of the highest officials in the bureaucracy and then given for illumination to special artists. Each period had its own form of the tughra; during the reign of Suleyman the Magnificent (r. 1520–66), the form was still rather simple: blue and gold dominate. In later times, the tughra was sometimes shaped like a helmet, sometimes triangular in form, and filled with abundant arabesques. The text of the document, written in the Divani script, which, like all chancellory scripts, contains numerous ligatures, turns slightly to the upper left, following the movement of the large curve. As the paper used for such documents was quite narrow, Ottoman decrees often reached a length of several feet.

MOSQUE LAMP

Earthenware ceramics were made in Iznik as early as the second half of the fourteenth century, but it was not until about one hundred years later that this center began to manufacture pottery with a composite body. The earliest composite-bodied ware made in Iznik was distinguished by an underglaze-painted blue decoration on a white ground.

Among the principal characteristics of this ware, known as Abraham of Kutahya (after the artist whose signature appeared on only one piece), are ornately contoured panels with small, highly detailed vegetal patterns.

A variant of the Abraham of Kutahya type, represented by this small mosque lamp, is characterized by a ground completely covered with delicate spiraling stems bearing small flowers. This motif serves as the backdrop for two beautifully executed Arabic inscriptions: "Power belongs to God, the One" (repeated three times on the body of the object) and (on the flaring upper section) "there is no hero except 'Ali; no sword except *dhu-l-faqar* ['Ali's sword]."

During this period in Turkey, pottery continued to imitate metalwork in shape as well as in design. This lamp, however, is one of a number made at this time that have a glass prototype.

86 Mosque Lamp
Turkey (Iznik); 1st quart. 16th c.
Composite body, opaque white glaze,
underglaze painted; H. 6⅝ in. (16.8 cm.)
Harris Brisbane Dick Fund, 1959 (59.69.3)

KHUSRAU HUNTING

The Persian poet Hatifi (d. 1521), who was a nephew of the great late fifteenth-century Herat poet Jami, wrote a *kham-seh*, or quintet, like other ambitious poets, in emulation of the great Nizami, substituting, however, a *Timur-nameh* for the usual section devoted to Iskandar (Alexander the Great). Persian literature and culture were greatly admired at the Ottoman court; Persian was considered the prime language for poetry. Therefore, it is not surprising to find Ottoman illustrated manuscripts of Persian poems, although it is per-haps unusual that the date of this manuscript is twenty-five years before the author's death. It should be noted that the manuscript was illustrated before the great rivals of the Ot-tomans, the Safavids, had come to power in Iran.

Ottoman painting during the reign of Bayazid II (r. 1481–1510), who was a great patron of the arts, was still in a for-mative state, with influences from both East and West. In this painting, however, the influence of painting in Iran under the dynasty of the Aq-Qoyunlu Turkmans is most prevalent.

The thick ground cover of some Turkman painting has here been turned into a more formal background of evenly spaced leafy rosettes on a similarly colored ground, while in the next plane the little grass tufts with flowers emerging from them are placed in much more even rows than in Persian painting, demonstrating, as does the even row of trees with their neat round tops, the Ottoman love of order. On the other hand, the painting is rich in its lively naturalistic treat-ment of the hunt in the foreground, with the ruthless at-tack of the hunting dogs on their prey, and in drama, as in the fallen figure being attacked by the lion. This lively natu-ralism and drama is also reflected in the falcon hunt over the next two planes. The attacking and fleeing birds are portrayed in explicit detail, but they also form a delightful pattern of spread wings. They are seen partly against the middle ground and partly against the farthest plane, which unifies that plane with the foreground in its dense foliage pattern, yet gives an appropriate sense of distance by its light coloring. This is an exceptionally charming miniature from an early phase of Ottoman painting.

87 "Khusrau Hunting":
Leaf from Khusrau and Shirin *by Hatifi*
Turkey; Ottoman period, 1498
Ink, colors, gold on paper;
miniature 4¾ x 2¹⁵⁄₁₆ in. (12.1 x 7.5 cm.)
Harris Brisbane Dick Fund, 1969 (69.27)

TEXTILE

Ottoman textiles illustrate the taste of the period for splendid floral silks, used for garments and furnishings. This vertical pattern, formed by wavy stems, flowers, and leaves, appeared during the second half of the sixteenth century and compares stylistically with the ceramic wall tiles in buildings of the same period. Swinging in rhythm from right to left on the undulating stalk are composite tulips and peonies, alternating in cadence within the curve of the stems. The flowers and leaves are further enhanced with miniature tulips and carnations, both favorite Ottoman motifs, and other naturalistic flowers. The chevron pattern on the stalks derives from an age-old symbol for water. The elegant and formal composition was created with a limited range of colors and metallic thread placed on a warm red ground.

88 Textile (fragment)
Turkey (Bursa or Istanbul);
Ottoman period, 2nd half 16th c.
Silk and metallic thread, satin and
twill weaves interconnected;
75⁹⁄₁₆ x 26½ in. (191.9 x 67.3 cm.)
Purchase, Joseph Pulitzer Bequest,
1952 (52.20.21)

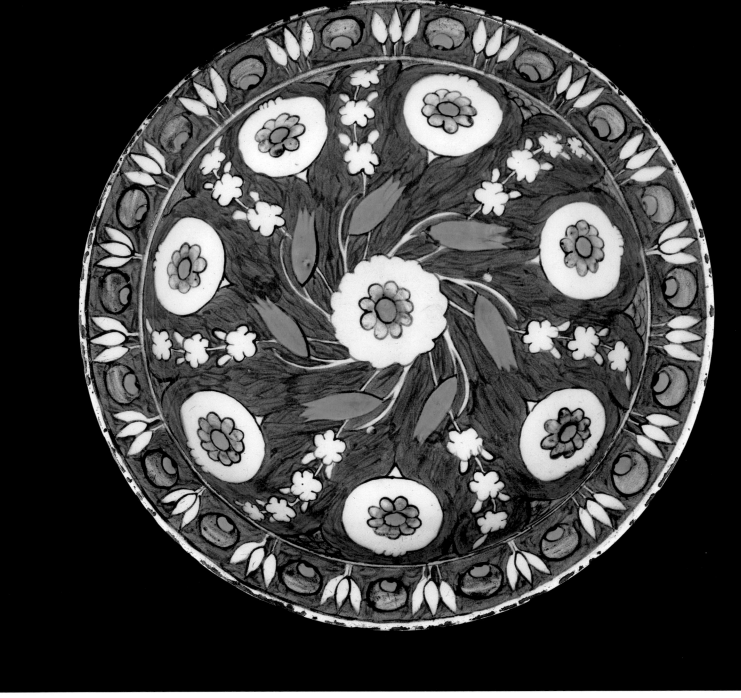

89 Plate
Turkey (Iznik); mid-16th c.
Composite body, opaque white glaze,
underglaze painted; D. 11¾ in. (29.8 cm.)
Bequest of Benjamin Altman, 1913 (14.40.732)

PLATE

The Iznik wares of Ottoman Turkey, produced from the late fifteenth century until about 1700, are among the finest Islamic ceramics. The nomenclature of the main stylistic types was based on the erroneous assumption, stemming from their appearance in quantity in certain sites, of a variety of provenances for the wares. Eventually, it was realized that the body material, the method of underglaze painting over an engobe, and the tight-fitting, thin, and lustrous glaze without a crackle were the same and that all of the wares were produced at Iznik.

In the so-called Damascus ware, to which this plate belongs, manganese purple, olive, and green-gray, and a greenish-tinged black for outlining were added to the early Iznik color scheme of blue and white with occasional touches of turquoise. The designs became much freer, often containing naturalistic large-scale plants. This plate has a balanced format; the pattern radiates out from a central rosette, surrounded by stylized tulips that appear to rotate in a clockwise direction; floral sprays grow out from the center, alternating with flower heads that relate to the central rosette. An effective border is formed by a closed crescent alternating with a stylized lotus plant.

Ewer and Dish

The dish in Plate 91 is one of those works that transcends time, place, and medium, while remaining a quintessential part of the culture that produced it. Like many other Ottoman ceramics, it manifests traceable Chinese influences, but it also employs an old Islamic geometric pattern in the center, and a characteristic early Iznik color scheme.

While most Ottoman ceramics were influenced by Chinese blue-and-white wares of the late Yuan and early Ming periods, this dish harks back to another source, celadonware. Characteristic of Yuan-dynasty celadons of the second half of the fourteenth century were large-scale dishes with floral scrolls in the cavetto and a geometric pattern in the center consisting of overlapping squares or circles. So skillfully has the cavetto of the Museum's dish been painted that it has the illusion of the three-dimensionality resulting from the carving on the celadons.

The design of the center of the dish, while perhaps being suggested by the interiors of the celadons, is an old Islamic geometric design formed from a grid pattern based on the circle and square. It was used primarily for architectural decoration and has been found as early as the eleventh century where it appears in brickwork on a Seljuk tomb tower in western Iran that is dated 1093. This pattern is used sparingly, but over a wide area and for a long time. It was found, for example, in buildings in Muslim India of the Sultanate and Mughal periods. The design appears, again sparingly, in miniature paintings, and it has been found on a ceramic fragment and dish of the Mamluk period, although it was not used there with nearly the presence and control of the Iznik piece. The Iznik ceramic painters were not slavish imitators of another culture's products; they were creative masters in their own line. Interestingly, the outside of the Museum's dish has a floral scroll design in blue on white based on the more frequently imitated Chinese blue-and-white wares, again showing the independence of the Turkish ceramist in choosing his sources.

The Golden Horn style of Iznik ware to which the ewer in Plate 90 belongs is characterized by thin circular spirals, generally in underglaze blue as here. This pattern appears on a variety of dishes, bowls, bottles, and mosque lamps. However, only one other ewer in this style is known, and the form of both appears to have been influenced by metalwork. There is a bottle of Golden Horn design with the date of 1529, so that the group may be considered roughly contemporary with the so-called Damascus ware to which the plate on the previous page (Plate 89) belongs.

90 Ewer
Turkey (Iznik); 1530–35
Composite body, opaque white glaze, underglaze painted; 8¾ x 7¹⁵⁄₁₆ in. (22.2 x 20.2 cm.)
Harris Brisbane Dick Fund, 1966 (66.4.3a)

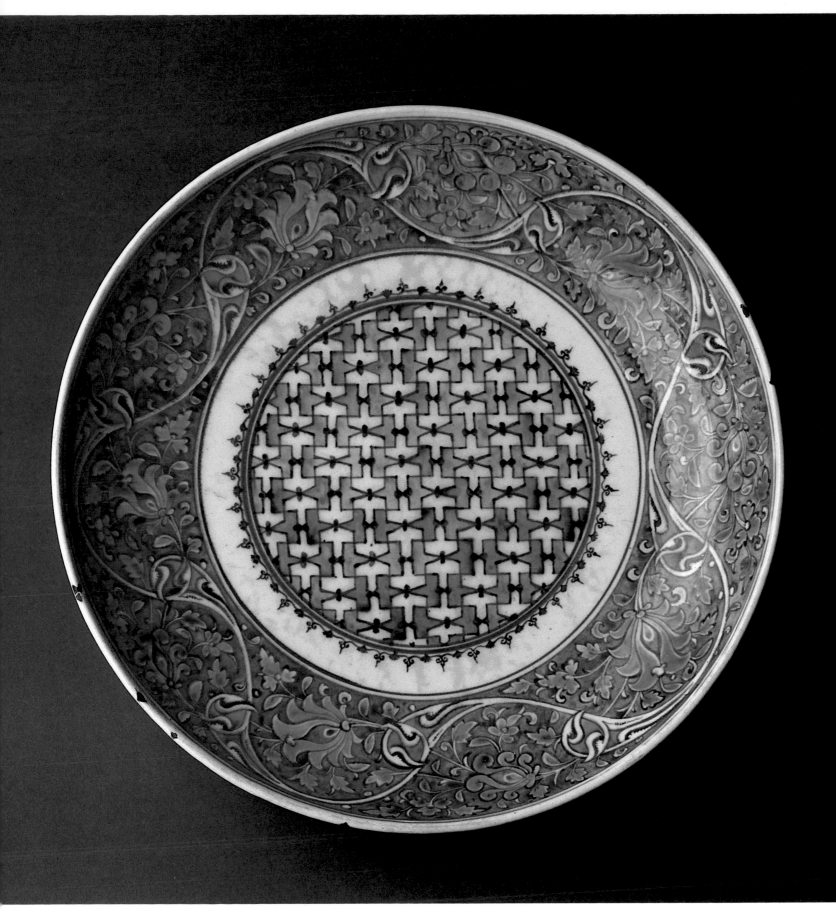

91 Dish
Turkey (Iznik); ca. 1525–30
Composite body, opaque white glaze,
underglaze painted; D. 15½ in. (39.4 cm.)
Bequest of Benjamin Altman, 1913 (14.40.727)

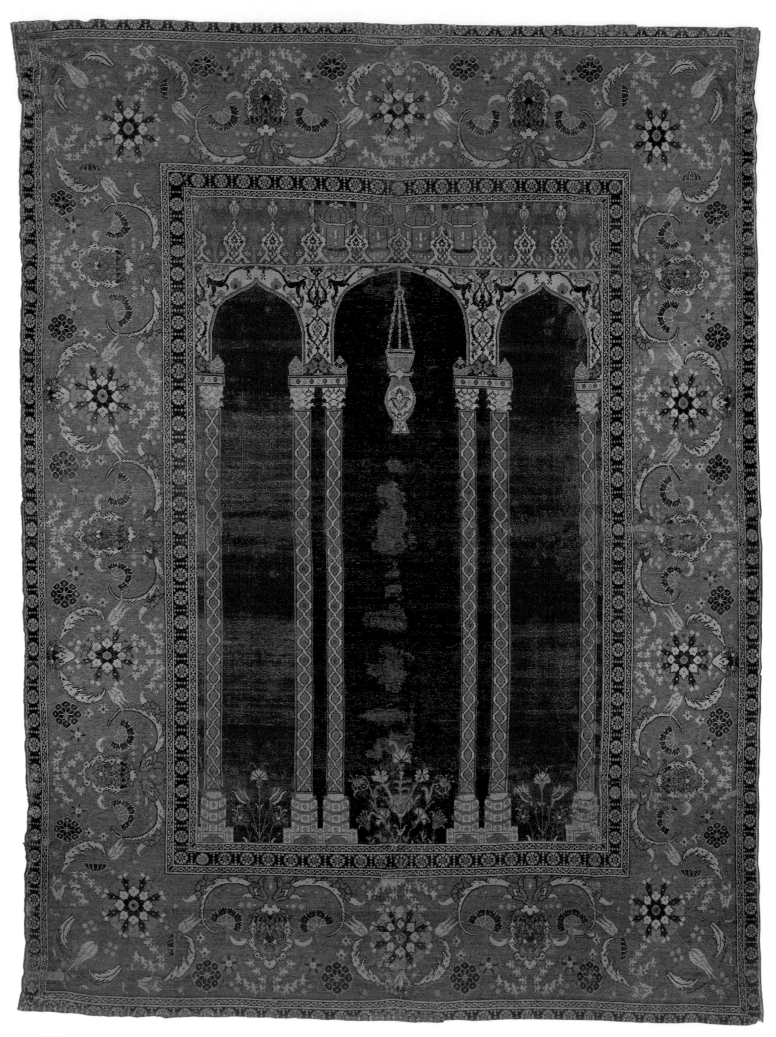

PRAYER RUG

The Ballard prayer rug is the most outstanding one in the Museum's collection. The type of design in the field became the model for the subsequent development of columned prayer rugs between the seventeenth and the nineteenth century, when a more stylized and conventionalized version of the pattern was used.

In the field is a portico with three pointed arches. The arches rest on columns decorated with overlapping chevrons, octagonal bases placed on a small plinth with a hipped arch, and Corinthian capitals. In the apex of the central and widest arch is a mosque lamp. The portico itself may be symbolic, referring to the Ka'ba in Mecca, which all Muslims face while praying. The mosque lamp alludes to the Sura of Light (24, verse 35) in the Koran. Above the spandrels, decorated with typical Ottoman blossoms and arabesques, is a row of crenellations framing domed pavilions or tomb towers. These appear to be placed in a garden setting, hinting at the reward of the bliss of the Paradise Garden promised to the faithful. Between the bases, along the floor line, are bouquets of naturalistic flowers taken from a typical Ottoman repertoire, tulips, carnations, anemones, and roses. The architectural flavor of the design makes it nearly three-dimensional in feeling.

LEAF OF CALLIGRAPHY BY SHEYKH HAMDULLAH

This leaf is from an album of calligraphy by the Turkish master Sheykh Hamdullah (d. 1519), to whom the reform of the Naskh style in Turkey is ascribed, and whose style has been used in Turkey to this century. There exist numerous album pages by him and his successors. All of them contain one or two lines in rather large Thuluth and an Arabic text in small Naskh. Most of them consist of sayings of the Prophet Muhammad; this page, however, contains an Arabic didactic poem about religious ambition, the first line of which is written once more in Thuluth at the top of the page. It became customary to mount such calligraphic works on marbled paper; the marbling throughout this album is of excellent quality.

Sheykh Hamdullah, son of Mustafa Dede, as he signed on the penultimate page of this album, came from a family of mystics in Amasya, Turkey; when his former pupil Bayezid II ascended the throne in 1483, Hamdullah followed him to Istanbul and was greatly honored by him.

92 Prayer Rug
Turkey (Bursa or Istanbul); Ottoman period, late 16th c.
Silk warp and weft, wool and cotton pile, ca. 288 Senneh
knots per sq. in.; 5 ft. 5 in. x 4 ft. 2 in. (1.65 x 1.27 m.)
The James F. Ballard Collection, Gift of James F. Ballard,
1922 (22.100.51)

93 Leaf of Calligraphy by Sheykh Hamdullah
Turkey; Ottoman period, ca. 1500
Ink, colors, gold on paper, marbled paper;
9 3/8 x 12 5/8 in. (23.9 x 32 cm.)
Purchase, Edwin Binney, 3rd and Edward
Ablat Gifts, 1982 (1982.120.3)

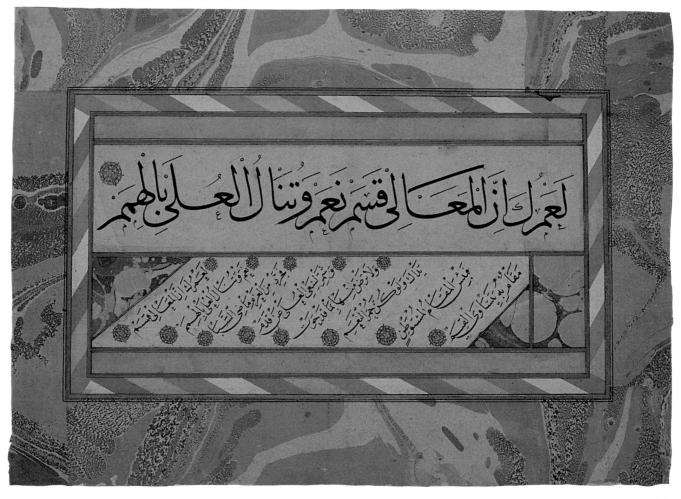

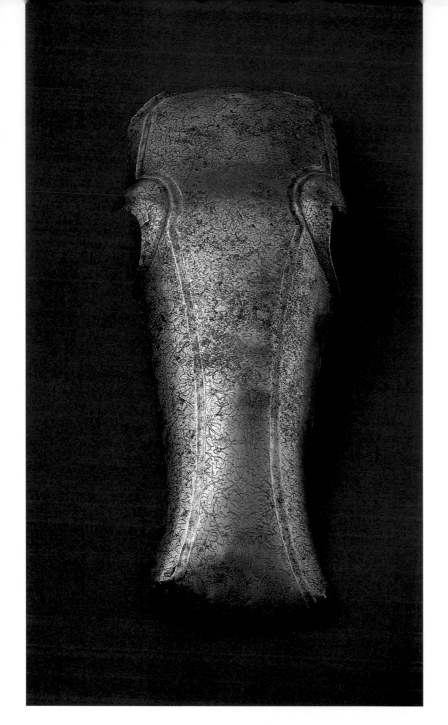

CHAMFRON

Gilt armor is frequently depicted in Ottoman miniature painting, worn by the horses of members of the imperial guard. It did, of course, vary in quality, and the finest examples are skillfully decorated with inscriptions from the Koran and with floral designs. The majority, however, are plain, but even these have a strength of design based on simplicity and linear clarity.

94 Chamfron
Turkey; Ottoman period, 17th c.
Copper gilt; 23¼ x 8¾ in. (59.1 x 22.2 cm.)
Bequest of George C. Stone, 1935 (36.25.496)

SABER

The hilt of this saber is a replacement; its guard is badly worn and has lost most of the rubies with which it was set, but its blade remains in almost mint condition. Carefully carved in relief and inlaid in gold, it bears an inscription from the Koran praising the omnipotence of God, His eternal nature, and His perfect knowledge. It also contains a passage (Sura 48) stressing God's forgiveness and the tranquillity that He sends into the hearts of those who resign themselves to divine direction. All of this is linked with verses relating the Koranic story of Solomon and the Queen of Sheba, ending with her abandonment of sun worship for the worship of God (Sura 27). Solomon is presented as an exemplary priest-king who is especially blessed by God and is one of the forerunners of the Prophet. He is endowed with divine wisdom and with magical powers.

The blade and guard are decorated in a style that was common in the sixteenth century, and it seems likely that the sword was made for a Muslim namesake of Solomon, probably the Ottoman sultan Suleyman the Magnificent (r. 1520–66).

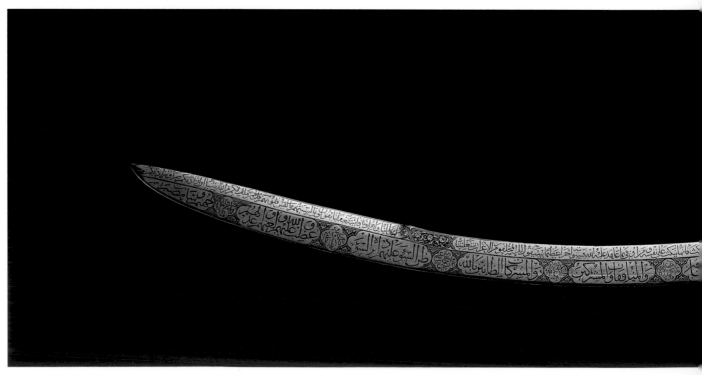

FIELD FLASK

Flasks of this type are related to the so-called "Pilgrim flasks," the form of which can be traced to pre-Islamic times. This example is worked in copper and shows some traces of gilding. It is engraved with large floral forms, some of which are enclosed in lobed medallions and interlacing knots. Around both faces is a heavy rim, and on either side of the neck is a ring for a chain. These features are probably survivals of a leather prototype—leather flasks were popular with the Ottomans, and luxury examples were even used as emblems of rank. The Museum's example can be dated to the seventeenth century, just at the end of the great flowering of Ottoman coppersmithing.

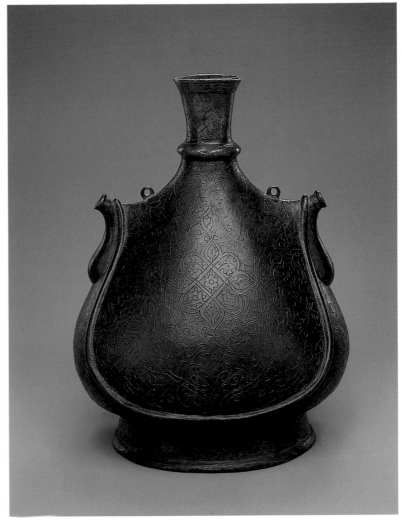

96 Field Flask
Turkey; Ottoman period, 17th c.
Copper, gilded; H. 8¼ in. (20.3 cm.)
Purchase, Alastair B. Martin, Schimmel Foundation, Inc.,
Mr. and Mrs. Jerome A. Straka, Margaret Mushekian, and
Edward Ablat Gifts, and Louis E. and Theresa S. Seley
Purchase Fund for Islamic Art, 1984 (1984.100)

95 Saber
Turkey; Ottoman period, 16th c.; grip prob. 18th c.
Steel, shagreen; L. 37⅞ in. (96.2 cm.)
Bequest of George C. Stone, 1935 (36.25.1297)

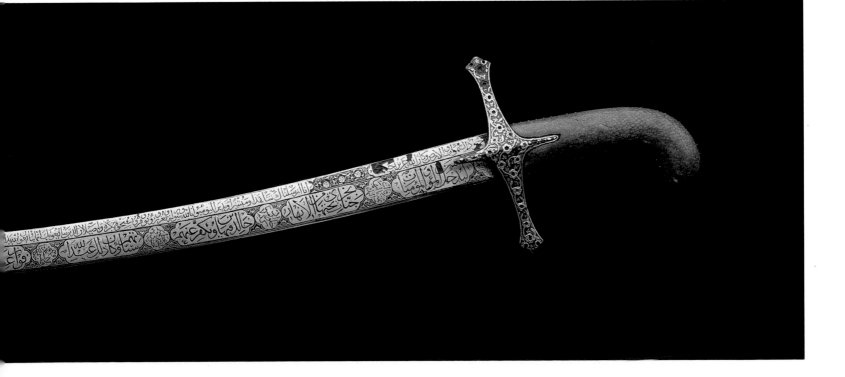

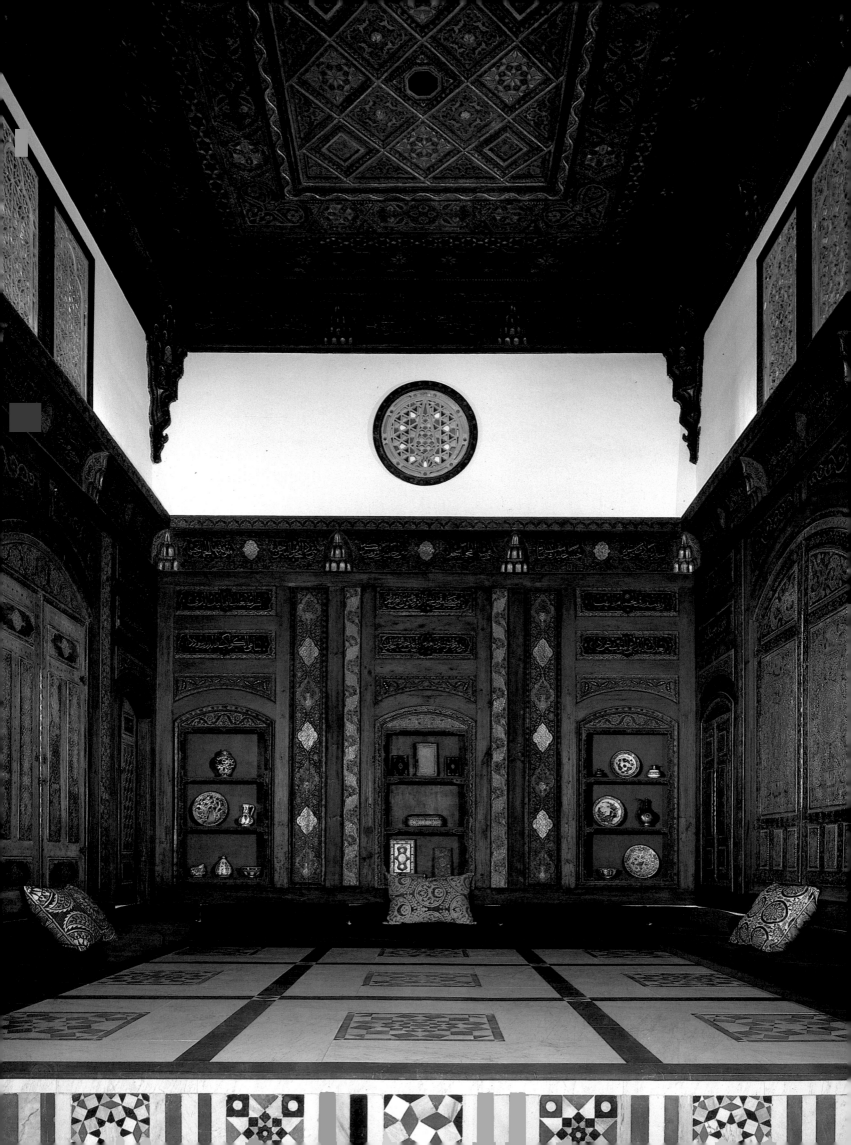

The Nur ad-Din Room

A Damascus house turned inward, cut off from the outside by sober high walls; it was entered indirectly from a bent entrance or inconspicuous vestibule leading to a central courtyard, which was the focus of family life. The splashing water in the fountain cooled the air, and sweet-smelling plants and flowers perfumed it and soothed the soul. Often fruit was placed in the fountain to cool before serving. From this centralized space, arched open rooms and closed reception units led off from the sides of the courtyard. In the warm weather, the shady open rooms and courtyard were the preferred living space, benefiting from the cooling shadows and breezes. In winter, the indoor spaces could be heated with braziers and warmed by rich carpets and colored cushions placed on low divans. Portable tables and trays provided additional furnishings.

This elegantly decorated room from Damascus, Syria, dated 1707, served as the reception area for the patriarch of the family and his male guests. It was divided into two areas, a small anteroom where the guests would leave their shoes and a raised, high narrow room where the visitors could recline on the cushions and partake of refreshments. A high-shouldered arch emphasizes the break between the two areas. The second fountain in the entrance also reinforces the importance of water in the life of the household. The sound of falling water, the subdued light filtered through the colored glass in the stucco windows, and the comfortable atmosphere created a soothing calm for all gatherings. Open niches held books and favored objects. Closets were used to store bedding, textiles, or other objects. Quarters for the women were located in a separate part of the house.

On the walls and cornices panels inscribed in Arabic contain poetry, followed by a eulogy to the Prophet Muhammad saying, "and the soul has no other need but the praise of Abu'l Qasim (Muhammad), the guide, the glorious prophet."

97 *The Nur ad-Din Room*
Syria; 1707
Wood, marble, stucco, glass, mother-of-pearl,
ceramics, tile, stone, iron, colors, gold;
22 ft. ½ in. x 16 ft. 8½ in. x 26 ft. 4¾ in.
(6.72 x 5.09 x 8.04 m.) Gift of
The Hagop Kevorkian Fund, 1970 (1970.170)

Below: fountain at entryway

98 Stone Relief Inscription Panel
India (Deccan, prob. Hyderabad area);
late 16th–17th c.
Black basalt; H. 11 in. (27.9 cm.),
total L. 77½ in. (196.9 cm.)
Louis V. Bell Fund, 1986 (1986.145)

INSCRIPTION PANEL FROM AN INDIAN MOSQUE

The inscription on this panel is in monumental Thuluth, and contains Sura 9, verse 18 of the Koran: "God Most High and Blessed and Holy says: Only he shall visit the mosques of Allah who believes in God and the last day and performs the ritual prayer and pays the alms tax and fears none but God, perhaps these are the ones that are guided on the right path." In the upper left corner, the word *Muhammad* is curiously written in reverse.

The monumental Thuluth is so classical in its form that it is very difficult to assign an exact date or provenance to the panel, although the type of stone is associated with the Deccan, in southern India. This striking calligraphy suggests a late sixteenth- to seventeenth-century date, a period when the Muslim art of the Deccan was at its finest.

LEAF FROM AN ANTHOLOGY OF PERSIAN POETRY

This leaf belongs to a work in Persian verse entitled *Mu'nis al-Ahrar fi Daqa'iqi l-Ash'ar* (*The Companion of the Free on the Subtleties of Poesy*), which is an encyclopedic anthology of Persian poetry by the little-known son of a prominent poet of Iran under the Mongols, Badr al-Din Jarjami, of the early fourteenth century. The manuscript is of particular interest in that the author gives in his neat Naskh script the date (A.H. 741) but not the place where he composed it.

> It was in the month of Ramadan, in the year 741 A.H., when the sun was in Pisces and the moon was in Cancer, that, by the Grace of God, this collection by the hand of Muhammad ibn Badr was completed. (Quoted from "An Account of the Mu'nis al Ahrar: a Rare Persian manuscript belonging to Mr. H. Kevorkian" by Mirza Muhammad ibn Abdu'l Wahhab of Qazwin, in *The Bulletin of the School of Oriental and African Studies*, London University, vol. V, 1928–30, p. 98)

The leaf illustrated here shows three horizontal paintings, each with the personification of the moon and a sign of the zodiac, starting at the top with the Archer (Sagittarius, Qaus), the Goat (Capricorn, Jadi) and the Watering Pot (Aquarius,

Dalw). The background of this leaf and many others in the manuscript is red, of a shade and density that suggest an Indian provenance, as do other uses of color, such as a mauve robe against the red ground. The robust liveliness of both human and animal figures is characteristically Sultanate as are such details as the even, abstract lines of the folds on the robes worn by the top and bottom moon personifications, and the braided effect achieved by the shading of the bricks of the well wall in the Aquarius picture. The brittle quality of the paper is shared by other Sultanate Indian manuscripts.

A problem yet to be solved in regard to this manuscript concerns the author. Did he travel or immigrate to India, and did he then write the manuscript there? Or did the completed text make its way to India to be illustrated there? The paintings are clearly close in date to the completion of the text, but the other questions must for the present remain unsolved. The study of painting at the Muslim centers in India during the fourteenth century is in its infancy. It appears, however, that then, as in the fifteenth century, it was greatly influenced by the painting of the Persian city of Shiraz, a thriving center of culture and trade.

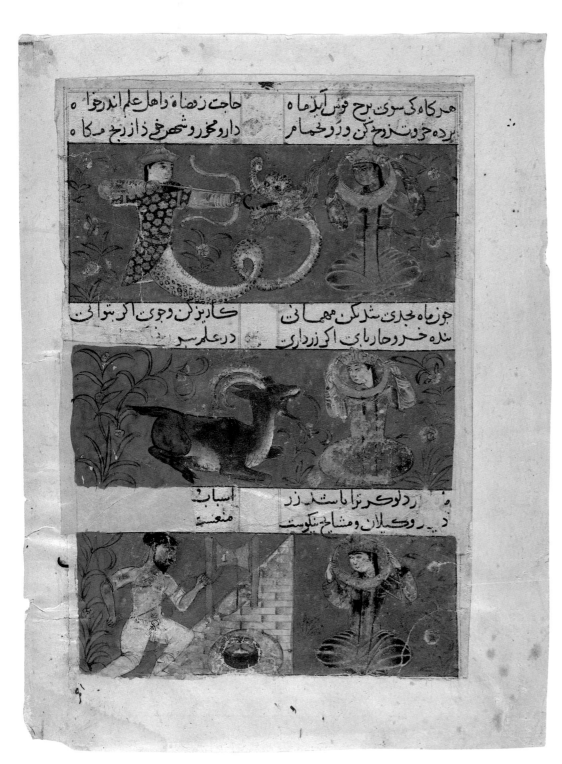

99 *Leaf from an Anthology of Poetry*
by Muhammad ibn Badr Jarjami
prob. India; Sultanate period, A.H. 741, A.D. 1341
Ink, colors, gold on paper;
8 x 5½ in. (20.3 x 14 cm.)
The Cora Timken Burnett Collection of
Persian Miniatures and Other Persian
Art Objects, Bequest of Cora Timken Burnett,
1956 (57.51.25)

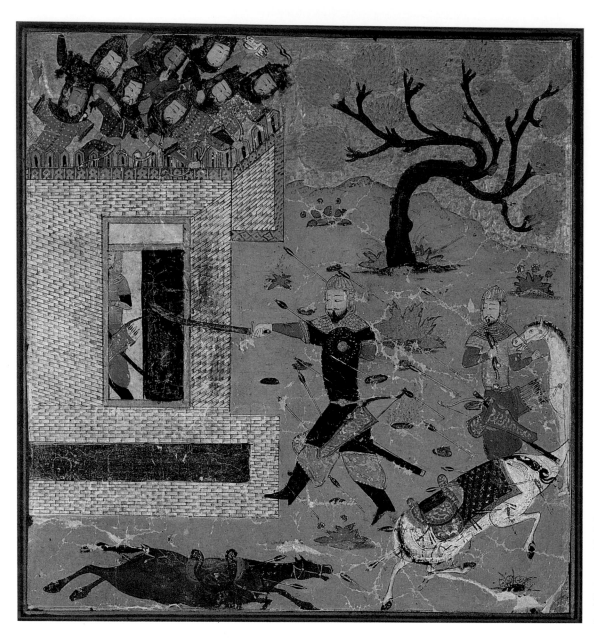

*100 "Bizhan Forces Farud to Retire
into His Fort": Leaf from a Dispersed
Shah-nameh of Firdausi*
Western India; Sultanate period,
1430–35
Ink, colors, gold, silver on paper;
7¹³⁄₁₆ x7⅛ in. (19.8 x 18 cm.)
Grinnel Collection, Bequest of
William Milne Grinnel, 1920
(20.120.247)

BIZHAN FORCES FARUD TO RETIRE INTO HIS FORT

The episode illustrated here is a prelude to the tragic death
of the half-brother of the newly found and crowned Iranian
king Kai Khusrau. In sending an army into Turan to avenge
the murder of his father, Siyavush, Kai Khusrau ordered
his general, Tus, to avoid the border lands of his half-
brother, Farud. Tus ignored the warning and the inevitable
confrontation between the Iranian army and an isolated and
inexperienced prince could have but one conclusion. The
intrepid young Farud, however, before his inaccessible
mountain fortress, was able successfully to defy several of
Iran's hero-warriors sent against him in single combat until
the appearance of the youthful Bizhan, son and grandson
of the great Persian paladins Giv and Gudarz. When Farud
shot Bizhan's horse out from under him, instead of retreat-
ing as had the other paladins, Bizhan pursued him on foot,
killing his horse in turn. As shown in the illustration, the
disconcerted young prince was barely able to bolt back into
his fortress.

In the *Shah-nameh,* the poet Firdausi appears to have had

a soft spot in his heart for the impetuous Bizhan that is
reflected, perhaps fortuitously, by his placement in this paint-
ing. He occupies the center of the stage, his towering figure
seeming to dwarf the slain horses in the foreground, while
Farud, the wronged victim of fate, is barely discernible
through the open doorway.

In spite of the evident debt to Iranian painting, particu-
larly the school of Shiraz, the picture is characteristic of the
Sultanate period in India, before the advent of the Mughals.
The almost square format; the direct approach to narra-
tive, heightened by the use of scale for dramatic effect, as
in the figure of Bizhan; the disregard for architectural plau-
sibility; the rhythmically repeated pattern of the archers at
the battlements—whose arrows have found targets in horses
already dead and a hero very much alive; the almost gal-
vanic curves of the tree; and finally, the choice of palette,
especially the light green mat ground, may all be associated
with Sultanate India. The painting clearly gains in charm
what it may lack in sophistication.

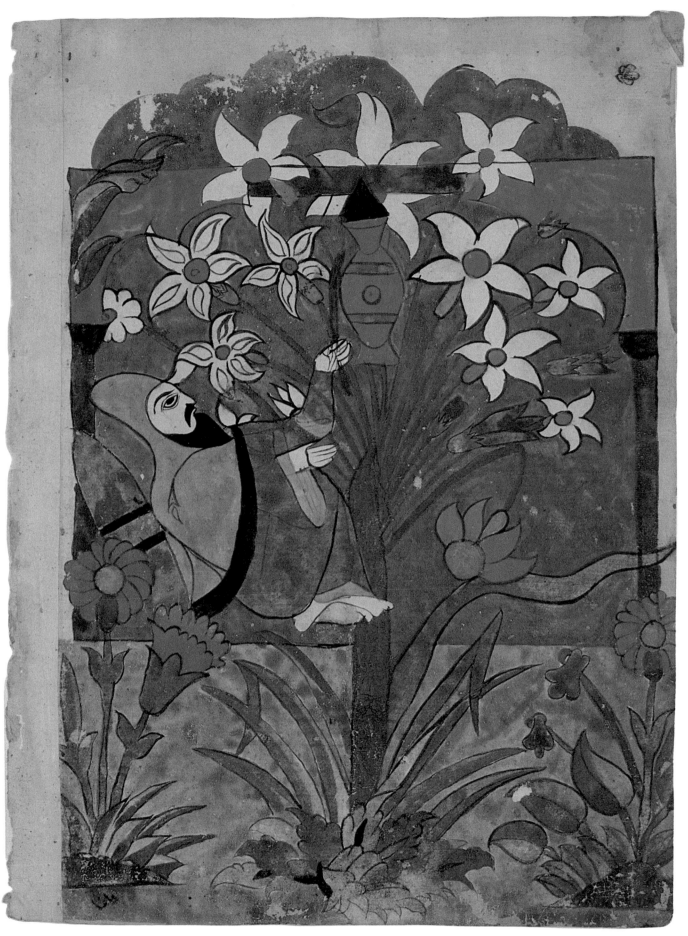

101 *"The Ascetic Striking the Jar of Honey and Oil"*:
Leaf from Bidpai's Kalilah and Dimnah
India (Gujarat); mid-16th c.
Ink, colors on paper; 12½ x 8⅞ in. (31.8 x 22.6 cm.)
The Alice and Nasli Heeramaneck Collection, Gift
of Alice Heeramaneck, 1981 (1981.373.79v)

Page 132: text

131

The Ascetic Striking the Jar of Honey and Oil

(Page 131)

An ascetic who was allotted a daily supply of honey and oil stored leftovers in a pot hung above his bedstead. He had a wondrous dream one night: he would sell the oil and honey and buy ten she-goats, which would bear so many young that after five years he could have a yoke of oxen and a cow, making him so rich in corn and oil and servants and maidservants that he could afford a wife and have a son so bright that he would become secretary to the king! In the excitement of the dream he brandished his staff—and smashed the pot, which spilled all the precious oil and honey onto his foolish head.

The Indian fable spread through the Islamic world. Its best-known illustrations were painted in Mamluk Egypt, whence their compositions returned to India, where this appealingly simplified account from the sultanate of Gujarat was made, based upon Mamluk prototypes. But other influences are also apparent. The palette glows like that of Sirohi—a Rajasthani school near the border of Gujarat—while the flowers recall the style of Ottoman Turkey, the result of close trading contacts and an extended, threatening visit by the Ottoman fleet, several of whose officers remained in Gujarat to serve the sultan.

Vigorous styles such as this move dynamically. Earthily folkloristic and intense, it influenced painting at the Mughal court following Emperor Akbar's conquest of Gujarat.

A Prince Receives a Holy Man

Mughal India was founded in 1526 by Emperor Babur (r. 1526–30), a prince from Central Asia descended from both Timur and Genghiz Khan, who inherited the throne of Fergana at the age of twelve. After many attempts to expand his kingdom, he crossed through the Himalayan passes and defeated the armies of both the sultans of Delhi and the Rajputs in 1526. He died a few years later, leaving a frail and threatened kingdom to his son Humayun (r. 1530–56). Babur's *Memoirs* (*Waqiat-i Baburi*) reveal the keen love of nature and accurate observation of life always characteristic of Mughal art.

Emperor Humayun was forced into exile in Safavid Iran where Shah Tahmasp not only showed him marvelous miniatures but permitted him to invite several of their artists (Mir Sayyid-'Ali, 'Abd as-Samad, and Dust-Muhammad) to return with him to India when he regained power in 1555. The Mughal ateliers, therefore, were directed by technically and artistically remarkable artists who trained many Indian-born painters. An extraordinary new synthesis was under way when Emperor Akbar (r. 1556–1605) inherited the throne at the age of fourteen. He encouraged his artists to illustrate such tales as the adventures of Amir Hamza in a style as vital as his own dynamic personality. Painted on cotton, there were once 1,400 of these particularly large pictures, which are among the most visionary of Indian art.

102 "A Prince Receives a Holy Man":
Leaf from the Dastan-i Amir Hamza
(Story of Amir Hamza)
India; Mughal period, ca. 1570
Colors on cloth, mounted on paper;
27⅞ x 21⅝ in. (70.8 x 54.9 cm.)
Rogers Fund, 1924 (24.48.1)

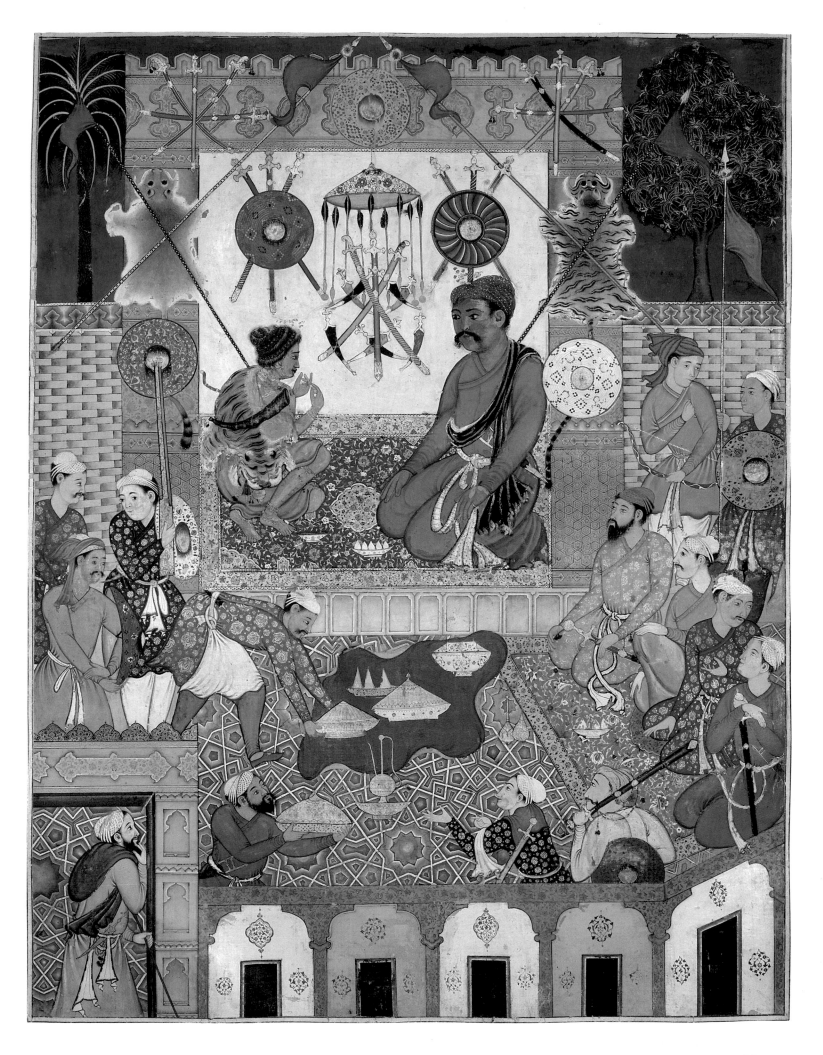

KRISHNA LIFTS MOUNT GOVARDHAN

To encourage understanding between Muslims and Hindus —the two major religious communities of his realm—Akbar commissioned illustrated Persian translations of Hindu epics. In this miniature the youthful god Krishna lifts a mountain to save villagers from the wrath of Indra. Villagers, animals, trees, and even the storm and the blue god are described with characteristic Mughal objectivity and insight.

By 1590, the explosive power of Akbar's expansive younger days—reflected in the composition of the Hamza picture —had calmed, and he encouraged greater subtleties of technique and interpretation in his ateliers. Individual figures, such as the grateful mother wearing green (on the right, just beneath the mountain), and the washermen (on the left),

are true portraits. Although Miskin was trained to paint with utmost finesse by artists from Shah Tahmasp's court (Mir Sayyid-'Ali and 'Abd as-Samad), his down-to-earth observation and energy owe much to the emperor's guidance.

An insightful contemporary account of Akbari painting is given by his official biographer, Abu'l Fazl in the *A'in-i Akbari* (*Statutes of Akbar*): "Most excellent painters are now to be found, and masterpieces worthy of a Bihzad may be placed at the side of the wonderful works of the European painters who have attained worldwide fame. The minuteness in detail, the general finish, the boldness of execution, etc., now observed in pictures are incomparable; even inanimate objects look as if they had life."

103 "Krishna Lifts Mount Govardhan":
Leaf from a Harivamsa (The Genealogy of Hari):
prob. by Miskin; India; Mughal period, ca. 1590
Opaque watercolor on paper; 11⅜ x 7⅞ in. (28.9 x 20 cm.)
Purchase, Edward C. Moore, Jr. Gift, 1928 (28.63.1)

Below: detail

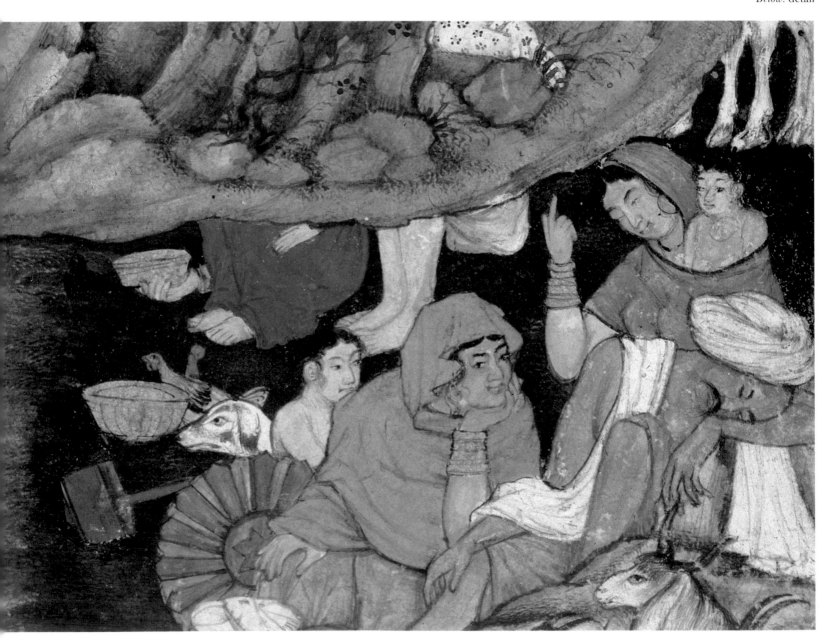

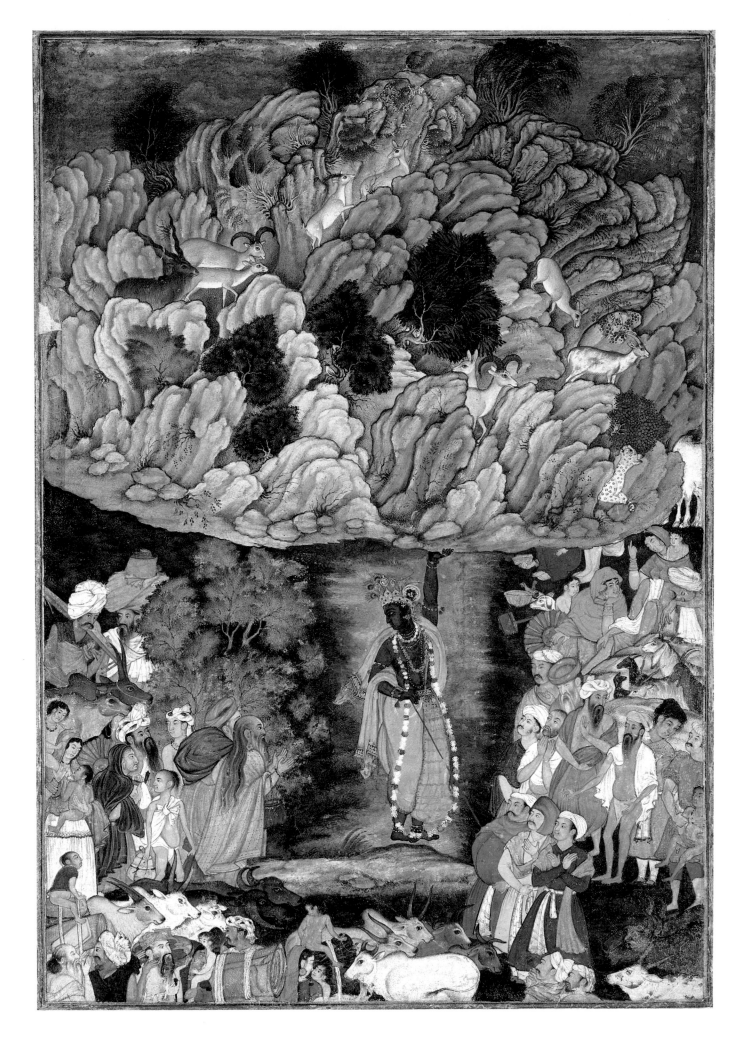

BUFFALOES IN COMBAT

These snorting, stamping buffaloes—two varieties of the same species—were drawn and tinted by Miskin, Akbar's most incisive animal painter, in recollection of an actual combat staged for the entertainment of the emperor and members of his immediate circle. Animal combats, whether between elephants, buffaloes, tigers, or smaller beasts, were frequent events at court, viewed by the emperor and his guests from a terrace or rampart. Sketching from life, the artist must have sat near the noble onlookers, who took bets on the outcome—as did the animals' grooms—and encouraged their favorites with ardent loyalty.

Miskin's draftsmanly style is unmistakable, and his gift for conveying both the inner spirit and outer form of animals probably inspired Akbar to summon him for the present assignment. Not even the great Basawan surpassed Miskin in capturing such dramatic details as the buffaloes' expressions of victorious exultation and gored despair. The loser in such a combat might be turned into a *mashk*, a leather waterbag, such as the one shown here being used to keep down the dust.

By delicate modulations of tone, which he achieved with invisibly small brushstrokes, Miskin modeled the animals' masks and bodies into tautly rounded forms reminiscent of Achaemenid animal reliefs, curvaceously ornamental yet starkly powerful. But unlike the Achaemenids, the Mughal artist stopped action at the most telling instant and achieved such a degree of empathy that we are practically able to hear the animals' bellowing.

104 "Buffaloes in Combat" attrib. to Miskin
India; Mughal period, late 16th c.
Brush and ink with color on paper;
6⅞ x 9½ in. (17.5 x 24.1 cm.)
Harris Brisbane Dick Fund, 1983
(1983.258)

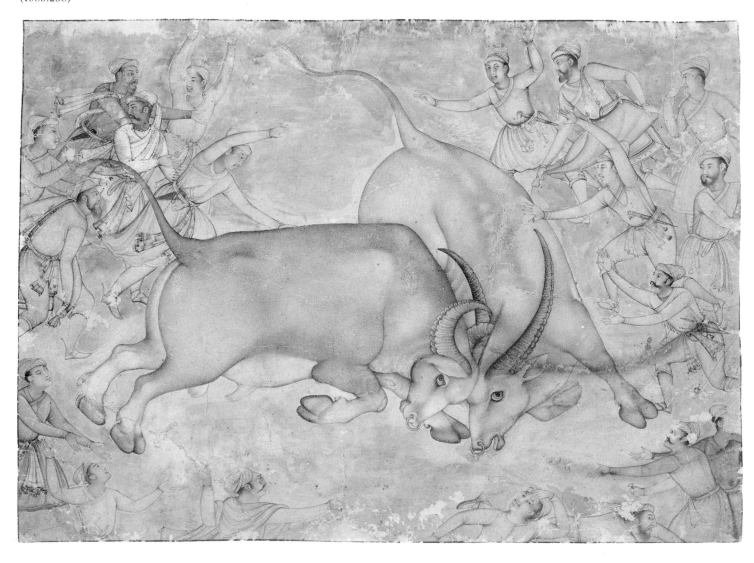

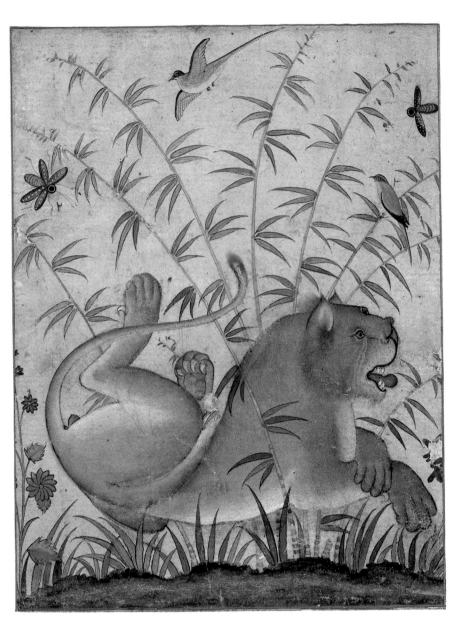

105 *"A Lion at Rest"*
India; Mughal period, ca. 1585
Ink, colors, gold, silver on paper;
8 x 6 in. (20.3 x 15.2 cm.)
The Alice and Nasli Heeramaneck
Collection, Gift of Alice Heeramaneck,
1985 (1985.221)

A LION AT REST

The lion, King of Beasts, has been the focus of imagists, both pictorial and literary, in many cultures, including the Islamic world, where he was a prime symbol of royal power, and, astrologically, of solar power. The nobility of the beast qualified it as a means of measuring the courage of kings and princes set in combat against it. Prince Bahram Gur, for example, fought a pair of lions to capture the crown of Iran, which had been placed between them. His success led the hitherto reluctant nobility to accept him as king.

The image of the lion appears in different guises in the complex and varied threads that make up the fabric of Islamic art history. The great Seljuk incense burner (Plate 27), for example, monumentally abstract as it is, could not be more of a contrast to the beast depicted in this painting taking its ease in a bamboo thicket by a stream.

The resting beast dominates the composition. The artist, who was clearly quite sensitive to the growing bent toward naturalism in Mughal taste, has captured the very essence of the animal, from its latent power to the total relaxation of a supremely supple feline. The exaggerated curve of the spine, however, is due to art rather than nature and sets up its own rhythms as it elongates into the backward-curling tail and doubles back into the turn of the bent haunch. The hind legs, thrust out to one side, are a foil for the front paws, which are lightly crossed over one another and languidly drooping. The idyllic quality is further enhanced by the decorative fanning out of the bamboo stalks, the picturesque birds, insects, and plants, all of which defy identification. The even, light, tawny ground harmonizes with the deeper tawniness of the lion.

The painting appears to date from the early Akbari period when the lyricism and idealization inherited from Persian art lingers and contrasts with the burgeoning naturalism of art under the Mughals.

106 "Plato Gives Advice to Iskander": from a **Khamseh**
(Quintet) *of Amir Khusrau of Delhi attrib. to Basawan*
India; Mughal period, 1597–98
Ink, colors and gold on paper; 9⅞ x 6¼ in. (25 x 15.8 cm.)
Gift of Alexander Smith Cochran, 1913 (13.228.30)
Opposite: detail

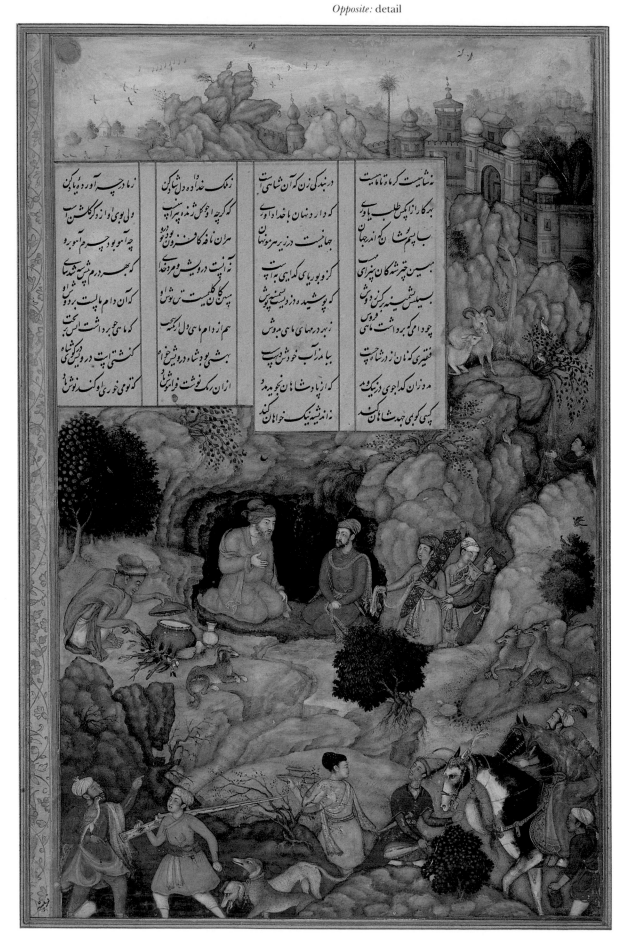

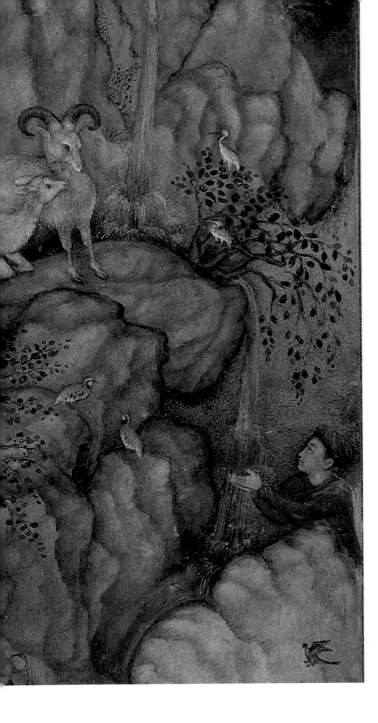

OVERLEAF:

WHITE MARBLE SCREEN *(Page 140)*

Emperor Akbar, who in effect refounded and established the Mughal empire, died in 1605 and was succeeded by his responsible but pleasure-loving son, Jahangir (r. 1605–27). This *jali* (marble screen) is similar to those commissioned by Jahangir, whose name means "world-seizer," to adorn his father's tomb and garden complex at Sikandra. Although Muslim designers and artist-craftsmen had lavished inventiveness on such geometrical ornament over many centuries, the masterful stonecutting of this screen is in the great tradition of Indian masonry. With its stately but joyous interplay of powerful zigzags and polygons, it combines the robustness of Akbar's architectural taste with the refinement preferred by his more connoisseurly son. Like most Mughal art, it conforms to human needs and feelings. Ornamental yet practical, it is perfectly suited to the changeable climate of northern India, blocking the sun's heat on warm days and storing it on cool ones. While allowing free passage of air, it provided security and a degree of privacy. Although impossible to see through from a distance, its narrow openings nevertheless allowed friends to exchange glances and whispers or to pass notes. So forceful and imposing is this fragment that it communicates the flavor of the whole.

OVERLEAF:

CARPET *(Page 141)*

During the reign of Akbar, carpet weavers were established in the Mughal cities of Lahore, Agra, and Fathpur Sikri, beginning a craft tradition that continues to be vital to this day. The impetus for the weaving of knotted-pile carpets probably came with the introduction of weavers from Iran, sometime in the early Mughal period. Many descriptions by European travelers to the Mughal courts, as well as Mughal records, describe the wealth of textiles and carpets that were used to decorate and furnish imperial Mughal palaces, tents, and garden pavilions.

Pictorial carpets from sixteenth-century Iran hint at the origin of the design on this splendid carpet. Scenes of animals in combat or hunting were probably adapted for patterns on carpets from Persian miniature paintings, indicating that court artists must have been instrumental in supplying designs or patterns for the production of woven fabrics. This composition clearly illustrates a combination of Persian and Indian concepts. A formal Persian landscape inhabited by mythical beasts, birds, and hunted and hunting animals pulses with the life and vigor of Mughal inspiration. Delicate trees placed on rocks and flowers echo Persian style, contrasting vividly with the sturdy Indian palm tree and naturalistic portrayal of birds and animals.

PLATO GIVES ADVICE TO ISKANDAR

After expanding and stabilizing the empire—and experiencing a strengthening vision—Akbar commissioned a series of especially fine manuscripts of literary classics, such as this *Quintet* by the Sultanate poet Amir Khusrau (d. 1325). Like the rest of the superb group, this volume was copied by a masterful scribe and illustrated by the most admired artists of his ateliers. Although pictures for many projects were designed by masters and colored by assistants, each of these was wholly by a major artist. Basawan, to whom this miniature can be assigned, was described enthusiastically by Abu'l-Fazl: "In designing and portrait painting and coloring and painting illusionistically and other aspects of this art he became unrivaled in the world" The most painterly of Mughal artists, Basawan was also a penetrating student of personality, whose incidental figures—such as the attentive cook (on the left)—interested him as much as the major players in his painted dramas. His attunement to animals is evident in the cook's hungry but disciplined dog (on the left) and in the foxes he keeps at bay (on the right).

107 White Marble Screen (jali)
India (prob. Agra); Mughal period, ca. 1610
Marble; 48⅛ x 16½ in. (122.2 x 41.9 cm.)
Rogers Fund, 1984 (1984.193)

Page 139: text

108 Carpet (detail); India; Mughal period, early 17th c.
Cotton warp and weft, wool pile, ca. 120 Senneh knots
per sq. in.; 27 ft. 4 in. x 9 ft. 6 in. (8.33 x 2.9 m.)
Gift of J. Pierpont Morgan, 1917 (17.190.858)

Page 139: text

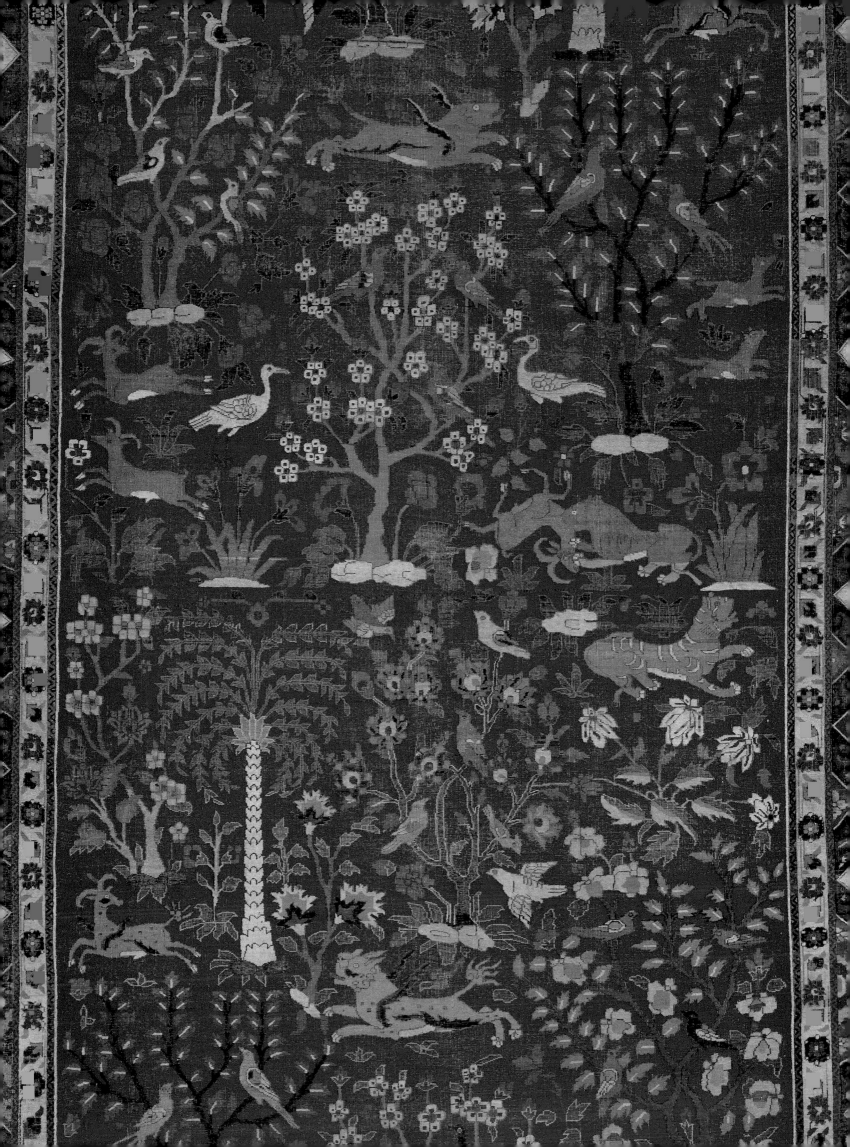

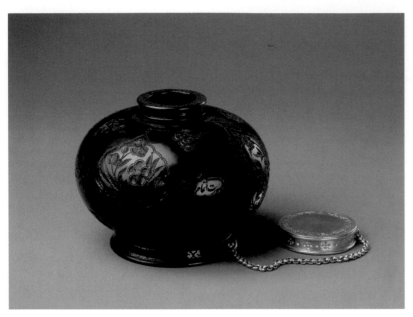

109 Inkpot of Emperor Jahangir
India; Mughal period, 1618–19
Dark green nephrite jade, mounted in gold;
H. 2½ in. (6.4 cm.), D. 3¼ in. (8.3 cm.)
The Sylmaris Collection, Gift of George Coe
Graves, 1929 (29.145.2)

INKPOT OF EMPEROR JAHANGIR

Sturdy, monumental, artfully rounded, richly adorned, and so weighty and well balanced that it could hardly be overturned, this dignified and useful inkpot can be seen as a poetic visual symbol of the empire inherited by Jahangir. If his father, Akbar, commissioned works of art as elements of a dynamic imperial vision, the son did so for delectation and spiritual nourishment. His miniatures, architecture, objects, and autobiography, the *Tuzuk-i Jahangiri*, reveal him as a responsible—if quirky, warm-blooded, and sometimes cruel—ruler, whose aesthetic concerns left enough time and energy for essential statecraft. Few rulers in world history match him in artistic discernment or breadth of taste. He collected pictures and objects from the Islamic world and beyond: Chinese porcelains, Augsburg gilt-bronze statuettes, engravings by Dürer and the Flemish mannerists, and Renaissance jewels as well as Persian miniatures. On coming to the throne, he released a large proportion of the imperial artists and craftsmen to feudatory courts and to the bazaar workshops, keeping only those whose work met his standards of seriousness and restraint. Indeed, the objects and pictures he commissioned belie his legendary frivolousness.

DAGGER

The hilt of this dagger is fabricated from gold over an iron core, and its scabbard fittings are of solid gold. All of the intricately engraved golden surfaces are set with gems and colored glass finely cut with floral forms. The bifurcate hilt and the floral forms are styles popular during the seventeenth century, probably in the reign of Emperor Jahangir. It seems likely that the dagger was part of a set of weapons and other objects crafted in the royal atelier. Swords and daggers were emblems of rank and thus indispensable items of dress for the Mughal nobility. The memoirs of Jahangir record innumerable occasions when such objects were either received as gifts or bestowed upon a loyal retainer. A luxurious example such as this could only have belonged to a noble of the highest rank.

110 Dagger
India; Mughal period, early 17th c.
Watered steel blade, gold hilt, locket and chape inlaid
with emeralds, rubies, spinels, glass; L. 14 in. (35.6 cm.)
Purchase, Harris Brisbane Dick Fund and The Vincent
Astor Foundation Gift, 1984 (1984.332)

111 *"A Nilgai": Folio from an Album by Mansur*
India; Mughal period, ca. 1615
Ink, colors on paper; Folio 10 x 15½ in. (25.4 x 38.7 cm.)
Purchase, Rogers Fund and The Kevorkian Foundation
Gift, 1955 (55.121.10.13)

Opposite: recto, a Persian narrative poem about a physician
in the city of Merw who was so beautiful that everyone
wanted to be ill; calligraphy by Mir-'Ali of Herat.

A NILGAI

Although flora and fauna were beloved by the Mughals from the age of Babur onward, Jahangir's natural-history studies are the most sensitively incisive and exquisitely finished in a long tradition. In this folio from an imperial album, the vivid arabesques of the border rippling with large and identifiable blossoms and foliage are nevertheless outshone by the central image, a particularly noble *nilgai*, or blue bull, probably from the emperor's zoological preserve. The portrait was endowed with animal wisdom by one of the emperor's favorite artists, Ustad (Master) Mansur, whom he honored as Nadir az-Zaman (Wonder of the Time). A specialist in botanical and animal subjects, Mansur frequently accompanied Jahangir on hunting trips and visits to Kashmir, the favorite imperial retreat. In him the talents of a disciplined, perceptive, and objective naturalist joined with those of an inspired draftsman and painter.

Usually a stolid and awkward animal, this *nilgai* silhouetted against a roseate tan ground is uniquely elegant and imposing. The appealing abstraction and precise rendering of forms and textures are well suited to Jahangir's albums, a microcosm of delights in which portraits of family, friends, and fellow rulers alternate with specimens of calligraphy and illumination, disparate miniatures, European prints, and delightful studies from nature.

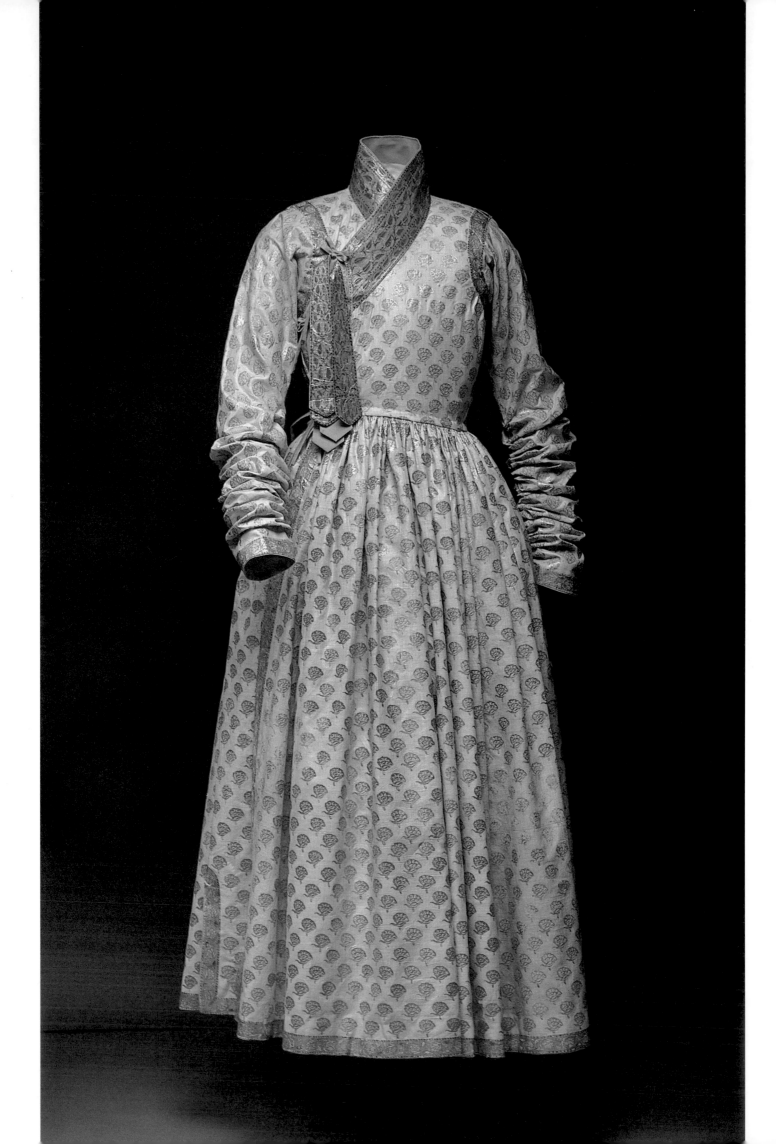

SHAH JAHAN NIMBED IN GLORY *(Page 148)*

The quintessential Mughal emperor, Shah Jahan (r. 1628–58), came to the throne following an active and successful military career, marred by troubled relations with his father. Under his peaceful rule, the Mughals reached new peaks of might and grandeur as well as new levels of religious orthodoxy and courtly formality. Impassioned by architecture and jewels, Shah Jahan built the famed Taj Mahal as the tomb of his beloved wife, Mumtaz Mahal, who died in childbirth. He was also a serious patron of painting and calligraphy who especially admired jewel-like color and finish.

His portrait from a royal album by Chitarman, a Hindu artist, emphasizes formal magnificence and presents him, as usual, in supremely aristocratic profile. The unapproachable image of empire—Shah Jahan's eyes will not meet ours—he stands on a marble platform, bereft of humanizing wrinkles or other suggestions of mortality, holding and gazing upon a portrait of himself. Every immaculate curl or crystalline detail of costume, textile, and jewelry is of such perfection as to isolate the emperor in his paradise on earth —a factor that contributed to the empire's gradual decline.

113 "Shah Jahan Nimbed in Glory" by Chitarman
India; Mughal period, 1627/28
Ink, colors, gold on paper; 15⅜ x 10⅛ in.
(39.1 x 25.7 cm.)
Purchase, Rogers Fund and The Kevorkian
Foundation Gift, 1955 (55.121.10.24)

MAN'S ROBE

The early Mughal rulers, Akbar and Jahangir, were interested in fashion, stuffs, carpets, and ornamental textiles. Both emperors had a penchant for inventing new names for garments and other clothing. Akbar is recorded as having ordered a new coat or dress with a round skirt to be tied on the right side. This *jama* may be a later version of the Akbari garment. Its lengthy sleeves would have been gathered up on the arm when the dress was worn.

In a painting of Shah Jahan (see Plate 113), he is seen to be wearing a similar garment tied with lappets on the right. He is also dressed in tight-fitting trousers, a colorful sash holding a dagger, and a bejeweled turban. Grandees of the realm wore similar clothing but dressed according to their rank. Sometimes, individual nobles were given robes of honor by the emperor as a mark of distinction.

112 Man's Robe (jama)
India; Mughal period, 2nd half 17th c.
Painted cotton with applied gold leaf;
L. 55 in. (139.7 cm.)
Rogers Fund, 1929 (29.135)

ROSETTE BEARING THE NAME AND
TITLES OF EMPEROR SHAH JAHAN *(Page 149)*

Few Mughal paintings surpass the sunlit splendor of this illuminated frontispiece to a royal album. Specially trained artists devoted their lives to painting such arabesque designs, patiently concentrating upon each tiny flower or tendril to bring alive a whole that is as intricately segmented and orderly as a heavenly beehive. Marginal drawings in gold of birds, dragons, and Simurghs often, as here, intensify their celestial spirit. Although comparable illuminations are found throughout the Islamic world, Mughal ones—like Mughal figural compositions—are more amply rounded and tend to glow with warmer hues.

The gloriously curvilinear calligraphic cipher in tughra style—reminiscent of marble inlays on the façade of the Taj Mahal—is by an inventive but anonymous calligrapher.

*114 Rosette Bearing the Name and Titles of Emperor Shah
Jahan: Opening Page from the* Kevorkian Album
India; Mughal period, ca. 1645
Ink, colors, gold on paper; 15¼ x 10⁷⁄₁₆ in.
(38.7 x 26.4 cm.)
Purchase, Rogers Fund and The Kevorkian
Foundation Gift, 1955 (55.121.10.39)

148

149

Dagger

The milky-white nephrite hilt of this dagger is carved with tiny flowers and acanthus leaves. It is perhaps the most sensitively carved nephrite hilt in the Museum's collection; the closest parallel is a jade cup carved for Emperor Shah Jahan in 1657. The curled pommel is of a form that appears on sword and dagger hilts during the seventeenth century. It has been variously suggested that this is a refinement of the crooked pommel designed to prevent the hand from losing its grip, or that it was a decorative feature indigenous to the Deccan, and introduced from there into northern India by Aurangzeb (r. 1658–1707) while he was still a prince. Comparison with the Shah Jahan cup marks this hilt as a product of the imperial workshops. It has been suggested that it was made for Aurangzeb shortly before his ascension to the Peacock Throne.

115 Dagger
India; Mughal period, ca. 1650
Nephrite, watered steel; L. 14⅜ in. (35.6 cm.)
Purchase, Mr. and Mrs. Nathaniel Spear, Jr.
Gift, 1982 (1982.321)

Dagger

Mughal sculptors excelled in the production of animal-headed dagger hilts. These were most often carved from nephrite and were worn at the waist as dress accessories. There was also a belief that nephrite protected the wearer against disease. Most of these dagger hilts were carved with horses' heads. Mughal jade carvers and painters delighted in realistic depictions of animals, and this imperial style reached its height during the seventeenth century. The *nil-gai*, or blue bull, is one of the most beautiful animals found in India. The hilt of the Museum's dagger is carved from a bluish-green nephrite that approximates the color of the beast. But the realism extends far beyond its color; and it is such an accurate and sensitive representation that one wonders whether it might have been carved from a specific model, perhaps from one of the captive animals kept in the imperial zoo.

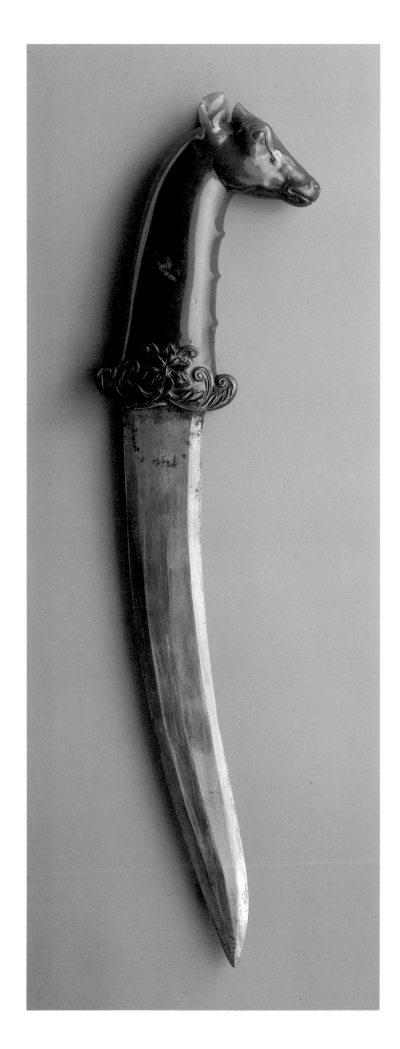

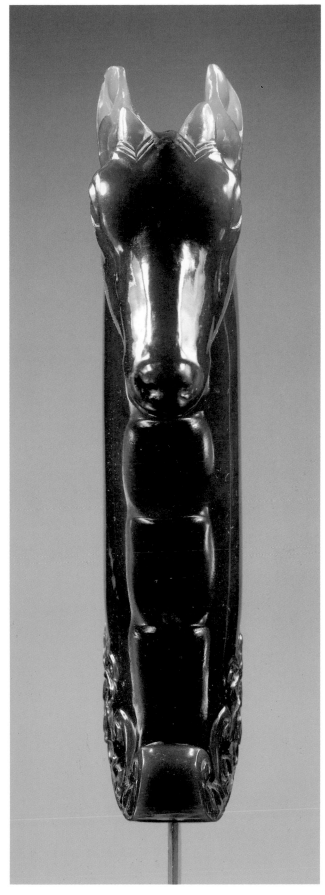

116 Dagger
India; Mughal period, mid-17th c.
Nephrite and steel; L. 15 in. (38.1 cm.)
The Alice and Nasli Heeramaneck Collection,
Gift of Alice Heeramaneck, 1985 (1985.58a)

Above: detail

HOOKAH BASE

When tobacco reached the Mughal court in 1604, doctors warned that it was detrimental to the health. Nevertheless, smoking came into vogue, especially when inhaled through a purifying and cooling water pipe or hookah. Smoking became so popular during the seventeenth century in India, Turkey, and Iran that artist-craftsmen of great talent devised remarkable objects to augment its ceremonial pleasures: mouthpieces of jade, amber, or precious metal; splendidly adorned flexible tubes; opulent finials for the *chillum* in which the tobacco burned; and, above all, bases to contain water. In India, many of these were manufactured at Bidar in the Deccan, where a special technique of inlaying brass, silver, or gold into an alloy of zinc, tin, and copper had been developed by the late sixteenth century. Rooted in the vigorous traditions of Islamic metalwork, so-called Bidri work adapted motifs from many sources. Generations of artful and ingenious designers traced and reshaped motifs from textiles, jewelry, and architectural ornament in order to satisfy the varying and changing tastes of patrons in many parts of India. By the mid-seventeenth century, when the earliest datable examples were made, Mughal influence predominated. Nevertheless, the bold and lively flower so sensitively repeated around this globular hookah base also brings to mind the zestfulness of Ottoman ornament and recalls such precursors as the stylized flowers brought to India from China via Central Asia and Turkman Iran.

117 Hookah Base
India (Deccan, Bidar); last quart. 17th c.
Alloy inlaid with brass;
H. 6⅞ in. (17.5 cm.), D. 6½ in. (16.5 cm.)
Louis E. and Theresa S. Seley Purchase Fund
for Islamic Art and Rogers Fund, 1984 (1984.221)

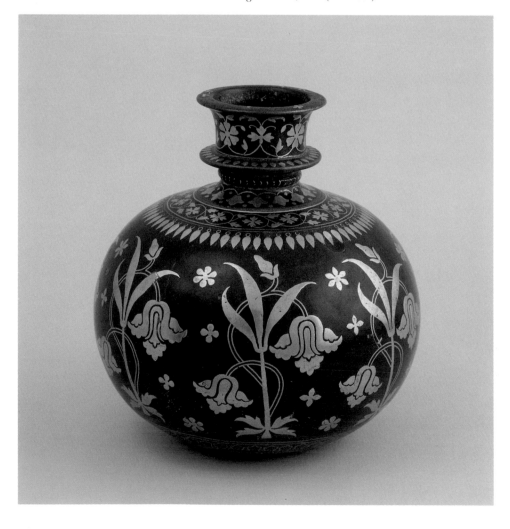

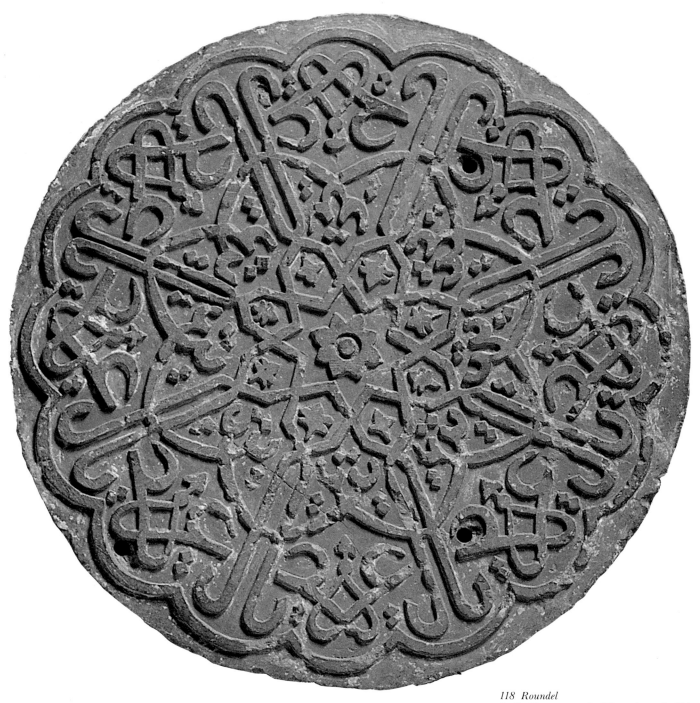

118 Roundel
India (Deccan, prob. Bijapur); early 17th c.
Sandstone; D. 18½ in. (47 cm.)
Edward Pearce Casey Fund, 1985 (1985.240.1)

SANDSTONE ROUNDEL

India is famous for its stonework, and a Persian source tells us that a calligrapher from Iran came to the Deccan in the mid-fifteenth century, penned a large inscription for a mausoleum, "and the Telugu craftsmen, with miracle-working fingers, executed the complicated patterns in stone."

This sandstone roundel from the Deccan, which probably dates to the early seventeenth century, clearly shows the skill of both the calligrapher and the stonecutter. It repeats the Arabic invocation *Ya 'aziz* "Oh Mighty!" (one of the ninety-nine Most Beautiful Names of God) eight times in mirrored Thuluth script. From the shafts of the letter *a*, an eight-pointed star emerges while the *z*'s of *'aziz*, mirrored and knotted, form a heart-shaped ornament. The calligraphy is reminiscent of the inscriptions in the Ibrahim Rauza, Sultan Ibrahim 'Adilshah's (r. 1580–1627) mausoleum in Bijapur; the number eight, besides its geometrical qualities, points also to eternal bliss and the eight paradises of which the Islamic tradition speaks.

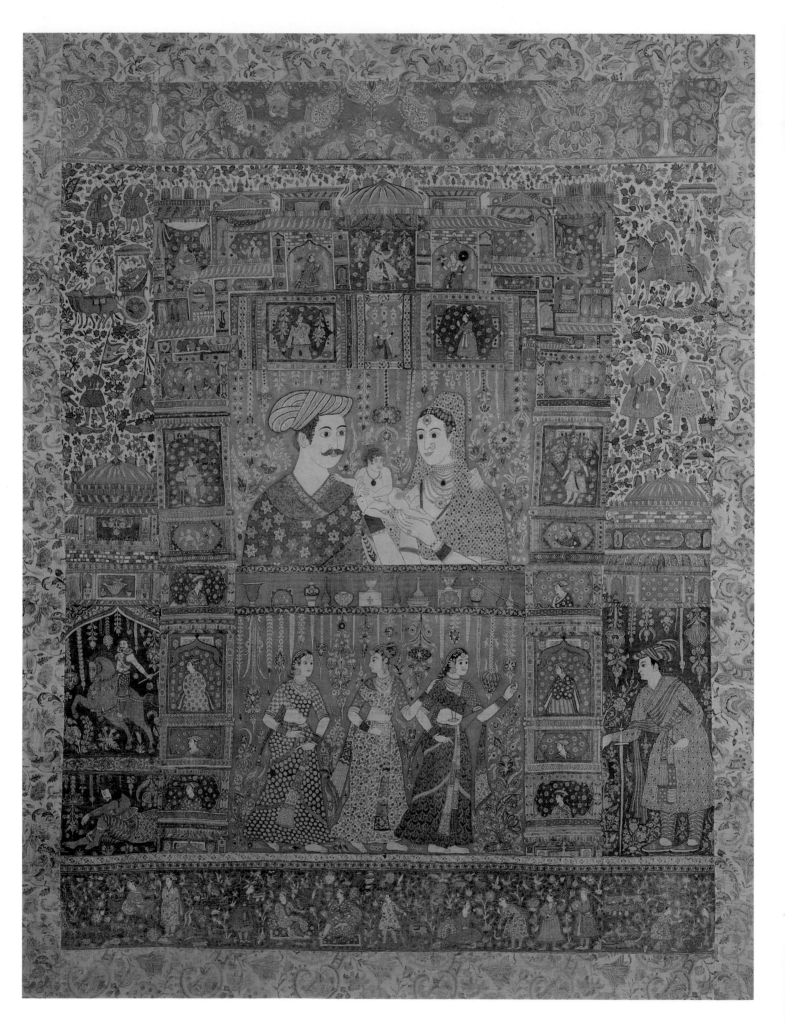

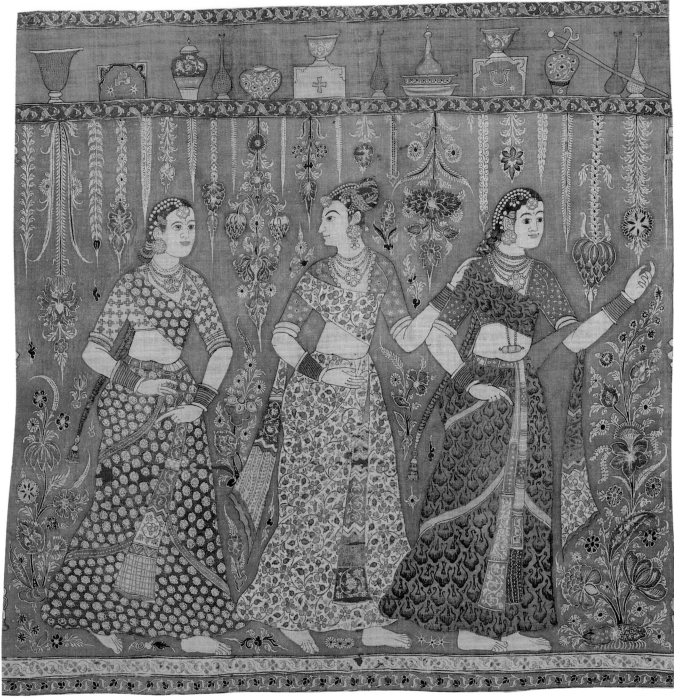

119 *Wall Hanging* (kalamkari)
India (Madras region, perhaps Pulicat);
ca. 1640–50, borders 18th c.
Cotton, mordants, resist medium, dyes;
8 ft. 3½ in. x 6 ft. 5 in. (2.53 x 1.96 m.)
Gift of Mrs. Albert Blum, 1920 (20.79)

Above: detail

WALL HANGING

Indians were superb dyers and weavers, well known since ancient times for fine cotton textiles. This wall hanging, designated by the technique called *kalamkari* (woven cotton patterned by a pen with mordants and resist mediums), demonstrates the perfection of the craftsmen and artisans. The famous process could take months to complete because it required numerous laborious procedures before the final design was accomplished.

The scenes may represent unrelated episodes of life in a contemporary palace, played out in different areas of a large princely edifice and its garden. An elegant couple with a small naked child dominates the spectacle. A still life of vases and bottles separates it from three ladies dressed in beautifully patterned saris who seem to be hurrying to a rendezvous. Figures sit or stand on balconies or in archways or pavilions, mostly dressed in Indo-Persian or Indian garments. Two Europeans, perhaps representing traders living in the area, add an exotic mark. Below, a courtly reception unfolds in a landscape with musicians, servants, guests, and even cats and other animals in attendance upon the nobles. Above, a row of standard-bearers, princely figures, and an ox cart march in procession toward an unseen goal.

Gameboard

Finely painted gold flowers are repeated with deft variation in the immaculate geometry of this sumptuous gameboard. One side is for backgammon *(nard)*, an Iranian game said to have been invented in the sixth century A.D. by Buzurjmihr, minister to Shah Nushirvan; the other for the ancient In-

dian game of chess. According to the *Shah-nameh* (*Book of Kings*), chess was brought to Nushirvan as a challenge from the Ray (king) of Hind, who would pay tribute to the Iranians if, by studying the board and pieces, they divined its rules within a week. Failure meant paying tribute to the Ray, but

120 *Gameboard*
India (Deccan); ca. 1630–40
Wood, painted, lacquered, gilded;
17⅜ x 14⅛ in. (43.8 x 36.5 cm.)
Purchase, Louis E. and Theresa S. Seley,
Purchase Fund for Islamic Art and Rogers
Fund, 1983 (1983.374)

Buzurjmihr fortunately triumphed at the last moment.

Whether made at Burhanpur or at the sultanate of Bijapur or Golconda, this gameboard exemplifies the gentle elegance of Deccani tradition. Similar in technique and style to a book-binding, its checkered geometry was enriched by a master of ornament to delight a princely patron. Superb in isolation, it must have been still more impressive seen in play within a comparably designed palace, hovered over by players wearing turbans and fine silk or cotton robes edged with similarly refined golden arabesques.

157

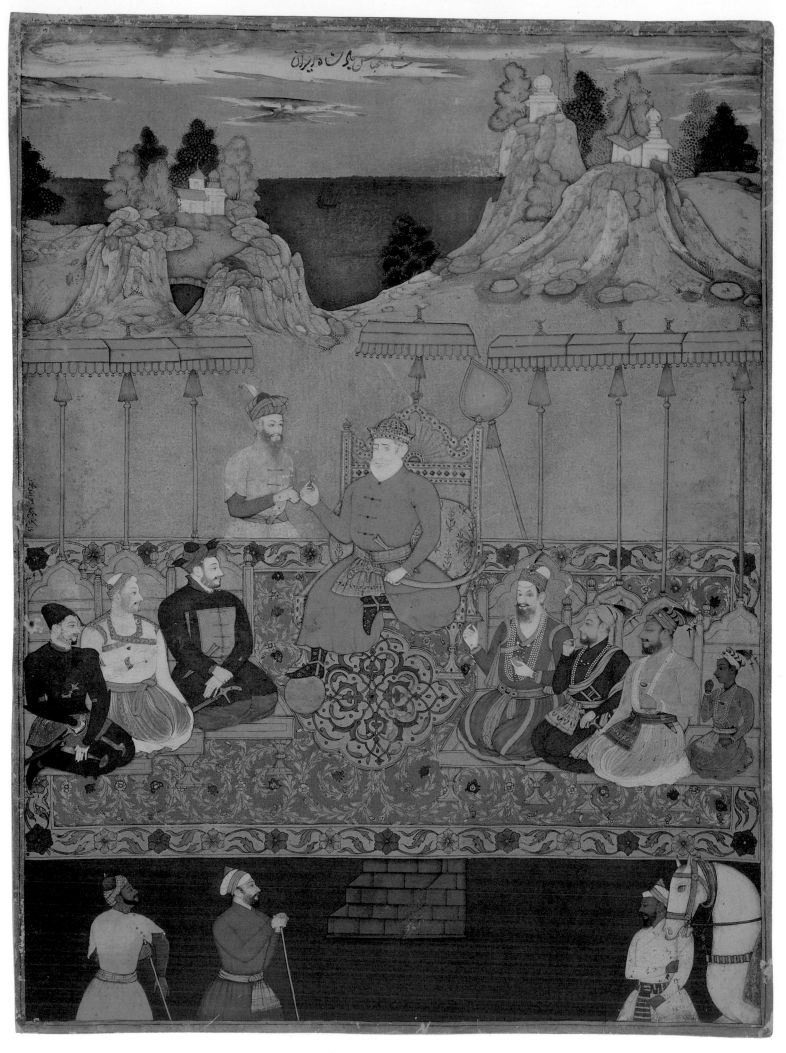

121 "The House of Bijapur"
by Kamal and Chand Muhammad
India (Deccan, Sultanate of Bijapur); ca. 1680
Opaque watercolor on paper;
16¼ x 12¼ in. (41.3 x 31.1 cm.) Purchase,
Gifts in memory of Richard Ettinghausen; Schimmel
Foundation Inc., Ehsan Yarshater, Karekin Beshir Ltd.,
Margaret Mushekian, Mr. and Mrs. Edward Ablat and
Mr. and Mrs. Jerome A. Straka Gifts; The Friends of the
Islamic Department Fund; Gifts of Mrs. A. Lincoln
Scott and George Blumenthal, Bequests of Florence L.
Goldmark, Charles R. Gerth and Millie Bruhl Fredrick,
and funds from various donors, by exchange; Louis E.
and Theresa S. Seley Purchase Fund for Islamic Art
and Rogers Fund, 1982 (1982.213)

O V E R L E A F :

THE HOUSE OF BIJAPUR

This appealing miniature—perhaps the last masterpiece of
Bijapur painting—sums up the dynasty's history and art.
Arranged in order are all the Adilshahi sultans whose king-
dom was founded in 1490, thus long preceding the Mughal
empire. Although Akbar initiated campaigns against Bijapur
in the later sixteenth century, this small Deccani kingdom
was not annexed until 1686, when Sultan Sikandra, a youth
of eighteen for whom this miniature was painted, was de-
feated and imprisoned in the massive fort of Daulatabad.

In its heyday, Bijapur extended to the Arabian Sea and
included Goa; but by 1680 the seascape portrayed here was
a nostalgic fantasy. Underscoring this point, it was rendered
in the style of Bijapur's most active patron of painting,
Ibrahim 'Adilshah II (r. 1580–1627). A talented musician
and poet, he maintained a court and ateliers that rivaled the
Mughals. Although Bijapuri painting is essentially poetic as
compared to the matter-of-fact "prose" of Mughal art, the
likenesses of the sultans here reveal strong imperial influence
in their fine naturalistic detail and penetrating character-
izations. Coloring, however, is lyrically Deccani, with lavish
passages of gold, rose-violet, and purple. Traces of this pal-
ette can still be found in the polychromy of Sultan Ibrahim's
romantic and picturesque tomb complex.

FLOOR COVERING *(Page 160 and gatefold)*

Mughal palaces, tents, and pavilions were spread with silken
hangings, carpets, and embroidered velvets for special fes-
tivities, such as New Year's Day (*nauruz*). Jahangir described
his journey on one New Year's visit to the house of his vizier
and brother-in-law, Asaf Khan, who had covered half the
road from the palace with velvet woven with gold and gold
brocade. This sumptuous carpet fits the descriptions of those
glorious textiles used only for the most splendid of occasions.

The centralized design, reminiscent of Iranian textiles,
features two main lobed medallions with pendants decor-
ated with a variety of flowers, palmettes, and leaves. Partial
medallions along the sides mirror their shape and decora-
tion. The shimmering ground of the field and the main
border display graceful, flowering spiral scrolls.

Inscriptions inked onto the selvages have recently been
translated from the Gujarati script. They give the names of
six textile artisans. Gujarat, incorporated into the Mughal
empire in 1584, was well known for the production of silks,
velvets, and cottons, and during the Mughal period there
were strong commercial relations between the region and
the ruling dynasty. It would be reasonable to assume that
the carpet, along with two companion pieces, was woven in
that region.

122 Floor Covering
India (prob. Gujarat);
Mughal period, 2nd. quart. 17th c.
Silk velvet on satinweave foundation,
supplementary metallic thread in twill;
15 ft. 3½ in. x 8 ft. 6 in. (4.66 x 2.59 m.)
Purchase, Joseph Pulitzer Bequest, 1927
(27.115)

Above: detail *Page 159:* text

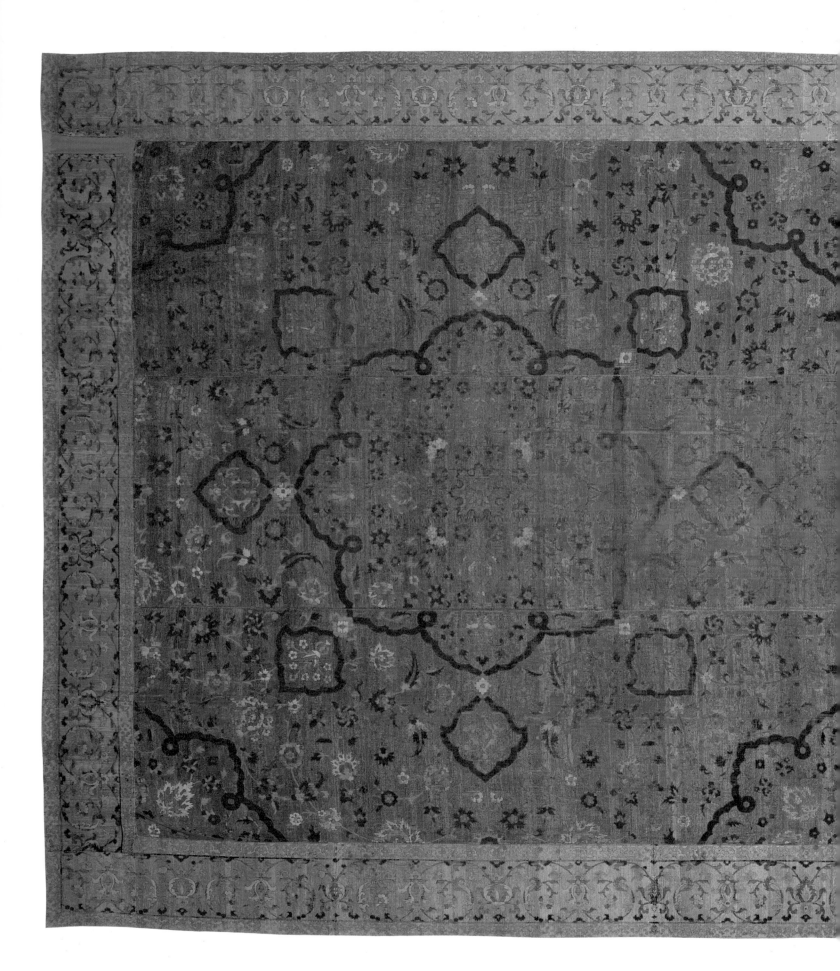

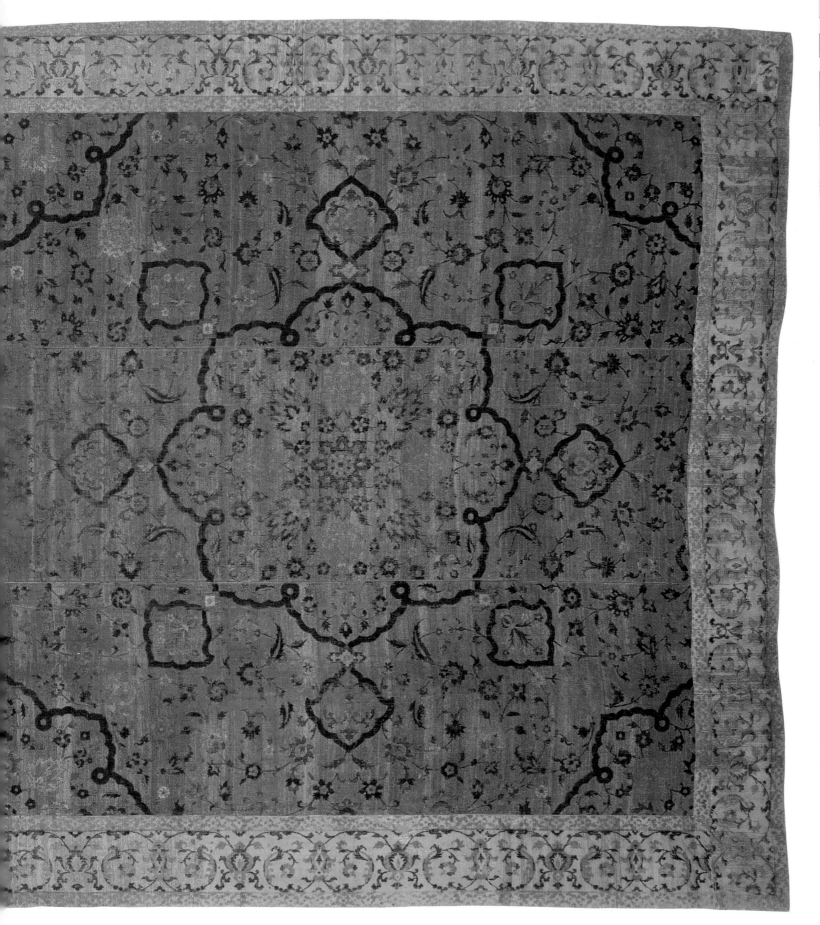

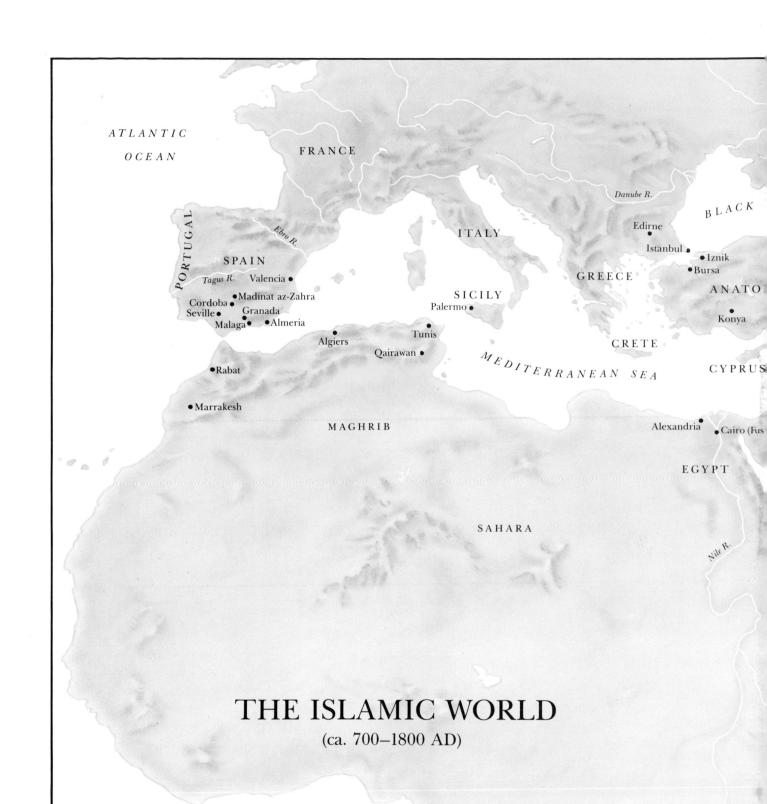

ATLANTIC
OCEAN

FRANCE

Danube R.

BLACK

PORTUGAL

SPAIN

Ebro R.

ITALY

Edirne

Istanbul
• Iznik
• Bursa

Tagus R. • Valencia

GREECE

ANATO

• Cordoba • Madinat az-Zahra
Seville • • Granada
 • Malaga • Almeria

SICILY

Palermo •

Konya •

CRETE

CYPRUS

• Algiers Tunis •
 • Qairawan

MEDITERRANEAN SEA

• Rabat

• Marrakesh

MAGHRIB

Alexandria • • Cairo (Fus

EGYPT

SAHARA

Nile R.

THE ISLAMIC WORLD
(ca. 700–1800 AD)

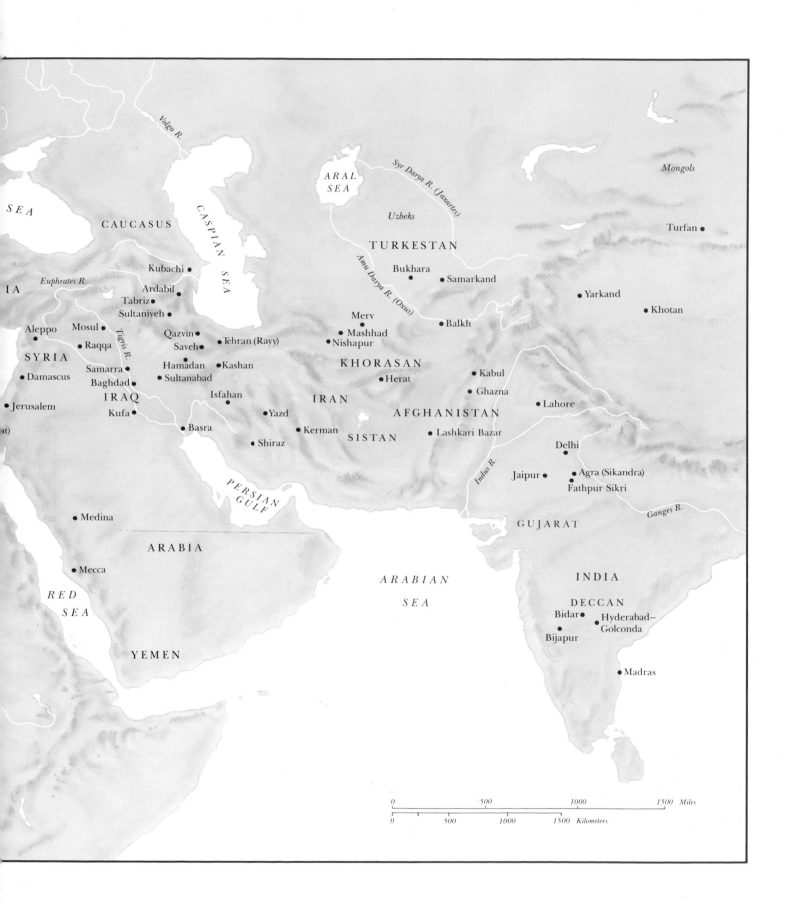

SEA

CAUCASUS

CASPIAN SEA

Volga R.

ARAL SEA

Syr Darya R. (Jaxartes)

Mongols

Uzbeks

TURKESTAN

Turfan •

Kubachi •

Euphrates R.

Ardabil •

Tabriz •

Sultaniyeh •

Bukhara •

• Samarkand

Amu Darya R. (Oxus)

• Yarkand

• Khotan

Aleppo •

IA

Mosul •

Qazvin •

• Raqqa

Saveh •

• Tehran (Rayy)

Merv •

• Mashhad

• Balkh

Tigris R.

SYRIA

• Damascus

Samarra •

Hamadan •

Kashan •

Nishapur •

KHORASAN

• Kabul

Baghdad •

• Sultanabad

• Herat

• Ghazna

IRAQ

Isfahan •

IRAN

• Lahore

Kufa •

Jerusalem •

Yazd •

AFGHANISTAN

Indus R.

Basra •

Kerman •

SISTAN

• Lashkari Bazar

Delhi •

Shiraz •

PERSIAN GULF

Jaipur •

• Agra (Sikandra)

Fathpur Sikri

Ganges R.

Medina •

GUJARAT

ARABIA

ARABIAN SEA

INDIA

Mecca •

DECCAN

RED SEA

Bidar •

Hyderabad–Golconda

Bijapur •

YEMEN

• Madras

0 500 1000 1500 *Miles*

0 500 1000 1500 *Kilometers*